Alek

Alek

My Life

from

Sudanese

Refugee to

International

Supermodel

Alek Wek

Amistad

An Imprint of HarperCollins*Publishers*

Unless otherwise noted, photographs are courtesy of the author.

A hardcover edition of this book was published in 2007 by Amistad, an imprint of HarperCollins Publishers.

HarperCollins books may be purchased for educational, business, or sales promotional use. For information please write: Special Markets Department, HarperCollins Publishers, 10 East 53rd Street, New York, NY 10022.

First Amistad paperback edition published 2008.

Designed by Lovedog Studio

Library of Congress Cataloging-in-Publication Data has been applied for.

ISBN 978-0-06-124334-9

08 09 10 11 12 ID/RRD 10 9 8 7 6 5 4 3 2 1

For my father, Athian Wek, and my mother, Akuol,
who filled me with love.

Also for my wonderful brothers and sisters:
Athian, Ajok, Wek, Mayen, Adaw,
Akuol, Athieng, and Deng.

Acknowledgments

So many people have helped me in my journey from the Sudan and back again. I give special thanks to my older sister Ajok, for giving me the opportunity to flee the civil war and emigrate to London. None of this would have been possible without her. Mora Rowe, my first agent in New York, helped to educate me as a model and as a person. She inspired me and stuck by me with good humor and strength. Thank you, Mora.

Maja Edmonston, my current agent, took me under her wing at a pivotal moment. Without her I wouldn't have this book. You have been so loyal. Chuck Bennett, senior corporate vice president of IMG Models, has always been there for me. Thank you so much.

Many great creative people have helped me over the years. Special thanks to Steven Meisel, Gilles Bensimon, Herb Ritts, Nick Knight, Peter Lindbergh, Inez van Lamsweerde and Vinoodh Matadin, Arthur Elgort, Annie Leibovitz, Michael Thompson, Mark Abrahams, David

LaChapelle, Richard Burbridge, Paolo Roversi, John Galliano, and Karl Lagerfeld for their great support.

There are so many great stylists, makeup artists, and hairstylists who have helped me immeasurably throughout the years. Thanks to all of you.

I'm grateful to Swarovski for their ongoing and generous support of Wek1933 and the charities we support.

Thanks also to Pirelli, Motorola Red, Barneys, Gap, Bloomingdale's, Macy's, Sephora, Saks Fifth Avenue, and Ann Taylor.

My gratitude goes out to Oprah Winfrey, for her genuine words of support when we first met. Your good spirit stays with me.

Anna Wintour and her team at *Vogue* have offered me so much support throughout my career. I'm very grateful for all you have done for me.

Franca Sozzani at Italian *Vogue* and her team have supported me from day one, and continue to be there for me always. Thank you for everything.

Thanks to everyone who has helped me with Wek1933.

The United States Committee for Refugees gave me a platform to raise awareness of the plight of Sudanese and other refugees. That has been a great honor.

The USCR also introduced me to the fantastic and dedicated people at Doctors Without Borders.

Riccardo Sala, you've inspired me in every way. I'm so very grateful. Thanks to all my friends for your great emotional support.

And to my fans, who have made all this possible. I deeply appreciate all you have done. You have given me more than I could have ever thought possible.

I am thankful to Lisa Queen, my literary agent, for bringing this book to light.

And thanks to the writer Stephen P. Williams for bringing this book to life.

Alek

Prologue

I was packing for the flight to London when my driver called to say he was waiting outside. I hurriedly went through my "toss bag" of beauty products and grabbed some small bottles of moisturizer. Every week cosmetics companies send me free products, and I set aside the ones that don't work for me and give them to my sisters and friends—I don't really use much makeup, except when I'm working. I put the bottles into one of the kit bags from WEK1933, the line of bags that I design. It always feels funny,

yet good, to carry a bag with my father's name and year of birth engraved on the brass zipper tags—like being home again, though it's hard to say where, exactly, home would be for me. I threw the kit bag, along with a pair of jeans—also a gift, from when I did a jeans story for American *Vogue*—a couple of T-shirts, and a cashmere sweater into one of my larger bags, and headed for the door. On the way out I said so long to my assistant, who would be handling the business while I was away. My driver held the door for me and then we headed out into the New York traffic.

I drank a cup of tea in the business-class lounge before my flight. When I boarded, I gulped some water and went straight to sleep. The thing about being a model is that people expect you to look fresh and bright after a transatlantic flight—no tiredness allowed.

London was my fourth home, after my hometown Wau, in southern Sudan, and a little rural village where I hid out from the fighting, and Khartoum, which was my first real home when I was a child refugee. So I have a soft spot for the city. I took a cab straight from Heathrow to my agent's office in Chelsea, arriving at about half past nine in the morning. My agent and I talked for an hour about some bookings, payments, and problems, and then a car rushed me to a shoot with a photographer. Into wardrobe. Then hair. Then makeup, and onto the set for a full eight hours of loud music, stressed-out stylists, and outlandish poses.

I had a good chat with the Cockney driver as my taxi crawled across London. It's funny, but in America my British accent fades a bit and a lot of Americanisms creep in—Brooklyn hip-hop talk and the like—but as soon as I get through customs in Britain, my English accent, with its full-on East London edge, returns. I love it. After all, I learned to speak English in England, on the streets of Hackney.

Alek

. . .

Back at my hotel after the shoot, I ordered a pot of tea and sank down into my bed. I felt lonely and tired—a peculiar symptom of jet lag for me—and thought of just going straight to bed, but I knew there was something better. I dressed and took a taxi over to my mother's house. Gliding through the London streets, I passed the hair salon where I worked as a teenager. The Arab customers there used to whisper nasty remarks to each other about how skinny, dark, and stupid I was, not realizing that I, too, spoke Arabic, which was the language used at the schools I went to in Sudan. I always pretended not to understand their remarks. I needed the job.

Mom greeted me with a big smile, as always, and sat me down for supper. Two of my brothers and one sister were there and we chatted away in Dinka, the language of our people. My other five siblings were elsewhere in London, in Canada, and in Australia. These days it is rare for all nine of us brothers and sisters to be together at one time but I instantly felt warm and glad I'd come. My mother served me a bowl of dried-okra stew and *kissra*, a type of Sudanese bread, and that tasted better than any four-star meal I've ever had.

My early-morning flight to Germany was canceled and I was late for the fittings for a runway show that afternoon. But the show went well, and afterward I rushed to my hotel to shower and get dressed for a party that evening. By ten o'clock I was exhausted and passed out on my bed.

In the morning I flew to Milan. The city was buzzing with models, makeup artists, stylists, journalists, and hangers-on, all in town for fashion week—such a great vibe. I had eight shows lined up over the next few days. Backstage, journalists kept sticking microphones in my face, asking for comments on what it was like to be black, to be African, to be a black African. I started to feel like an exhibit in

3

a zoo. In the hotel I turned on the TV. It was tuned to the Fashion Channel. There was Alek Wek, in an interview from some previous fashion week. "It's like, wow, you know," she said. I fell asleep, but it wasn't restful.

I awoke in the middle of the night to the sound of gunfire. I jumped out of bed and grabbed my clothes. The militias were outside. I was terrified.

Then I noticed the glow of light coming under the hotel room door. I realized where I was: a luxury hotel room in Milan. I heard the gunfire again: it was a truck collecting rubbish in the piazza below my window. I was not in Sudan. There was no threat.

A few days later I flew back to New York. In the hallway of my house I came face-to-face with an oil painting of a pair of sandals on a gray background. The sandals were like leather flip-flops. I'd painted them a few months before, while thinking of Wau. The sandals were the same shape as the rubber ones I used to wear as a child, the flimsy ones I wore when I was running through sharp grass, afraid that armed men were going to catch me and kill me. These leather sandals represented security and strength, when for so long there had been fear and flight. I'd always wanted leather sandals as a child. And now, in this painting, I had them.

Chapter 1

After I was born, the seventh of nine children, my mother and I returned from the hospital to her simple string bed, in a cement-block house in a little town called Wau. My parents named me Alek, after one of my beloved great-aunts. Alek means "black spotted cow," one of the most common and best-loved types of cow in Sudan. It's also a symbol of good luck for my people, the Dinka. I got my long body from my father—I'm nearly six feet tall—and my mother gave me my smile. My inky skin came from both of them.

When a child is born to the Dinka, the family has a party. When I was born, family and friends came from all over, thanks to the bush telegraph. There were very few telephones where I grew up, so my father mentioned my birth to someone at the market. And that woman told a man who was delivering rice to a place up the road. He told someone there, who was taking a herd of cattle south, toward the villages. And pretty soon the news of my birth had spread far and wide. Some of my relatives traveled for hours in the backs of trucks, or walked across miles of barren landscape to reach our home.

The women got together and made oils and perfumes from herbs and bark, which they soaked for days and mixed in special ways that only the elders know. As my mother tells it, the house was filled with women in their traditional robes and everything smelled wonderful. For two days these women cared for my mother and me. They fed her a special porridge and chicken soup, and wiped her brow with damp cloths. She didn't have to do anything but lie back, take special baths, and luxuriate in sensuous smells. Then the men brought a black goat to sacrifice, according to our tradition. Everyone ate good millet cakes and other sweets, which were such a rare treat in my family. As custom dictated, my mother stayed in the house for forty full days and nights after she gave birth to me.

It was a rare moment of peace in my country, and I was blessed with a very special welcome into the world. A Dinka welcome.

My people have lived in the southern Sudan for thousands of years. We're related to two gracile East African tribes, called the Nuer and the Masai, which make up the Nilotic people, who are

known for their dark skin and tall, lean bodies. There are about twenty Dinka tribes altogether, and each is divided into many smaller groups, with villages spread over a huge area. My family is from the region called Bahr el Ghazal, in the southwestern part of the country. Bahr el Ghazal is also the name of a river that meanders through the swamps and ironstone plateaus until it joins the White Nile at a lake called, simply, No. The White Nile goes on to meet the Blue Nile at Khartoum, and proceeds from there to Egypt as the river we know as the Nile.

Based on the stories my parents and grandparents told, it seems that Sudan has always been a violent land. In the eighteenth and nineteenth centuries, slave traders came through this territory, capturing Dinkas and others and taking them north to be sold in the Arab countries. It is said that even in the twenty-first century, children from the south have been enslaved and sold.

The main thing to understand about my country is that it has always been split between the Islamic Arab north and the animist and Christian south. They don't ever seem to mix that well and the north has always tried to dominate the south. The British, who ruled Sudan from the late nineteenth century until the 1950s, governed the north and south separately, but in the 1940s, just before independence, the British gave in to pressure from the Islamic leaders in the north to unite the country. The northern government then proceeded to impose Islamic culture on the southern people, most of whom weren't Muslim or Arab. Of course, there's money involved, too. Sudan's vast oil fields are in the south, along with a lot of fertile land and water.

The south has never wanted to be dominated by the Muslims in the north; in 1955 a brutal civil war broke out and lasted until 1972. Then, in that year, both sides signed the Addis Ababa Accord,

which guaranteed autonomy for the southern Sudan. I was born five years later.

Since we've always been seminomadic, totally dependent on the weather and whipped by the forces of political change around us, the Dinka are used to living through cycles of wars and uprisings followed by peace and prosperity, hunger and then bounty. In the wet season, rural Dinka live out in the villages, in conical, thatch-roofed huts, growing millet and other crops. In the dry season, they take their cattle to riverside camps. We Dinka are born expecting change.

The Dinka have never had a central government or anything like that, except those imposed on us by the leaders of Sudan. Instead, we are divided into family-based clans, and Dinka are very aware of which clan they belong to. Some of the more important clans will have leaders who influence the whole tribe. But in general, the clans are split into smaller groups and each of these will have control over just enough land to provide water and pasture for their beloved cattle.

These animals are so essential to the Dinka that even though my parents raised us in a small, relatively cosmopolitan town called Wau, far from their home villages, my mother still kept about fifteen head of long-horned cattle in our courtyard.

Like my father, Athian Wek, my mother, Akuol Parek, grew up in a thatched hut in a village south of Wau. My mother has a different name because in our culture children always take—and keep—their father's name. By the time my parents married, the civil war between the north and south was in full force and they had to flee. They roamed Africa, living for long periods of time in refugee camps and towns and cities in Kenya, the Central African Republic, and elsewhere. That was just how life was for them. They had to build a life on the run, so to speak.

My mother gave birth to her first children while she was in exile. When peace eventually came to the south, my parents returned to Sudan and settled in Wau, which was then a town of about seventy thousand people, roughly three hundred miles from the Ugandan border. They chose Wau because it was relatively sophisticated, compared with the villages where they had grown up. While they had a deep respect for their Dinka heritage, their life as refugees had shown my parents more of the world than they would otherwise have seen. They realized that they wanted their children to have a good education and the freedom to marry whom they wanted: most marriages in the villages were arranged. In fact, my mother defied her parents to marry my father, whose family wasn't deemed to be wealthy enough. My parents saw that Sudan, and the world at large, was in the midst of a great transition and they wanted us to be raised free from some of the more restrictive Dinka tribal customs—such as polygamy and facial scarring—so we could prosper in the modern world. They chose to settle in Wau, which, while having a large Dinka population that was respectful of its tribal customs, also had good schools and businesses.

Wau had originally been settled by slave traders in the nineteenth century, but had become a center for trading cotton, tobacco, peanuts, grains, fruit, and vegetables, and also had a few small workshops. I loved walking by the blacksmith's shop, where the smiths forged metal over fires built into holes in the ground. They'd heat the metal until it was glowing red and then bang it with a hammer.

A lot of Dinka lived there, but so did a lot of Fertit, Jo-Luo, and Arab Muslims from the north. It is a diverse place, where people really get along—at least when they aren't at war with each other. Much of the town was destroyed in antigovernment riots in 1965. The government rebuilt the buildings, including a strategically

important airport, after the peace treaty of 1972. There was one modest hotel and a small cinema. By the time I was born, in 1977, Wau was a nice little town where women shopped for food in the market and vultures prowled the streets, looking for scraps.

I grew up in what was considered a middle-class family in Wau. The middle class was fairly large in the town and was mostly made up of doctors, teachers, and government workers, who lived in houses made of stone and zinc. There were plenty of people poorer than us, who lived in neighborhoods where the houses had thatched roofs and the adults worked in the fields or did other hard labor. There weren't that many people who were richer than us, aside from a handful who owned local factories or other businesses. I always felt very comfortable with what we had, although most people in Europe or America would have called us poor, since we didn't have electricity or an indoor toilet, let alone a stereo, a TV, or any kitchen appliances. We had enough to eat, a solid house, and simple clothes. For that we felt fortunate. Before I was born, Wau had running water, but the government cut it off at some point and the system fell into disrepair. After that, everyone had to rely on well pumps. It wasn't a bad life at all. You just had to know how to make the most of what you had. We painted an old oil drum in our yard in bright colors and used it to collect the rain that fell on our roof. That rain-water tasted delicious.

My father, Athian, worked at the local board of education. He left the house each morning wearing a suit and tie and carrying a black leather briefcase. He was a very stylish man, about six feet five inches tall, slender, and handsome. A real gentleman. He didn't talk much, but when he spoke he was always straightforward. He expected you to listen to what he had to say, and I learned early on that even though he was usually easygoing, he wasn't one to mess with.

Alek

I remember once, he told me to go out and sweep the veranda, but I refused. Without a word, he stepped into the yard, pulled a switch from a bush, and made me stand in front of him as he peeled off each leaf and twig to make a good whip. Then he lashed the backs of my legs three times and told me never to disobey him again. I don't think I ever did.

My mother, Akuol, was always talking, always smiling, but she was also strict. My parents were a good match. They'd known each other since they were teenagers, and a deep river of trust ran between them. Dinka men can sometimes be domineering, and my father was no slouch as the man of the house, but he was different from other Dinka men. For instance, he chose not to be polygamous, even though he could easily have done so, since taking multiple wives is accepted—even expected—in Dinka culture. He always consulted my mother before making big decisions. They were a real team. Except when it came to money. In that respect, my mother was the dictator of the family. On payday my father would hand his money straight over to her and she would pay the rent and buy the food.

A few times a year she would take us to the market to buy clothes. Sometimes they would be new; other times we'd buy from the vendors who bought used clothing by the pound and sold them by the piece in little towns like ours. These are the same clothes that people in wealthy countries dump into collection boxes. We would often wear strange shirts advertising Manchester United football team or Jimmy's Rib Joint in Harrison, Kentucky. We didn't care: the clothes were inexpensive but well made and we couldn't read much English anyway.

My father was so tall it was difficult to find clothes to fit him. My mother would pick up some fabric swatches from a vendor in the market and they would decide whether he wanted a lightweight suit

or one in a more formal fabric, checked or striped, and then they'd go to the tailor.

In the evenings my father would sit in a shaded chair on the veranda and have a cup of tea while he listened to the BBC World Service on his little battery-powered radio. Sometimes I would sit with my father and listen to the radio, but usually my mother would intervene and tell me to finish my homework. Education was very important to my parents, and my father would back her up completely.

"What did you learn today?" he asked me every night at dinner. "Did you learn how to rule the world?"

"No," I would have to say.

"Well then, get in there and do your homework."

And that's what I did.

We lived in a two-bedroom house with a veranda and a walled-in courtyard with a garden and space for the cows. There were four boys in the men's bedroom with my father and five girls in the women's bedroom with my mother.

The boys were Athian, who was born in 1961, in my father's hometown, Kawajok; Wek, who was born in Liberia in 1966, when my parents were on the move as refugees; Mayen, who was born in Liberia in 1969; and Deng, who was born in Wau in 1982. He's the tallest of the bunch now, at six feet seven inches, compared with my measly five feet eleven.

Besides me, the girls were Ajok, who was born in Uganda in 1964; Adaw, who was born in Uganda in 1972; Akuol, who was born

in Uganda in 1974 and given our mother's name; and Athieng, who was born in Wau in 1979.

By the time I was a young girl, Ajok, Wek, and Athian had grown up and left home. When I was nine years old, Ajok was living in London with her husband, a Sudanese man who was training as an architect over there. There were still plenty of us children to keep our parents busy.

Our yard consisted of hard-packed dirt, which kept snakes and other animals away. There were papaya and mango trees out there, and my mother kept a few rows of okra and tomato plants. There was no plumbing or electricity so we used an outhouse in the courtyard, with newspaper or leaves instead of toilet paper. In the kitchen there were a few stew pots and a griddle. Our rooms were furnished with stools and chairs, and we slept in beds made of woven string.

I can't say that we had much in the way of luxuries, except that we had more than a lot of other people. Poverty is relative, and compared with many people who sometimes had trouble putting food on their tables, we were doing really well. Yet we also had neighbors who had generators for electricity, hot running water, and other comforts we couldn't imagine having. The truth was, we never thought about these things. We rarely feasted but we never went hungry. We always had clothes, even if they were hand-me-downs.

I grew up in the typical Dinka way, following my mother from here to there until I started school. She had a strong entrepreneurial spirit, and was constantly trying to make money on the side. She

always had something growing in the garden, which she'd sell. Or she would lease land and raise crops, such as peanuts, to sell in the market. She even brewed liquor in a homebuilt still. People loved to buy her liquor, which was pure and strong and tasted good—so they said. She never drank it and I never tried it. My father did, however. Occasionally he would meet his friends for a drink or two. My mother would always be furious with him.

"What did I tell you?" she'd shout. "What are you drinking for?"

My dad would just kind of smile and tell her that he'd have a drink once in a while if he wanted to and if she didn't like it she should just go on about her business and let him be. He so rarely drank it wasn't really an issue, but my mother hated people being drunk, on principle. To her, it was as bad as being lazy.

There was always work to be done. Every morning my mother would get up before everyone else and milk her cows. Then she'd wake us up and give us a cup of tea and a bit of bread, which was usually all we had for breakfast—we never ate more than two meals a day and often ate only one, or even none, if money was tight or if nothing was ripe in the garden. This was the accepted way to eat and nobody thought twice about it. It takes a long time to die of starvation and I learned early on not to complain if we were forced to miss a meal, or even a few of them. A bit of hunger isn't going to kill a person, even if it does sap your strength and spirit. It certainly makes you appreciate the food that you do receive. After drinking our tea we would make our beds and tidy up the rooms. Then we'd sweep the house and wash the floors before going out into the yard.

"Don't forget to pick up the manure," my mother would say.

Now, the Dinka have a special relationship with cows and so the thought of picking up manure isn't such a bad one for us. Cow

dung is really quite clean—after all, it is just grass and water. And it's not just the dung. Sometimes, a village boy herding cattle will stick his head under a cow when it's urinating so that the liquid goes over his hair and body. That's because cow urine kills lice and keeps mosquitoes away. It's just a different way of looking at the world. If you think about it, that boy is clever to take care of his infestation that way, since medicines and insecticides are so scarce in the countryside.

It didn't really bother me to reach down and pick up the manure with my hands and throw it into a pile in the corner of the yard. It didn't even smell bad. We'd leave the manure to dry while we went to school and then in the evening we would burn it so the smoke would keep the flies and mosquitoes away. Then we'd rub the ashes onto the cows' skin to keep the ticks at bay. Sometimes we would use the ash—which had been purified by being burned—as toothpaste. We didn't have plastic brushes in those days; we chewed on sticks until they went soft and then we would rub them along our teeth and gums. The sticks worked well on their own, but worked even better with the powdered dung. Years later, when I was twenty-six, I went to the dentist for the first time. He said that I had incredibly healthy teeth, so I'm definitely an advocate of sticks and powdered dung for good oral health! Although I admit that when I left Africa I started using a toothbrush and toothpaste, since I no longer had cows.

My mother was full of love, and treated us well. In general, Dinka children are expected to listen to their elders and keep their mouths shut. This is especially true in the villages. My parents were usually pretty easygoing and didn't demand too much of us, but they did

expect us to be respectful. My mother loved us but raised us with an iron fist—sometimes backed up by a stick she'd use if we got too far out of line. Still, somehow, when I was young, I got it in my head that I could do what I liked. I was a tomboy, always climbing trees and walls and sometimes I just wouldn't listen. I liked a neighbor girl called Sarah, who lived near us, and sometimes I'd sneak out after dark, climbing over the back walls until I got to her house, so we could play games and sing songs in her yard. One night I came home streaked with dirt from the packed-dirt walls and my mother said, "Look at you, you've ruined your clothes with all that climbing."

She was angry. I ran and tried to hide, but she wasn't playing around. She walked out into the yard and snapped a branch off a bush. Then she found me hiding behind the rainwater barrel. It all happened so fast my butt was stinging before I could run again.

Being beaten like that was normal in my culture. Parents whipped their children to keep them in line. Most, like my parents, would only do it when they felt it was absolutely necessary. The teachers at school would do it too. It wasn't until I went to a school run by Italian nuns that I realized that not all adults whipped children.

That school was my favorite. Like so many of the good things in our town, it was operated by Christian missionaries from Europe rather than by the government. These people came from all over the world to help improve our lives, little by little. The world knew that the civil war had destroyed much of our country and had turned vast numbers into refugees, many of whom ended up in Wau with few prospects for the future. Aid organizations sent volunteers to help the people who were in need. Often they were missionaries who wanted to convert us to their religions, and many times they

succeeded, which is why there are so many Christian Dinka. But some of the organizations didn't bother with God talk and just got on with simple plans to make things better. UNICEF did one of the best things ever seen in Wau when they built a series of well pumps across town. I'll forever be grateful for that clean water. I was lucky they built a pump near our house. Many people in Sudan walk for hours every day to collect water, but we only had to go down the road.

As I got older, my mother started sending me to the pump for water every morning and evening, which I enjoyed. I had to stay at home after school, working or doing lessons, so going to the well was one of the few times I'd get to see my friends. We'd chat about things—our teachers, other kids—or play games. Once, when we were playing, I was thrown in the trough that collected the water and had to walk home soaking wet. My mother didn't like that.

Less frequently, I would be able to sneak off to a place that I loved. Near the well, a path led up across the grass to the highest part of town. Great, spreading acacia trees shaded the trail and there were tall shea trees, which we called *lulu*, on the hill. Sometimes I'd see women gathering the small shea nuts. Later they would press the nuts to get shea butter, which is prized as a moisturizer. There, on the hill, I could see for miles across the vast plain that surrounded Wau. I'd sit in the grass and scan the horizon for airplanes coming in to land at the airport. The silver glint of sunlight hitting the wings would mesmerize me and I'd lose myself in imagining where the plane had been and what kind of people were on board. Well-dressed foreigners from somewhere far away, I knew. Farther than

Khartoum. The other side of the world, perhaps. I loved my home-town, my family, and our house, but I also loved to imagine flying through the deep blue sky, heading somewhere exciting.

I knew what that was like, because when I was only five I flew in one of those planes, all by myself, when I was sent for medical treatment in Khartoum. I'd had serious psoriasis all over my body since I was a baby. No one knew what to do about it. It made my entire body itch and I'd scratch my skin until it bled. Often it would get infected and ooze pus. There were scabs all over my legs, arms, and chest, even on my face. The palms of my hands would get cracked and sore and it felt better to keep them closed so the wounds didn't stretch.

"Alek, open your hands," my mother always said. "If you keep them closed they're going to heal that way and you'll never get them open again."

She hated seeing me suffer. When I felt like crying from the pain, I would sneak off to a corner where she couldn't see me, because when she did, she'd look like she was going to start crying too. I even had it on the bottoms of my feet, and walking on the open sores just made it worse. Sometimes I could see my flesh through the cracks, and all the oozing liquid, and I'd feel so ashamed. But I just had to get used to it. My skin turned ashy and white. My mother shaved my head and rubbed Vaseline into my scalp to keep it from flaking away.

It's so strange that I grew up to make my living off of my looks, after so many years of looking like a monster. I'm lucky we didn't have many mirrors.

My mother became desperate, because nothing she did helped. She dressed me in my only good dress, a cotton shift with thin yel-low and pink stripes and patch pockets, and we walked down to a

little wooden storefront near the market. She rapped on the shutter that covered the window.

"Yes, one minute, please," came the shopkeeper's voice.

This wasn't our usual store. The man opened the shutter and peered at us with bloodshot eyes. Behind him were narrow shelves lined with beer and liquor bottles. A plastic bucket full of matches was on the counter, along with a tin cup full of loose cigarettes.

"Give me six cigarettes and a small bottle of the cane liquor," my mother said.

I was shocked.

"But you don't drink!" I said.

"And I don't smoke, either," she replied.

"What's that for, then?"

"No need for questions from a little girl called Alek. That little girl's always got questions. You'll find out in time."

The shopkeeper wrapped the cigarettes in a piece of newspaper and then did the same with the bottle before handing them to my mother, who quickly hid them in her pocket.

We continued down the hill toward a part of Wau that I'd always been forbidden to go near. It was on the far side of the railway line, literally on the wrong side of the tracks. Country people lived there, often in houses made of mud or even just in tents of sticks and cloth. Children ran around naked in the dirt.

We came to a small farm, with yellow flowers growing on a vine along the fence and herbs in pots near the porch of a little wooden building.

"Here we are," my mother said.

"What?"

"There's a man here who's going to look at your skin. He's got special powers."

I felt so nervous my stomach got jumpy. Then I smelled the goats: that sour, stale, stomach-churning goat smell. I could see a herd of them and a bucket of goat's milk sat on a rock in the sun, collecting flies. I wanted to throw up.

My mother called out.

"What do you want with me?" came a man's voice.

"I came with my daughter," my mother said.

He opened the door, and smoke from his cooking fire drifted out. Then he followed the smoke, looking like something out of a fairy tale. He had matted gray dreadlocks, a wispy beard with beads braided into it, and yellowish eyes. His raggedy clothes were held together with twine and he wore a necklace of feathers. I was sure he was crazy. Why did my mother bring me here?

"Look at you," he said, examining my forearm. "You need help."

He negotiated a price with my mother—she would bring him a sack of peanuts. The smell of animals and smoke was overpowering as we stepped into his dark house. Bright sunlight filtered through cracks in the plank walls.

"Tobacco?" he demanded.

My mother handed him the cigarettes and the bottle of cane liquor.

"Stand," he said to me.

He took a handful of fresh herbs and shook them around my body while he mumbled supplications to God—or the Devil, who knew? Then he rubbed the herbs on my arms and face to release the oils, before scraping my skin with a thin wooden spatula. When he had finished, he showed me a pile of granules that he said he'd scraped off my skin. They looked like rotten millet. It was disgusting and I knew it was all a trick. He gave me a strange look, as

Alek

if he knew exactly what I was thinking. Then he took a swig of liquor and sprayed it out of his mouth in a fine mist to coat my skin. He opened the newspaper, took out a cigarette, and examined the brand. He smiled. My mother had brought the counterfeit Marlboros, which were more expensive than the Sudanese brands. He lit the cigarette and blew short puffs of smoke in my face, making me cough. Then he inhaled a huge lungful of smoke, burning at least a quarter of the cigarette. He let the smoke out in a cloud and waved his hands to make it waft over my body. "Done," he said. "Wait outside."

I stood in the yard, my skin itching like crazy, until my mother came out with a bag of herbs. All the way home I forced myself not to scratch, because I didn't want my mother to think she'd wasted her time and money on this witch doctor. But I knew she had.

At home my mother steeped the herbs until they made a thick, bitter drink that made me gag. For two weeks I dreaded my morning dose of this concoction. Of course, it didn't help at all. My skin still bled and oozed and itched. She took me to several other healers, each of them weird and a bit scary, but none of them helped. I could see sadness and a sense of hopelessness on my mother's face.

Finally she decided I should go to Khartoum. My father was there, getting treatment for a broken hip. He'd accidentally ridden his bicycle into a deep pothole one dark night on a road not far from our house. The doctors in Khartoum inserted steel pins into the bone to hold it together. My father was staying with my uncle, who was a doctor, and my brother Athian, while he recuperated. My mother thought that if anyone could help me my uncle could. She also thought it would be good for me to visit my father. So, one morning she packed me a little bag with a change of clothes and we walked several miles out of town to the airport. There she asked the flight

attendants to look after me and I walked out onto the tarmac and climbed the stairs to the plane. The propellers looked massive; I had no doubt that they would be able to carry us aloft over the desert.

Inside, I sat in the most comfortable seat I'd ever known. I could see the pilot in the cockpit with all the complicated dials and buttons. It was exciting, but it was also hard to leave my mother. Looking out of the little window, I saw her at the edge of the runway. I waved and waved but she never waved back. I guess she couldn't see me. We took off and flew high above the vast plains, to the city. Athian met me at the airport and I stayed in Khartoum for months, visiting doctors who all said my psoriasis was incurable. Finally my mother sent word that I should return home and go to school. Back in Wau, my skin got even worse. We saw more witch doctors. Nothing helped. When I was seven, my mother somehow got me into a German missionary hospital over an hour's walk outside of town, near the Jur River. The Germans were known for being good with skin conditions, so we thought they would be able to find a cure. I remember that on one of my first days there a German doctor took one look at me, said, "Oh my God," and left the room. It was that bad.

I stayed in that hospital for a month. They rubbed creams on my body and wrapped my legs and hands in bandages. It drove me mad not to be able to scratch but that helped me heal a little. The food was good and I rested in the sun. But I was so lonely by myself. My parents came to visit as often as they could, but it was too far for them to come every day. I missed my mother so much. Sometimes she would stay at the hospital for a few days, but not often, as she had to look after my brothers and sisters at home.

The hospital was like a maze, with rooms off a veranda and a hidden courtyard filled with flowers. It was really clean and pleasant. Eventually my skin healed and they said I could go home. I felt

Alek

great. But as soon as I stopped the treatments, the psoriasis came back and I started scratching myself until I bled. It was agony. I couldn't squeeze a lemon without my hands burning as the juice got into the cracks. The other children would sometimes make fun of me. I hated it. I didn't feel normal.

I think that the years I spent suffering from psoriasis taught me not to take beauty too seriously. Just looking at someone and passing judgment isn't really so meaningful—saying someone is ugly or beautiful. Beauty is a much deeper issue. I know, because I was ugly for much of my childhood, and then my skin cleared up and people thought just the opposite, but I remained the same person, with an ugly side and a beautiful side, like everyone else. There was nothing substantially different about me; just my skin was better.

Despite my psoriasis, I had a pretty good childhood. Often in the mornings, if I wasn't at school, I'd go to the market with my mother to get vegetables and meat from the women who brought their supplies in from the countryside on donkeys. The meat could be really nasty, because they just cut it up and laid it out on tables in the open air, with flies buzzing on it. You had to cook it thoroughly to kill any parasites. There wasn't any choice, so we didn't really think about it very much. You could find anything at the market, even fat roasted termites that people would crunch between their teeth like potato chips.

One of my favorite foods was a flat bread called *kissra*. To prepare it, you make a batter from corn or other grains, pour it out onto a griddle, and then spread the batter out with a palm leaf. When it's done, you lift it off the griddle and stack it on top of the others

you've cooked, like American pancakes. The bread is dipped into stews.

There was *ni'aimiya*, a stew made of onions, spices, peanuts, and okra or meat, sometimes with yogurt or milk mixed in. There were other stews that I liked even more, called *waika*, *bussaara*, and *sabaroag*, which were made from dried okra powder and sometimes had potatoes, eggplants, and spices in them. Our main day-to-day food was a wheat or corn porridge called *asseeda*. Sometimes my mother would serve the porridge with a dried-fish dish called *kajaik*.

For a special feast, we might also have *elmaraara* or *umfitit*, which are made from sheep offal, onions, peanut butter, and salt, and eaten raw. I loved the rare occasions when we had soups, such as *kawar'i*, made of cattle hooves and vegetables, and *elmussalammiya*, which is made from liver, flour, dates, and spices. We mostly drank tea or water, and sometimes milk. Every once in a while we'd have fruit drinks, which were made by blending orange and lemon pulp with water.

My mother tells me that I had my own special diet when I was a young girl: I liked to eat sand.

"I'd find you licking it off the walls," she said. "I'd always be catching you putting sand in your mouth."

She thought the sand had caused my psoriasis, but I doubt it. I don't know why I ate sand. I know that some people eat dirt, and scientists say it's a way for them to get the minerals they otherwise lack. I can't really imagine it, but perhaps I was missing something in my diet. Who knows? I felt it was a completely normal childhood. Until the tanks came. When I was eight, great rumbling convoys of army trucks draped with soldiers entered Wau. Everything changed.

Alek

Chapter 2

It was shocking to hear army trucks rumbling through the streets of my little town and to see men in green uniforms leaning against the walls of my friends' houses. Wau was not my simple home any longer; it was a military zone, with rebels on the outskirts, soldiers in town, and the lawless militias wreaking havoc everywhere. I couldn't even climb the hill to spot planes anymore, because the soldiers had communications equipment up there and they'd be suspicious of what a young Dinka girl was doing.

For several months, only military flights had been allowed to land at the airport, so I'd known that a lot of soldiers were coming into the area. They'd kept pretty much to themselves and I'd hardly seen them on the streets. Now I couldn't walk to school without passing lots of guns, and even tanks. I marveled at the machinery. It was hard to imagine they could turn it on me, but when my mother told us never to dawdle on the streets because they were just too dangerous, I began to realize that the soldiers weren't necessarily there to protect me. My parents definitely didn't allow us out after dark.

However, we tried to keep our daily activities up. My mother would still take the cows to pasture and there was always water to bring home from the pump. One afternoon my younger sister, Athieng, and I put our plastic water jugs on our heads and went to fetch water. We saw some other children there and we started playing hide-and-seek. I loved hanging out with Athieng, because, unlike my other siblings, she didn't boss me around. She actually looked up to me.

We were in my favorite hiding place, behind a fat old acacia tree—for some reason, everyone always forgot to look there. After a while we paused for a drink of water. Suddenly the daylight turned that deep yellow color you only see at the equator and I realized that twilight was descending. Mother would be worried.

"We've got to get home," I said, grabbing Athieng's arm. We filled the jugs and rushed off, droplets falling onto our faces, as we hadn't closed the lids properly. I made sure my sister kept her eyes on the path whenever we met someone on the way home. The darkness always made the militias hungry for stealing and shooting. I wasn't going to let anyone hurt my sister.

A green military half-track passed, kicking up red dust. One of the soldiers in camouflage peered at me from below his dark beret. His teeth were white and he licked his dry lips as he watched us.

Alek

We ran back along the road, passing more green trucks on the way. Helmets, guns, and gas canisters hung from the sides of the trucks and the soldiers looked primed, excited, ready for action. It scared the life out of me. My sister and I ran into our courtyard and hurriedly closed the gate, trying to keep the world out. There were our mother's cows, her vegetables. It felt good to be home.

Inside, my mother and father were hunched over the radio, listening at low volume. My mother looked up, held her finger in front of her mouth, and said, "Shhhh—close the door."

They were listening to the rebel radio station, which was illegal. You didn't want anyone to catch you listening to it. On the radio the announcer was saying that the conflict had spread to Wau.

"War?" I said.

My father nodded. The war had resumed, after ten years of peace. They'd been keeping it from us children, hoping that it would bypass Wau. But now it was too late for that.

The second civil war began in 1983, when I was six years old, after the rebel leader John Garang formed the Sudan People's Liberation Army (SPLA) to fight off the northern troops that were trying to dominate the south. Fanatical conservative Muslims were threatening President Gaafar Nimeiry's rule and he decided that he must bend to their wishes and not let the south be autonomous any longer.

Gaafar Nimeiry announced that the whole of my country would henceforth become an Arab Muslim land. The north was hit first. He declared a state of emergency in that part of the country and suspended most of the constitution, replacing northern courts with special "emergency courts" run according to sharia. Sharia is a system

by which Muslim clerics can interpret the Koran and Muslim teachings to decide how people should live. It's often called the "Islamic law" and can be very harsh, with amputations and stonings being used to punish people for adultery or selling liquor. Non-Muslims were given fewer rights and, along with women, were considered second-class citizens. But there was no way around it—this was the new law.

It wasn't long before we started hearing that one-handed thieves were walking shame-faced on the streets of Khartoum, their hand having been removed as punishment for their crime. A money trader there was hanged for having non-Sudanese bills in his pocket. Entrepreneurial women were whipped for selling alcohol. Opposition leaders were jailed. Fearing Nimeiry's attempts to impose sharia on the south, and not wanting to be dominated in any way by the north, the SPLA fought back. Towns and villages began to fall to the rebels all across the south. Each time the rebels won a battle, their radio station would play a special song. Wau was a prime target for both sides, because of its airport.

Almost overnight, my parents became much more protective of us. Wau had always been a trading crossroads, where Dinka, Blanda, Nual, Shual, Muslims, Christians, and others all lived together happily. I always found it interesting to learn about other people's customs and traditions. We Dinka have ceremonial marriages to cows. Other tribes marry goats.

Once the soldiers arrived, the easy social life we had with our neighbors from different tribes and religions fell apart. Everyone became suspicious of other people. Suddenly, we heard some of our neighbors saying it was the Dinka who were causing all the trouble. That if it weren't for the Dinka, who made up a lot of the rebel SPLA, there would still be peace. In Sudan, it's generally very easy

for a person to tell which tribe you're from, just by the way you look or dress. For instance, the Gurchol men wore bands of string around their waists and draped cloth from the front down between their legs and up the back, where it was again tucked into the band so that the end draped over. The various types of Dinka were easily distinguished, not only by their tall, thin bodies but by the dotted or V-shaped scars on their foreheads and cheeks.

These accusations about the Dinka made us fear that we'd be singled out.

It was the dry season and the nights were really hot. We loved spreading blankets out on the veranda or on the ground in the evening so we could lie in the cooler night air and tell each other stories until we fell asleep. We always went to sleep really early because we knew the neighborhood chickens and dogs would wake us before sunrise, or earlier. Suddenly our parents said we couldn't sleep outside anymore, because of the fighting on the outskirts of town.

We started locking the doors to the house in the early evening, and if one of us was out when the sun started setting, at seven or so, we'd panic.

"Where's Deng? Where's Adaw—it's getting dark!" my mother would say of my brother and sister. "I hope they don't run into *those* people."

All through my childhood I'd felt safe in Wau but it was now clear that even the local police had no real control. We kept hearing about militias that were forming, groups of gangsters with no political loyalties at all. They were dispossessed men who had been run out of their hometowns by the government soldiers, they were poor, or they were just bad seeds. All they wanted was to rob, molest, rape, and destroy. They didn't care who you were. Out in the countryside, they would break into a farm, killing the owners and

stealing all their food. That's how they got their provisions. Many of them weren't much more than teenagers with guns. Sometimes they would kill a policeman and steal his uniform, so you never really knew whom you could trust.

They were the darkness people, only coming out at night, so I hardly ever saw them.

One evening I was lying on my bed when I heard some men outside in the street, yelling like they were drunk.

"Mother!" I cried out. "What's that?"

"Hush," she said harshly.

I hushed.

"It's militia," she whispered. "We can't let them know we're here."

We huddled in silence, fearing the worst. Then we heard them pass.

My friend Aisha told me stories about the militias stealing children from their families and selling them as slaves. She said that there were slave corrals out in the bush, where the child slaves got water only once a day and stale bread with mealworms in it just twice a week, if they were lucky. My world suddenly seemed perilous.

Some of our neighbors disappeared. We never saw them moving out of their houses or walking away. We just noticed that they were gone. We would hear gunshots in the night and then the rumors would come down to our yard, passed over the walls, from wife to wife. The whispers were terrifying: "Did you hear what happened to Robert? He's gone. Dead." Or "Deng's wife was kidnapped at gunpoint and taken away to be a slave."

One afternoon, the radio announcer said, matter-of-factly, that everyone in Wau should stay in their houses because a rebel offensive was just beginning. The rebels wanted to take control of the

town and its airport. Since they were mostly Dinka, it was quite confusing; we didn't know which side to trust—our government or our people?

My father's view was more along the lines of "Dinka or not Dinka, they could easily kill you. Let's not get too excited about the rebels coming to liberate Wau." He didn't trust any of them.

The sound of Kalashnikovs peppered most nights and I never got used to it; I could never sleep through it. The rebels were fighting the army. The army was fighting the police. The gangsters were killing whoever stood between them and money, or clothes, chickens, or even someone's old flip-flops. You couldn't turn your head without seeing an automatic rifle. If there was a bullet to spare, it might just be for you. The sound of the weapons was terrifying.

Every day we ran home from school and closed the gate tightly, trying to keep out the impending darkness. My mother sometimes scolded us out of sheer worry, then gave us a hug.

"You stay inside now," she would say.

She served us a meal of *kissra* and okra stew. Then we heard men coming up the road, just on the other side of our wall. They shouted at a man and we heard him pleading with them for mercy. They gave it. They laughed at him and they let him go. Then they went on to harass or kill their next victim, depending on their mood. These militias were our nightmare.

We crowded around the radio whenever we could, addicted to the war news. We'd hear that another city had fallen to the rebels. It was hard to believe, because the government soldiers were definitely keeping the rebels from entering Wau, although we'd heard that there were plenty of them on the outskirts of town. More soldiers poured into town each day. We'd hear the trucks, hear their ammo

going off at night as they chased down militia or fired weapons at random around the town.

One morning I was walking to school when a convoy of trucks started moving into the center of town. I stood next to a tree and watched the procession pass. It was a long line of them, grinding into town, like nothing that we'd seen so far in the war. The government was really gearing up for something. It made me think that maybe these rebels were more threatening than I thought. Were they so powerful they could scare the government? Maybe the rebels had some good points. But I wished it would all end.

Having all these government soldiers in Wau gave it the feel of a military compound. Everything seemed so unfriendly. I could tell that my parents were nervous. I started worrying that they might be killed or kidnapped, or just disappear. If you start to think about your mom or dad disappearing, at nine years of age it can be overwhelming, terrifying. A shadow was hanging over me. I had felt free until the troops arrived. I began to think that the government must have been doing something very wrong if they had to back it up with all this force.

Still, despite the war, we needed water every day.

To carry the water, we used old cooking-oil containers that you could buy in the market. I would coil a piece of cloth on top of my head, set the container up there, and then head off.

"You're skinny but your neck is strong," I remember my sister telling me one day.

"It's all in your heart, you know," I replied. "It doesn't matter how big your muscles are."

With that empty canister on my head I'd turn right out of the

gate and walk up the dirt road. Most of our neighbors lived in modest cement-block or wood houses, some of them quite makeshift. There was one mansion, with porches all around and brick walls. It was the home of a man who owned a large brewery on the edge of town, near the river. There were so few rich people in Wau we never thought of the differences between them and us, but we knew they had more possessions. While I wasn't jealous or covetous, I loved imagining myself living in that house, with its upholstered furniture and electricity generator. Just past this mansion—which, in truth, was probably no larger than the average middle-class American house in the suburbs—was a road that went left up the hill to where I had once spotted planes. To the right it descended into a poor area, where some of the militias came from. By poor I mean that people were barely able to cobble homes together from scrap wood and straw, and rarely had more than a couple of days' worth of food in the house at any time.

"Don't ever go down there by yourself," my father had warned me. "Someone might want to kill you."

The police were always down there, fighting with the militias.

The well pump was right at this junction, in a broad field of green grass that was as beautiful to me as any park I've seen since. One day, when we went there, everyone had gone, except my sister Adaw and me. I smelled something awful in the air. I knew it was death. Then I saw a woman's body lying in the grass about fifty yards away, her tongue hanging out like an old piece of leather. She couldn't have been there very long but already her corpse smelled rotten, owing to the intense heat. I wanted to see her corpse up close.

"No, Alek, don't!" Adaw said.

I realized she was right. Then I saw another body. We ran straight home.

After that, my mother would always come with us to get water and it wasn't at all unusual to see dead bodies there.

"Don't look," my mother would say.

How could we help it? I sneaked glances on every visit we made to the pump. Over time the bodies turned into bones, bones inside clothes. That was war to me—dead bodies left to rot.

If my mother could have carried enough water on her head for all of us, she would have gone to the pump by herself. The killing field across from the pump got worse every week. I worried that the rotting bodies were going to seep into the water supply, but my mother said that they were too far away. Still, every time I took a sip of water I thought of those bones.

Soon my mother forbade us to leave the house alone. She didn't need to worry. I was too scared to leave. I was going to stay safe inside our house forever, my mother always near. Before the war, in the evenings, we children walked by ourselves to the missionary school to play volleyball and other games. That seemed absurd now. The nuns canceled everything so that they could stay in the safety of their convent. My parents made sure we were inside, behind the gate, by five o'clock.

Word was that the local police were running out of ammunition. They had always done their best to protect the local people, but now the only ones with bullets in our town were the government soldiers, who, when it came down to it, really couldn't care less about people like us, especially the Dinka, and the gangster militias, who definitely didn't care about anyone. Those two groups just started shooting at each other all over town. All night long there'd be Katyusha rockets blazing across the sky, and the sound of automatic weapons being fired and men yelling. I always woke before dawn and that was the only quiet hour. We couldn't leave our courtyard. The shooting got

so bad that, at one point, we couldn't leave our house for three days. Strangely, all the violence led to a kind of beautiful togetherness in the neighborhood. My mother had stockpiled some potatoes and other roots; we had enough dried okra to last, and several containers of water. Our neighbors had done the same. If someone needed something, they would just ask their neighbor for help. I remember passing a bucket of milk over the wall to the woman next door. In turn, she gave us some tomatoes. We took care of each other.

Just before sunset on the second night, my family shared a meal of *kissra* and okra stew. After we had cleared everything away, my older brother Mayen helped our father get to his feet so he could use the latrine in the courtyard. He had come back from Khartoum with the pins still in his left hip to help it heal. The doctors had told him to come back to have them removed after a few months, and he had planned to, but then things in Wau became very difficult. His hip became badly infected and he could only hobble. With such trouble walking, he fell and broke his left arm, too. He was having a miserable time, but there was no way he could return to Khartoum for treatment. He struggled to get to the latrine each night, but he did it on his own. He was proud that way. I was worried about him.

Soon, there were a lot of trucks on the roads, and gunfire in the distance. For reasons we didn't get to know, everything felt even crazier than usual.

Then I heard men coming up the road. Some trucks. All of a sudden, a firefight broke out right outside our house, just as my father was struggling to get back from the latrine. He had to throw himself to the ground to avoid the bullets flying over the wall. My heart ached to watch him lying in the dirt, his face racked with agony. We couldn't do anything for him.

"Duck! Duck!" my mother instructed him.

The bullets kept flying. That was the longest twenty minutes of my life.

The next day my parents whispered to each other, and their faces seemed more worried than ever. The radio said that all citizens of Wau should prepare to evacuate.

That night a group of militias appeared at our wall and pounded on the solid metal gate. My mother gave my father a worried look.

We had no idea who they were or what they were looking for.

"They must be at the wrong house," said my mother.

They started fiddling with the lock on the gate.

"Hush," my mother said. "They can't know we're here."

She blew out the kerosene lantern and we huddled together in terrified silence.

Just then the militias got through our front gate. I could hear them walking outside near the veranda, moving very carefully. By that time so many civilians had taken up arms that the militias were afraid of being shot by us.

My mother suddenly sat up with a jolt and said, "I left the front door unlocked."

She crept to the door and flicked the latch. The lock made a clicking, metallic sound. The militias' guns exploded in a blast of bullets. They must have thought the clicking lock was a gun. They sprayed bullets into our walls and through our windows. We dived under the beds to hide, but my father couldn't bend well enough and his legs were sticking out. He was almost crying from pain. Then the shooting stopped. The militias fled. They must have thought we were shooting back at them, but we had no guns. Just an angel, I guess. We huddled together even as they left in search of easier prey. It felt like the darkest night ever.

Alek

Chapter 3

I stared into the darkness after the gunmen left. There was no moon and we couldn't light the oil lanterns for fear of the light being seen outside, so it was impossible to see a thing. My little sister snored and fidgeted on the floor next to me, oblivious to everything. Gunfire in the distance kept me on edge; I feared the militias would return. There was a smell of gunpowder. Men were yelling. Each time one of the cows snorted out in the yard I thought it was someone climbing over the wall. Sucking in my stomach and flattening my

shoulders to the cold concrete floor made me as thin as a board. The bullets, if they came, would whiz right above me.

It's the same thing I do now on the runway—throw my shoulders back and lengthen my body. In ten years I went from dodging bullets in a scarred and frightened little town to strutting for fashion editors while wearing elaborate couture.

But that night I had no dreams of Paris, no ideas about London, no clue as to where exactly New York was. Not even a hint that I was about to become a refugee myself.

The rebels and the government both wanted control of the airport in Wau, so they were going at it with guns, bombs, clubs, and whatever else they could muster. If my family got caught in the middle, we'd all be killed. The militias were the most terrifying of all. They would move down the dirt streets, blasting Michael Jackson's "Thriller" from a stereo while they robbed anyone who got in their way. They would steal a family's cooking pots. They would shoot people on their way to the market and take the few coins they had set aside for food. A lot of the militias were still children.

As I waited for sunrise, I pictured the soldiers, the rebels, and the militias attacking each other. I had seen dead bodies, so I knew what happened when someone got shot. In my imagination, they shot and stabbed and kicked each other until they were all dead and we were able to sleep in peace.

Still sleep didn't come, so I drifted between prayer and imagination, just trying to keep my mind off what was happening outside. I thought of a photo I saw in a magazine that a foreign aid worker had left behind at my school. It was of an ochre-colored house in a grove of tall pine trees on the edge of the sea somewhere far from Africa. The dining room had high glass walls; the table was set for a big meal and decorated with a huge vase of sunflowers. The light

in that photo was a soft yellow and it felt so peaceful. I wondered if people really lived like that, or if it was just a fantasy.

The shrill sound of 122 mm Katyusha rockets made me jump. What if a rocket came right through the roof, right into our room? I had to pee but I held it in. It got painful but I wasn't about to step outside after what had happened to my father a few nights before. More Katyushas went off, closer this time, and when they exploded, I swear, the ground shook. Then there was utter silence, even more frightening than the sound of the rockets. I was sure we were going to die.

Somehow I was so tired that somewhere between that thought and the roosters crowing, I dozed off. When I woke up, the air smelled of death. I wanted to vomit. Then my mother walked into the room.

"Alek, what are you dreaming about? It's time to get up," she said.

She stood over me and my sisters, stirring the air over our heads with a *wush-wush-wush* of her hands. That meant "Get moving, girls!"

I opened the door to the early-morning sunlight. For a moment the world looked lovely. Our neighbor's banana tree rustled in the breeze and a palm stood tall against the coming light. My mother's cows had lined up in the courtyard as usual, waiting for her to lead them out to the pasture.

Meanwhile, my father stirred on his bed, taking his time getting up. He was only about forty but he moved like an old man. His hip was killing him after he slept all night on the floor but he didn't make a sound as he slowly uncurled to his full height. He just stretched, said "Good morning," and turned on his radio. He usually listened to the BBC, but sometimes in the afternoon he'd turn

on the rebel radio station, very softly, so the government soldiers wouldn't hear it and haul him away. Even as the situation escalated, my family didn't get involved in politics. Since the rebels of the SPLA were mostly from the south, where we lived, and were mostly Dinka, like us, they treated us pretty fairly. My parents were probably more inclined to support them, but as a family, we tried to stay out of the way of anyone with a gun. There wasn't much profit in taking sides.

The radio said that the local government was urging all the people of Wau to flee. The situation was just too dangerous.

"As if we didn't know," said my mother.

I held the hem of my dress, as if to protect myself, and stepped gingerly into the yard with my sister. Everything looked calm, so we went to the gate and looked outside. People were already walking down the road, carrying loads on their heads. The exodus had begun. Then my sister beckoned me over to see some bullet holes that had splintered the wood of our gate, which was sheathed in zinc.

"Mama, look at this," we called out.

My mother came over and shook her head. Then she pointed to a hole in the ground, where one of the militiamen had rested his rifle. "Bayonet" was all she said.

Back inside my parents huddled in private. This was how they always did it. They talked things over and came to an agreement. It's really quite inspiring to remember how my mother and father were able to communicate so well and work together to face all the hardships that they had suffered.

At one point I heard my mother say, "That's it—I can't take this anymore." Then she saw that I was listening and lowered her voice. When their conversation ended, my father turned to us. His skin was pale but his eyes were on fire.

Alek

"We will leave for the villages today. It's no longer safe for us here."

From the tone of his voice we knew that we had no choice.

My parents had spent their entire childhoods in the midst of various wars in Sudan. Ever since the British colonizers granted my country independence in 1956, we've been ruled by military regimes that backed Islamic governments, although the country—the largest in Africa—is made up of a lot of different tribes and religions. Finding a common center has been tough. When they were growing up, and also after they started a family, my parents had to flee their homes for other African countries, such as Congo, Uganda, the Central African Republic, and Liberia.

None of this was new to my parents. They were about to be refugees again. If it made them sad, they never showed it.

The villages where my parents and their extended families had grown up were south of Wau, far from the main roads. In the villages, people still lived the old way, in round mud huts with no running water. They grew or hunted almost all their food, and in the dry season, the younger people would take the cattle far from the villages, to an oasis, and live there while the cattle grazed. The villages had no telephones, so it was hard to get information from our relatives about how things were going in the countryside. My parents thought that if we went to one of these villages, we might be safe. There was no guarantee, so we just had to walk there and take our chances.

I had never been that far into the countryside, and I had no idea what lay ahead of us. I'd heard that things down there could be really strange. The few times our cousins had come up to Wau to visit us, they'd worn makeshift clothes, and sometimes they had fleas or lice that they would ask us to pick out of their hair. All my friends would

tease them. My aunts would sit in bed with their shoes on, getting dirt all over the sheets, which we thought was quite peculiar. But my father said that's how they did it at home, where they slept on straw mats instead of beds.

Five years later, when I went to England, I got a firsthand lesson in how wrong it is to judge people by their backgrounds. That's because I was misjudged myself. In Wau, I belonged to a well-educated, worldly family, but in London I was the one everyone teased for being a primitive country girl.

In their eyes, I was no different from my village cousins. I was an unsophisticated African, whose skin was darker than night. They were second- or third-generation immigrants, with lighter skin, and they knew the ways of London. I realized then that it is all relative, and that you shouldn't think badly of others for not having the same advantages or viewpoint. I felt bad for having judged my village cousins harshly at times in the past. In fact, I felt like I would have given anything just to see their friendly faces at that moment. It had taken a long journey for me to figure this out.

After we had a quick cup of tea, my mother started "packing" for the trip. She didn't haul suitcases out of the closet as I would do today. She didn't tell us to fold our underwear and get three changes of clothes, or pack all our toiletries in a bag. No, none of that. Instead, she laid sheets on the ground, which would be wrapped up around everything. She told me which cooking pot to grab from the kitchen. We took a knife, one or two cups, and a container for water. All eight of us would be eating with our fingers in the Dinka way, so there was no need for many utensils. My mother packed powdered okra that she could cook along the way, since there would be no place to get food. She carefully tied up a bundle of salt, for cooking and trading with people. It was worth a lot, because outside of the

towns people rarely had salt. We gathered all this up into the sheets that would serve as our suitcases.

These days, when I travel, I have maid service, room service, laundry service, and turn-down service. Back then, we had nothing really, bar our wits. The amazing thing was that my parents made us feel safe and comfortable anyway. Which just goes to show that comfort is a state of mind.

I was comfortable that morning in my nicest outfit, a floral print cotton dress with an elastic waist, which we had bought in the market. It was very simple. That and flip-flops was all I wore. None of us took even a change of clothes or anything personal.

Before we could leave, my mother had to say good-bye to her cattle. They were her children, in a way. Each one had a name and she could pick out their individual faces from far away. Cattle have always been central to the Dinka culture and are part of our identity. One of our myths is that when our god, called Nhialac, created the Dinka, he gave us a choice between having cattle or a mysterious unknown something he called the "what." The Dinka chose cattle, because they represented wealth and dignity. That has given us Dinka a very strong self-image, which has been passed down through the generations. I know this has helped me remain positive through all the difficulties I've faced in my life. As a Dinka woman, I've always been proud that my ancestors were smart enough to choose the cattle over the "what."

These days, with all the Dinka people who have moved abroad, the culture has begun to change. We see a lot of other kinds of wealth that we never saw in the southern Sudan, ranging from the average American's reliable plumbing to celebrities' sports cars, and we realize that living the old way isn't necessarily such a rich life after all. Still, we try to keep our culture intact. Cattle remain

symbolically important to me and other Sudanese expatriates, even if it's not very practical to keep livestock in our new homes far from Africa, in places like London, New York, and Sydney.

When I think about all that has been destroyed and changed by the war, I am inspired by a quote from Ariathdit, an early-twentieth-century Dinka prophet. At the turn of the century, the British colonialists put him in prison for sedition while they took over the country. After they released him, he said, *"Piny nhom abi riak mac."* Which means: "The land may be spoiled, yet it will remain intact." We may have lost a great deal during the civil war, but the Dinka culture will never be destroyed.

That's how my mother always thought. That's what led her to arrange in advance for a local man to drive her herd of cattle down to the village if the time ever came that we had to flee. She would preserve our family culture even if everything else about us had to change. The cattle would be really valuable in the village. We could get milk from them, or could even sell one if we had to. They would also give us a sense of self-worth and a spiritual connection to our past.

The morning we left our home, my mother was able to say good-bye to her cattle in peace, because she knew she'd see them soon. Even though we were in a rush to get as far from the fighting as possible before nightfall, she spoke softly to each cow, addressing each by name, giving this one a scratch and that one a rub, assuring each one that everything was going to be fine. I swear they gave her sympathetic looks in return. I don't think she'd ever have been able to flee Wau without knowing that her cattle would be cared for, and that she'd see them soon. If I hadn't been so sure that my mother loved me even more than she loved her cows, I would have been jealous.

Alek

Walking out through the front gate, I felt sad to leave our home behind. Most of us children were pretty young at the time. I was just nine, and then there was Mayen, eighteen, the joker of the family; Adaw, fourteen, who definitely always acted like my "older sister"; Akuol, twelve, who was serious and sensitive and very loving—we were quite close; Athieng, seven, who idolized me in the way that little sisters do; and little Deng who, at only four, was the baby of the family, the little king. The three other siblings, who were older, were away, studying and working in Sudan and England.

It was going to be hard for us to walk far, but we all carried something, however small, on our heads for a little bit of the time. Even Deng knew that when we weren't carrying him he'd have to carry a little bundle himself. There was no choice and even as children we knew that if we stayed in Wau we would probably be killed.

I balanced one of the smaller bundles on my head and stepped out into the road with the rest of my family. People sometimes called us the Wek Army, because there were so many of us. That's what kept us together and helped us do so well: we were a little community of our own, my mother and father, my brothers and sisters.

It was a hot morning and the fog burned off quickly as we walked along the road, which was already busy with other people fleeing their homes. The main road out of town was packed with people, as if a whole city had come together to form an endless line of refugees. We were those very images you see sometimes on the television. A couple of years ago I was in the first-class lounge at JFK, waiting for a flight to Paris, when CNN started showing footage of people fleeing their homes in Sierra Leone. It was a long line of dark-skinned people, mothers holding children's hands, fathers carrying bundles, the lucky ones wearing sandals and the rest barefoot on the dusty road. Looking around me at all the well-dressed, well-

fed people chatting into their phones or pressing buttons on their electronic gadgets in the lounge, I suddenly felt very much alone. In many ways I felt closer to these refugees in their ragged clothes than I did to the privileged international travelers whose class I had somehow joined.

That morning in Wau, I was right in the middle of it, nine years old and heading off into the bush, to a world I'd never seen before. There were all kinds of people on the road: Muslim women covered in deep red or blue or green scarves, Nubian men in long white robes, Christians wearing American castoffs from the markets. But mostly it was Dinka like us, who were walking south, toward the borders with Congo and Zaire. We were headed deep into Dinka territory, where our ancestors had herded cattle for untold generations.

As the miles passed, the crowd of people on the road thinned out, as some families veered off toward their own ancestral lands, and by the time we reached the old brewery that produced all the beer for this part of the country, the walk began to seem less stressful. The brewery sat on a huge plot near the Jur River, and over the years, my mother had leased some of the property there to grow peanuts, which did well in the sandy soil. She sold the peanuts to get money for the family. Since they were friends, my parents walked over to chat with the manager. He was a tall, charcoal-skinned man, and I remember that he was very warm to my parents.

"Aren't you going to leave?" my father asked him.

"I can't," he said. "I've got to take care of the brewery."

My mother shook her head.

"Don't be loyal to a fault," she said. "It's just bricks and beer when it comes down to it."

"Well, I won't risk my life for the bricks—but beer, that's another story!"

Alek

He was so good-natured, even in the face of it all. Before we left, he gave my father some advice on which trail to follow. He said that once we had crossed the river, we would have to avoid all roads, as they were crawling with armed men, both rebels and militias.

"Stick to the bush," he told us. "You can't trust anybody."

Just past the brewery, the pastureland at the sides of the road turned into wetlands, with tall reeds stretching out as far as we could see. There were only a few trees here and there—I'd never seen anything like this. Soon we reached the Jur River. Since it was the rainy season, the river was high on the banks. It seemed so wide that I couldn't imagine what was on the other side. The river alone was terrifying. Everyone knew that in places it teemed with crocodiles and hippopotamuses and other animals, though my father assured us that there weren't any around here. I'd seen the huge fish that came out of these waters, for sale in the market, and I didn't want anything to do with them.

Some men had pulled their dugout canoes up onto the mud bank and there were probably two dozen people there, waiting to cross. Out on the water I could see another dozen or so of these dug-outs, dangerously full of people and their possessions—including chickens, a goat or two, some big sacks of grain—bobbing up and down in the water. I was worried, as I'd never tried swimming in my life.

In fact, I only learned to swim a few years ago, when I was twenty-seven. I was on a friend's yacht off the coast of Sardinia and, looking at that amazing sea, I said, "Yes, I want to learn how to swim." I was on vacation, surrounded by luxury, yet my first thought was that if I ever had to cross a river again to flee a dangerous situation, I'd want to know how to swim! I got one of my friends to teach me. The first time I tried, I sank like a stone, which terrified me, but I

went back in. It was so beautiful, and so frustrating. I kept it up, and after a few days I was floating on my back in the sea. It was the most amazing feeling—pure freedom. In a way, it let me conquer that river back in Sudan, at least in my mind.

I had none of these thoughts at the river that day. Instead, I felt trapped. I knew I was going to drown.

"I'm not going," I said to my mother.

She hardened her face and dropped her eyelids. As stubborn as I was, I couldn't stand up to The Look.

"If you want to live you'll get in that boat."

I climbed into one of the canoes with three of my siblings. The captain looked scared and kept glancing nervously at the shore, checking for men with guns. Nobody knew when the bullets would start flying. I sat in the front, back-to-back with my sister, and our stuff was piled up around us. The boat wobbled as we set off and I yelled, "Help!" but my mother just said, "Alek, hush." I clutched the sides of that rough little boat so tightly I'm surprised they didn't snap. Luckily the water was calm that day.

Ironically, as we crossed the river, we could see a perfectly good bridge upstream, but the government troops wouldn't let refugees like us use it. They wanted it closed in order to keep the rebels out. When we reached the other side, I scampered out of the canoe and started walking.

The trail ran through high reeds, so you couldn't see more than a few feet in front of you. It was a tunnel of bright green grass, and the ground was squishy and wet. My flip-flops kept catching on roots, but my mother steered me along with her gentle encouragement.

By late afternoon we were still walking through the wetlands, surrounded by thick scrub and reeds. We could have just been wandering in circles, for all I knew: one bunch of shrubs looked pretty

much like another. Fortunately for my mother, the angle of the sun in the sky and the types of leaves on the bushes—one area has certain plants that another doesn't—were as good as any map. She had learned these tricks when she was young and, despite all our troubles, she found joy in walking through the bush.

"This is my childhood all over again," she said.

Instead of acting like a put-upon mother of nine children, she tried to teach us what she knew. Her good mood was infectious.

We hadn't eaten anything since our cup of tea that morning and were getting hungry. My mother spotted a bunch of pumpkin leaf growing nearby and sent me to collect it.

"Remember that, Alek?" she said. "We bought it in the market."

I did. I remembered the stew she made with the leaves, which made me even hungrier. We stopped a few more times along the trail to gather greens called *tamalaca*, as well as wild okra and a fruit called *amaco ding*. I was so hungry I wanted to eat it right there. Suddenly, my mother stopped dead in her tracks. There, not fifty yards away, were some SPLA rebels carrying weapons. Her face grew stony, which meant she was nervous. That made me afraid. The men had already spotted us and they came forward.

"Don't say a word," my mother told us.

My father was a few hundred yards behind, walking slowly with Deng and Athieng because his hip hurt, so he couldn't help.

My mother pressed her lips together, her face determined. I could see she was scared, but I think what the men saw was a tough woman they wouldn't want to mess with. They were cold and businesslike, looking us up and down and examining our bundles of grain and cooking pots. My insides felt like jelly.

"You from Wau?" said one.

He looked like the leader, though he was dressed only in a ratty T-shirt, trousers, and sneakers.

My mother said we were headed for the villages. He just grunted and stared. It looked like trouble to me.

Then, out of the blue, my mother surprised him with a big smile that melted his harsh face.

"Do you need anything?" she asked.

The rebel looked at her for a long moment, which made me think that yes, he needed a lot, and he wished we had more to give him. He needed guns and food and clothes and trucks and radios. He needed the government to stop trying to enforce Islam. He needed freedom for all the people in Sudan.

"What do you have?" he asked.

"Soap," said my mother. "I could give you a bar of soap."

He nodded. He had so little that a bar of soap was good enough. This was the kind of man the rebels thought could bring down the government? They had a few bullets but no food.

My father came up, and after a tense moment he and the man shook hands. The other rebels watched. My parents spoke to the man for a while, gesturing up the trail. It looked like the man was giving them advice. The rebels left, fading into the bushes as silently as they'd appeared. Then my parents gathered us around and told us we weren't going to our father's village after all. The rebels had warned them there were some government troops in that direction. We were going to a different village instead, one where my father's more distant relatives lived.

"We don't know them but they'll welcome us," my father assured us. "We'll have a good life there."

I had my doubts, but I didn't say so. Already it felt like we'd left

any chance of a good life behind in Wau, but there was nothing to do but move forward.

We walked on, looking for a place to spend the night, until we finally found an abandoned hut.

"The animals won't come near a place where people have lived," said my father.

We didn't break in, because that wouldn't be right. Instead, we swept the ground outside the hut with leafy branches to make a hard surface. Then we lay our blankets on the dirt while my mother beat the ground with a big stick to let any wild animals in the area know that we were here and that we were human and that they'd better stay the heck away.

"But what about the snakes?" I said.

I hated snakes. I always have.

"The snakes don't want to eat little Alek," my father said.

"And the lions?" I asked.

"Lions want a fat girl, not a skinny little girl like you," he said. "This is where we are so this is where we're staying."

He was right. Where else were we going to go?

My mother sent us children off into the bush to look for dry wood and grass to build a fire, and told us that whoever brought back the most wood would win. She was always setting up games for us so everything, no matter how bad, would seem like fun. We found a little pond and brought back some water. My mother cooked the greens up into a stew, seasoned with a little salt, and cooked some grain to go with it. She boiled the water for us to drink. We gathered on the ground around our feast and ate it with our fingers from the three flowered enamel plates my mother had brought with us. Those plates made the meals so much nicer. It's amazing

what a small amount of civility will do for you when you're in a hard situation.

We were so hungry this food tasted as good as any meal I'd ever had, though the food was finished pretty quickly—there was only just enough to go around. I was used to small amounts, so it didn't really bother me. To this day, I don't eat huge meals and I hate seeing food go to waste. I trace it all back to those days walking in the bush, when we always had enough, but only just enough. I learned just how little it takes to survive. I also know that it could all disappear in a heartbeat. It's good to keep that in perspective, which is why I don't waste things—food, money, friendships, or opportunities.

As the sun set on our little camp, I don't think I had ever felt so glad to be with my family. They were everything to me. We had no home, no town, no government. All we had were each other, our blankets, and the stars above, which, since there were no electric lights for miles and miles, shined brighter than I'd ever seen them. It was incredible to be in the bush, falling asleep in the open air, but later I woke in the darkness to the sound of something rustling the leaves nearby, and my heart started to race. Militias? Rebels? Soldiers? I pictured them surrounding us, ready to shoot. Just as I was about to wake my mother, a big bird flew out of the bush. I let her sleep.

The sun came up, and my mother gave us each a cup of water to start the day. That was it. I hoped we'd find some fruit along the way, or maybe some roots to chew on, because otherwise there would be no food until nightfall. We packed up our things and started walking straight across the bush. Sometimes there would be a cattle trail, or a path that people had used, but often we were just tramping through the grass.

Soon we reached the jungle, which was hot and slow going, espe-

Alek

cially for my father, whose hip was getting more painful and stiff with each passing mile. The sun fell through the trees to dapple the ground, but even then it felt like we were walking through a slick green cave and each of us wore the humidity like a heavy suit. My sweat attracted flies, which bit me, drawing blood, which attracted more flies. It was a never-ending battle. There were thick clouds of mosquitoes. I would slap them off my face and neck, but as soon as I got rid of one, another would appear. It was miserable. We walked in the jungle all day. The next day too. My flip-flops were useless on the slippery tree roots and in the mud, and the sharp grass dug into my skin.

By the fourth day, I was starving. Eating only a small stew of leaves and roots at night doesn't satisfy or nourish, especially if you've walked for eight or nine hours. We continued trudging through the jungle, my stomach aching as if it had been turned inside out, when my mother suddenly spotted some fruit hanging from a tree.

"Oh, children, look at this," she said, excited.

She picked some of the fruits and broke them open so we each could have a piece.

"It's called *amurok*."

It tasted sweet, and my body flushed with good feeling as I swallowed it. From then on we saw a lot of this *amurok*.

Years later, during my second week in London, one of my classmates, a Scottish girl with pale skin and red hair, gave me a red apple. I'd never seen a fruit like it before; it was so hard and shiny, like a little rock. I bit into it and the flavor took me right back to the forest. It tasted just like *amurok*.

. . .

On the second night, we stopped and made camp at another abandoned hut. As usual, we lay down together on the grass mat, with the sheets on top of us. My mother and father were on the outside and the younger ones, including me, lay in the middle. I heard movement out in the forest, birds calling and frogs croaking. It was incredibly noisy. Then I heard a rustling sound and, of course, I thought it was a lion.

"How are we going to sleep?" I asked my mother.

"Listen, Alek, these are the noises I used to hear when I was young," she said.

"And you're still here," I said. "Nothing ate you."

"Thank goodness for that!" she said. "Just look at it as another new experience that will be fun and make you stronger."

My father pointed out the constellations as we lay there in the fresh air. I suddenly felt safe, with all my brothers and sisters beside me, and I thought, Really, this is a beautiful life. Somehow my parents had a way of making everything seem good.

My joy was short-lived. I woke in the darkness with raindrops falling on my forehead. Soon it was a deluge and I was soaked. I felt like a frog myself. I fell asleep again but woke at dawn, cold and wet. It was still raining. I smoothed out my floral print dress and put on my flip-flops. I wiped the water from my face, brushed my teeth with a stick, and resumed walking with my family, feeling hungry and hoping we'd find some food. Sometimes I'd just rub my hand on my belly to soothe its aching. Now, over two decades later, the thought makes me want to cry.

Ever the optimist, my mother found the bright side. She reminded us that now we didn't need to bathe. She sang silly songs,

made jokes, set up games, and told us stories about how life was when she was young. We'd just been forced from our home and we didn't know exactly how to get where we were going, or even if there would be people around when we got there. Yet here she was, in a good mood.

At least there weren't any men with guns. No bombs or missiles. No planes and helicopters, she said.

We walked like that for two weeks, laughing all day and sleeping outside in the rain with our rumbling bellies at night, until one day we noticed cattle grazing and an old man walking toward us. My father said, "We're here." I couldn't believe it. I felt a big rush of relief that our walk was finally over. I could see the village where my father's extended family lived. There were tiny round huts made of mud and straw, arranged in a line. When I saw those huts, I felt a real pang. Our house in Wau was huge in comparison. I felt sad, and frightened of how different the village might be from my home in Wau.

Then people came running toward us and I thought, What on earth have we got into here? All of a sudden there were twenty or so kids surrounding us, saying, "Welcome! Welcome! Where are you from?" I thought that perhaps it could be nice after all.

But that didn't last.

"City kids, city kids," they said. "We're going to eat you alive!"

They laughed uproariously. I couldn't see what was funny at all.

From that first moment, I dreamed about leaving. It couldn't happen soon enough. But I was only nine. I didn't understand war. I didn't realize just how good village life might be compared with that.

Chapter 4

We sat under a large tree at the edge of the village and passed a gourd of well water back and forth between us. It tasted so fresh and pure. I felt very far removed from the mud puddles and thirst of our journey. The villagers gathered around us and stared, while the elders caught up on the news with my mother and father. My siblings and I stared back silently. Almost all of the villagers were barefoot. Many of the women just had brightly colored wraps around their waists and no tops. Some of the men wore long beige trousers and

Alek

tunics but most wore nearly nothing, and almost all of the men car-
ried spears, for hunting or fighting enemies, or scaring the living
daylights out of us—who knew? The children, some of whom were
completely naked except for a coating of mud and dust, stood lean-
ing on each other, holding hands and looking at us as though we
were aliens. I guess that to them we were from another planet, with
our rubber flip-flops and our cotton dresses. They weren't used to
seeing people who lived in towns. Really, the difference between
town life and country life in Sudan is the difference a century makes.
That doesn't mean one is better than the other, but it's impossible
not to see a chasm between the two. My parents would have to be
the bridge.

I gazed past them and took in the small village in one long look.
The shady area where we sat was surrounded by fields of dry stub-
ble from the last millet harvest. Little green shoots of the new crop
were just starting to appear. Long-horned cattle stood in a pen
nearby, others walked freely through the village. There was a
massive round cattle barn with packed-dirt walls and an undulat-
ing woven grass roof that rose up to a peak. Behind that a series
of much smaller round houses with similar roofs flared out along
red dirt paths. You would have to bend low to get through the tiny
wooden doorways of the houses. Everything was handmade and
worn, stained with sweat and rain. Smoke from cooking fires drifted
in low gray rivers that intermingled above the landscape. There was
a constant *bleh, bleh* noise from the lowing cattle. I was relieved to
be safe in our ancestral village, and after two weeks of walking with
hardly anything to eat I was starving.

One of my father's aunts led us down the path to a group of four
little huts and opened the door to our temporary home. Peeking
inside I saw a dirt floor, mud walls, and a thatched ceiling. Light

poured through the gaps where the thatch didn't quite meet the mud wall, and the light only illuminated how dirty the place was. This was where all eight of us would sleep. I was grateful, but I was also disappointed. I could see that our lives here weren't going to be easy and I felt guilty for being so spoiled as to worry about that. After all, this was better than what we'd left. I didn't say a word.

That evening we joined our extended family for dinner around the fire. A group of village children formed a little wall near us and just stood there staring as we sat in the dirt. I salivated at the thought of the hot beef and vegetable stew that we were going to eat, along with *adung*, a hot grain dish. I hadn't smelled meat cooking in weeks, and my stomach was screaming for it. One child, a boy with short hair and bright eyes, wearing nothing more than a pair of pants, couldn't take his big wide eyes off me. When I made a face at him, his eyes just got wider. I looked away, but when I looked back he was still staring. Snot dripped out of his nose.

"What do you want?" I said to the boy. "Why are you looking at me so hard?"

Our hosts, who were my father's cousins, stopped what they were doing and gave me a look. "A girl does not speak that way," my father's cousin said. He had fine scars across his forehead, and heavy plugs stretched his earlobes. He scared me a little.

"But he keeps—" I started to say.

"Hush, child."

My father gave me a look that said "Alek, things are different in the villages." They took the stew off the fire. We squatted in a circle around the pot and when it was my turn I pulled a piece of meat from the stew. What a disappointment. It looked awful, nothing like my mother's cooking. I took a bite and chewed but it made me gag.

Alek

Looking closely, I could see the remains of worms and bugs in the dried beef.

"I can't eat this," I whispered in my mother's ear. "It's dirty."

"I know, Alek, but you can't say that. Shut up! We've only just got here."

I felt ashamed. I didn't realize that in the village children weren't allowed to have their own opinions. Especially about things like food. You eat what you're served.

"Have some, Alek, you're so skinny," one of the women said.

I really didn't want to eat it but I took another piece of dried beef and forced it down, worms and all.

"You'll never make it, being so skinny." The woman laughed.

I smiled and chewed and hid the fact that I wanted to throw up.

"Eat, eat," the woman said.

I went to bed on a blanket that night, curled up in my sister's arms. It did feel good to be full, even if there were worms in my belly. I was going to have to learn how to be a village girl, or else I was going to starve.

In the morning I walked out into the bush to use Mother Nature's bathroom. When I came back, my mother was pounding grain with a big wooden mortar and six-foot-tall pestle. She'd lift the heavy pestle up with both hands and bring it down hard on the grains, over and over again.

"What's that?" I asked.

"There's no flour here, you have to make it yourself."

There would be no tea for breakfast today, I realized. I drank a cup of water and got to work sweeping the hut, using a wisp of straw bound together with woven leaves.

"But, Mother, we only got here last night," I said. "Don't we get a break?"

"This is the village, girl. There are no breaks."

I was downcast.

"You'll get used to it."

The work went on. My sister ground more flour for our meal later in the day. I collected the okra someone had given us and spread it out in the sun to dry.

My mother's cows had arrived in the village, delivered by the man from Wau who had heard on the bush telegraph that we'd changed our route, so my mother had been up since about four o'clock, milking them straight from the teat into a long-necked gourd. Now she was shaking the cream back and forth, back and forth, to make butter. She cooked that down to clarify it into ghee for cooking, then she started turning some of the milk into cheese and putting the rest of the milk aside to make yogurt. She asked my sister and me to collect the fresh dung and spread it out to dry; we'd burn it in the evening, as the smoke would keep the bugs away.

We worked all morning to get everything organized for dinner, but meanwhile we didn't get a bite to eat. I quickly learned that people in the villages never ate more than once a day, unless it was some fruit or nuts they found growing in the bush. We children would always be out there, looking for something to eat. The other children from the village would help us find the right food, but they never stopped making fun of our accents. Or our looks. Or our clothes. We were a big joke for them.

"Alek, will you go to the well?" said my mother as the afternoon waned.

I walked down the trail toward the well. An old woman stared up at me from her stool as I passed. Her metal necklaces seemed to lift her chin and I thought I saw a glimmer of a smile in her eyes, even though her face remained impassive. There was something very impressive about her.

Alek

Down past the cow barn I found the well. If I hadn't been paying attention, I would have fallen right in. It was a perfectly round hole, six feet in diameter and lined with ridges that showed how it had been chiseled out of the earth with sticks and shovels. Two wooden planks had been set across the top. Looking down into the darkness, I tried to imagine being the man who dug the bottom few feet. There would be no way out.

My mother had given me an empty cooking-oil container for carrying the water back to our hut. Back in Wau we'd had a pump and I just had to stick the container under it and move the lever up and down. This well was much more difficult. You had to walk out on the wooden planks and drop the bucket down into the well. It was tied to the planks so the bucket wouldn't fall into the water along with the rope. But what was to keep me from falling in when I tried to hoist the bucket back up? Standing at the edge of the pit was so dizzying that I almost turned and walked away, but I couldn't face my mother without water. Then some village kids showed up.

"City girl, don't you fall in."

"You're a scaredy-cat. Nya, nya."

I flushed with shame.

"What's wrong with your face, girl?" asked one of them.

My psoriasis. I didn't answer.

She was a tall girl, maybe twelve years old.

"You don't know how to do it, do you?" she said.

I shook my head. I was scared of her. Scared of the well.

"Let me help you," she said kindly.

She smiled and it felt like she was saving my life. The other kids quieted down and together they helped me fill my container. Suddenly I felt a little more at home in the village. I hoisted the water to my head and walked back to our hut with a smile on my

face. When I passed the old woman with the necklaces, she looked up from her stool and lifted her fingers in greeting.

She was so regal in all her jewelry. The Dinka don't have much of a history of representational art—traditionally they never painted on canvases or paper, or even on stones or wood. Instead, they would decorate their own bodies with paints, scars, and beaded necklaces, shoulder pads, and other items made of ostrich shell, ivory, and metal—even Venetian glass beads brought long ago by European traders. The men could be real dandies; some even wore tight beaded corsets on special occasions. The old woman on her stool was such a rich representation of our culture that she made me feel proud. She'd waved at me! I no longer felt quite such a stranger in the village.

At that time there were over a million Dinka living in southern Sudan. In the years since, so many have fled or been killed that it's hard to say how many are left, but we have always been the largest group in the region. It's believed that ancestors of the present-day Dinka were the first people to bring domesticated cattle from Egypt south of the Sahara Desert, where they settled in the floodplain of the White Nile. The Dinka of today probably solidified as a group around A.D. 1500 and we've fought off invaders ever since, from the Ottoman Turks in the nineteenth century to the invaders of our most recent civil war.

Originally, the Dinka didn't live in villages all the time. Each group, of up to perhaps a hundred families, would follow their cattle from pasture to river, depending on the season. The women and children would sleep inside temporary homes and the men would

sleep with the cattle in their mud-roofed pens. These days most villages are permanent settlements, although some members of the clan will still drive the cattle to pasture and to the rivers when necessary.

In the Dinka language, we call ourselves the *Moingjaang*, or "people of the people," and our family ties are vitally important. Just as we counted on my father's distant relatives to help us escape the war in Wau, any Dinka feels sure that his blood relatives will do anything within their power to help him when he's in need.

Clans are traced through the male line—women become members of their husband's family after marriage. It's said that if a man doesn't produce a son, he will never become an ancestor and will therefore be condemned to an eternity of oblivion when he dies, as there are no heirs to continue his line. To prevent this, if a boy dies before he can marry, his brother or another relative will take a wife in his name, and any children born from that wife will be considered to be children of the dead boy. The same is true if a man dies before his wife has children—his brother will father children with his widow and they'll be considered the dead man's offspring.

Obviously, men dominated the village—or thought they did, as in most places on earth. Polygamy was common. My father never had more than one wife, because he and my mother just didn't think it would work very well, but lots of men, especially in the villages, had two or three. Some tribal leaders have had several hundred wives, which is a true sign of wealth, since the husband had to hand over a lot of cattle to buy each wife. The Dinka are careful to avoid marrying within their immediate clan, to avoid inbreeding.

Girls are taught at a young age to cook outside over a fire, and I was no exception. In the villages the basic foods are millet porridge, milk, and vegetables. Men will fish or hunt game, such as deer and crocodiles, but these aren't part of our staple diet and, while we ate

beef in the village, it was only when a cow died of natural causes or as a ceremonial sacrifice. Dinka rarely kill a cow just to eat the meat, and it's considered vulgar and unhealthy to eat an animal you find lying dead in the forest or on the side of the road.

In the countryside, the women traditionally plant and tend to the crops, such as peanuts, grains, beans, and corn, and the men look after the cattle. Cattle are so central to our culture that a man will, in a way, fall in love with a special cow, giving it a private name and singing songs to it. The Dinka man "marries" his cow, although the relationship is spiritual and symbolic rather than carnal.

One day the elders of the village directed a group of ten- to sixteen-year-old boys from the surrounding area to shave their heads. That night they brought them together to sing traditional songs telling stories of the clan. There must have been fifty boys and men there, some of the men wearing beaded corsets and kilts woven from cows' tails. Most carried spears or long branches with leaves at the end. Several men beat a drum that they had made by burning out the insides of a log.

I could hear them chanting and singing all night. The songs were stories about the village, about our creation, and about Dinka who had done important things. Since they had no pens or paper, the village storytellers preserved their people's history in these songs, passed down through the generations. As the songs went on and the hour grew late, the boys fell into a trancelike state, or fell asleep sitting up, and in that way they passed the night.

At dawn their parents led them to a clearing, where they sat cross-legged. An elder held a sharp knife to the first boy's skin and

then twisted his head so the knife sliced fine, feathery lines into his forehead as the boy called out the names of his ancestors. Blood poured down his face but he did not scream. Crying out would have shown him to be a coward, and it also might have caused the knife to slip, making an uneven scar that would have marked him for life as a weakling. He was a man now, able to herd cattle, hunt, and protect the village from invaders. After the scarring ceremony, the boys' fathers wrapped large leaves around their heads to cover the wounds.

Looking at these newly minted men, with their blood dripping into the dirt, I felt both sick and proud. My father had the same scars. I turned to look at my mother and for the first time the scars on her arms made sense to me. Then I panicked—what if they wanted to scarify me? The Dinka women of old wore ritual scars. My aunt had told me about squatting in the dirt and being held down while a man sliced her face.

Sure enough, after I had been in the village for a few months, the older women started talking about how it was my time. I freaked out, but my mother put her foot down. She and my father wanted their daughters to do well in the modern world, in the cities, without scars to forever mark us as outsiders. So, despite the indignation of the village elders, they refused to let anyone take a knife to my face. Thank goodness for that.

Curiously, in my own family it was my mother, not my father, who was obsessed with the cows and made sure they were cared for. Although he grew up in a village and understood everything about cattle, my father really was a modern man, more accustomed

to walking with his briefcase down to the office than grabbing a spear and heading out into the bush. Plus, his bad hip made it hard for him to get around. The villagers must have seen us as an odd family.

My mother's name, Akuol, means "gourd" in Dinka. It's very appropriate, because gourds are incredibly useful and important to life in the villages. We dry them and use them as serving pots, storage pots, everything. When they crack, we'll sew them back together. You can keep using them for a long time.

In the village, my mother was like one of the gourds—very utilitarian. She got things done and her industriousness made her the envy of many people. Even her cows were envied. I remember that some of the other families coveted her best bull, which was tall and broad, a good stud animal. My mother would breed him with her cows and get quite valuable calves. One morning a herder brought his cows past my mother's small herd, pretending to be casual about it. But he lingered for a bit too long. It turned out he wanted to trick my mother's bull into mounting his cow, for free. My mother told him he couldn't use her bull unless he paid for it. The man walked on.

Another morning I was woken by my mother shaking me by the shoulders.

"Alek, get up, my cow is giving birth and she needs help."

We ran out in front of the hut and there was Alwel, moaning, looking like she was going to collapse. Her tongue hung out of her mouth and she seemed so desperate that I started crying.

"Alek, there's no time for that. Come, hold her."

I put my arms around the cow's neck to stabilize her while my mother went behind.

"That's right, Alek, keep her steady."

Alek

I stepped in a pool of warm and sticky blood with my bare feet. My mother was talking to the cow.

"Good girl, Alwel, good girl."

Alwel was a common name for brown cows like this one. My mother really loved her. She reached into Alwel and gently groped for the calf's hind legs—it was in breech. Alwel stared into my eyes with the typical vacant cow look, but I thought she must be very upset.

"Straighten up, Alwel," I ordered her.

She was surprisingly still.

"Here she is!" said my mother.

She pulled. I could see the strain on her face. Then Alwel's front legs almost collapsed as the heifer came out and fell to the ground. Alwel groaned and inhaled. The heifer was alive and healthy, spotted gray and very pretty.

Half an hour later the heifer was nuzzling her mother for milk.

"You did a good job, Alek," my mother said.

Nothing made me happier than her praise.

Dinka people are expected to behave honorably and with dignity. To the outside world, our bearing—standing tall, chin up, prideful—might make us seem a little bit arrogant. We don't mean to appear that way; we have an equal need to be kind and respectful, and generous to others, especially to fellow Dinka. All Dinka are expected to extend their time, food, and courtesy to each other. When the communities have problems, people gather in public meetings where the chief listens to everyone discuss their disputes, and then settles them.

Traditionally, each village had a strong leader called the "spear master," who received his wisdom and power from spirits. The British colonialists worked hard to eradicate this practice, because they didn't want such powerful village figures to disrupt their imposition of colonial rule. Nowadays there is less reverence for the tribal leaders, although the spear masters still have influence in many of the rural villages. While the modern world checks in every once in a while—in the form of trucks; bush pilots, who risk their lives delivering people and goods to remote areas of Africa; and the occasional tourist or researcher—the rural Dinka culture has remained very traditional. Our village, which was populated by my father's relatives, had no electricity or running water. I remember some knives and cooking pots, but there weren't any radios—or radio signals to pick up—or lights of any kind, other than the moon and stars at night. Even candles and lanterns were rare.

While I'm not that religious, my people do believe in a deity called Nhialac, who created all life. We communicate with him by way of spirits and rituals that we perform when someone dies or is born, or when someone is sick or in crisis. Sometimes cattle are sacrificed as offerings to Yath and Jak, the primary intermediaries between us and Nhialac. Historically, the Dinka have resisted converting to Islam, but the Christian missionaries have been very successful. These days, about one in twelve Dinka considers themselves Christian, though most of the Christians, including my mother, still practice many traditional Dinka rituals. Once a Dinka, always a Dinka, really.

We don't have a Dinka holy book and a set of rules, with certain things we do each week. Our spirituality is much more fluid, with no real distinction between the supernatural and the natural worlds.

Alek

The rural Dinka especially have an almost never-ending contact with the spiritual world through their relationships with their cows and the natural environment. Ancestors populate the spirit world and actively influence the day-to-day lives of their descendants. The spirits, which live in trees, objects such as masks and animals, and even people act as intermediaries between us and our god. When something great happens, like rain during a dry period, the Dinka will praise the spirit that controls rain. We can praise, but we can't really question God, because in comparison we're just little specks on the planet.

There is also a strong belief that some people inherit the powers of sorcery and witchcraft and can use them to harm others who cross their path. To counter these spells, Dinka will consult diviners who can track down the witch and remove the spell that has been cast.

One hot morning, when I went outside to sweep the yard, the village seemed to be in a heightened state of excitement. Even the birds were making a lot of noise. It turned out that there was going to be a funeral for a very respected elder of the tribe, and the men were preparing to sacrifice a cow.

Later that day we gathered near the dead man's family shrine, an elaborate yet primitive mud and straw sculpture about six feet high. Some men brought a huge white cow and tethered it by both horns to a stake in the ground. The poor thing kept pulling its head back to break free, but to no avail. A man poured milk from a gourd onto the tethering stake. The men recited incantations and then one of them went up to the cow and sliced its neck with a fishing spear. Blood pulsed out of its jugular in scarlet bursts and I felt my own body collapsing from shock. I had to hold my mother's elbow for support. Within moments the cow had fallen to its knees. Then its

back legs buckled and it tumbled to the ground. There were smiles all around. I didn't understand. Why did they kill the cow? I realized that the other children were right: I really was an alien. There were so many things I didn't understand.

I went back to the hut and told Athieng and my little brother, Deng, what I'd seen. They wanted to run over to see the blood, but I stopped them.

While I never thought of my parents as being particularly lenient, village life taught me just how easy I'd had it in Wau. As a child, I always spoke my mind. I'm usually a very relaxed person, but if I'm not happy about something, I say so. When I was a child that was doubly true. My parents respected our opinions, so long as we respected their authority, but in the village the adults were surprised that we had opinions at all, let alone expressed them. They especially didn't want to get lip from a girl. Every man, and that includes the young men, felt he could boss me and any other female around. If you didn't listen, they would give you a smack. They didn't beat you badly, but they certainly let you know what they wanted you to do.

The problem was that my parents had raised me differently. My father treated my mother with respect and was never violent toward her. I didn't understand why the men in the village felt they could hit a girl or, even worse, steal her from her family in the middle of the night and marry her, just as long as they made the proper payment of a few head of cattle. But they could. That happened many times. If the girl complained, no one would help her. The wives were chattels.

People like to romanticize life in the African bush. There are many wonderful things about rural Africa, but for women, the villages can be really rough places. It's true all over Africa.

Even during the rainy season, the nights began to get really hot. One night, the hut was a stifling mud prison, so we took our bedding outside. The rest of the village had the same idea. In the dim moonlight, I could make out the shapes of sleeping people in front of each hut.

"Mother, what about the lions?" I asked.

"Shush," she said tiredly.

"A lion would snap you in two, Alek. You watch it," said my older brother.

"He would?"

"Stop scaring your sister. You keep talking like that and it's going to come true—only the lion's going to eat you, not her."

With that, his eyes opened wide and he looked terrified. We lay on our backs in the darkness, listening. A branch snapped and a bird flew out of a tree, wings beating. I could hear movement out in the bush. Or was it the wind?

"Poppa?" I said.

"Don't worry," said my father. "A lion wouldn't come near a village. They're too intelligent for that. No lion wants to end up warming some elder's backside."

I soon fell asleep to the rhythm of my sister's breathing.

I awoke with the most horrendous rustling noise right inside my ear. I slapped my ear with my palm and it just got worse. I sat up and screamed.

There was a bug in my ear. I screamed again, which woke my mother and father. I was squirming around and clawing at my ear to get it out.

"Mommy!" I cried out.

"What is it, Alek? Be quiet, you'll wake the village."

That's just what happened. A man's voice came from the group of huts across the trail: "Damn it, girl, be quiet!"

"She's got a bug in her ear," my sister called back.

"So?"

"It's driving her crazy."

"Don't back-talk me," he shouted. "I'm trying to sleep."

The village men were angry, unreasonable people. Not like my father, who came over to comfort me.

"Hush, darling," he said.

Some children walked over to laugh and point at me. I was so upset that I started crying.

"Quiet!" the man ordered.

The bug moved in my ear; I screamed.

The man rushed over and raised a switch to hit me.

"Stop!" my father said.

"You don't tell me to stop," the man replied, and swung at me. Thankfully he missed.

My father was limping, in no shape to fight, but he stood his ground.

The children were laughing. I was screaming and crying so hard.

"Help me," I cried.

"You'll just have to wait until it crawls out," the children said.

It felt so cruel.

Then the man whipped me, over and over again, until my father

Alek

finally managed to stop him. I jumped up and ran off toward the bush, clutching my ear.

"Elephants are going to stomp you," one of the children cried out.

"Watch out for snakes!" said another.

It was pitch-black in the bush, except for the glowing eyes of lions I conjured up out of fear. I just kept running. I'd trip and fall over into the dirt and get up and keep running. I was deep into the bush before I stopped and looked around. Nothing. I was all alone. I wanted to be at home in Wau, with my mother telling a story as I drifted off to sleep.

I realized that, of course, the villagers were right. There was nothing anyone could do. I was making a fuss out of nothing. I stayed out there until just before dawn, the bug making a racket the whole time. When I came back, my family was still asleep on the ground. I started the fire and then sat nearby, watching until each of them awoke. No one said anything about my ear, or the fact that I'd spent the night in the bush.

Sometime that afternoon the noise vanished. The relief wasn't nearly as acute as the bother had been. I never did see what kind of bug it was. Every night after that, I slept with one ear on the bedding and my arm over the other. I fell asleep wishing for the concrete walls and tin roof of our home back in Wau.

I know my problems were just those of a child, and that in comparison to all the hardships my parents and the other adults of the village had to contend with my difficulties were minor. The bug, after all, was just a bug and it didn't stay that long. I learned a lot

from my parents while we were in the village. Through it all, my parents retained a hopefulness, an optimism, that has really helped them through a great deal of pain. I know that many people would have reacted with anger and rebellion, or by drinking and taking drugs, and I'm so fortunate that they didn't. I think our strong Dinka culture played a big part in that, but, even more, it was my parents' basic nature and worldview that carried us through. They saw virtue in pain; they didn't ignore suffering or try to cover it up, but neither did they let it take over their lives. We always had the feeling that as long as we had each other—my parents, my brothers and sisters, and me—we'd be all right. I think that's true: we gave each other hope. It's really very inspiring to have absolutely nothing yet still have hope that tomorrow will be a good day. That is a great gift that my mother and father gave me.

As the weeks passed in the village, this innate optimism was severely tested. My father's hip only got worse as we waited out the war. One morning, I went into the hut and found him curled in the fetal position on his blanket, a strange look in his eyes.

"Help me up, child," he said.

He seemed like another man—distant, frightened, and desperate.

I called for my brother and together we lifted our father. He needed to go to the bathroom, so we walked him into the bush. Each step was agonizing. In the bush, he waved me away, for privacy. I looked away and held back my tears. I couldn't bear his suffering.

Soon it became nearly impossible for him to bend or sit without falling. Walking was a painful and slow experience. It seemed that he was harboring an infection inside his pinned hip, but he never complained.

There was an old man who lived in a hut on the edge of the vil-

lage. I'd seen him now and again. He was very tall and often appeared out of nowhere, covered in white dust. His head was shaved, but he left a rough tuft of matted hair on the crown of his head; his V-shaped facial scars were black lines under the dust and he wore a necklace of white bone and indigo-colored beads with a gold clasp. He smoked a long brass pipe with a stone bowl. His dusty face was bony and stern, looking down on us from his great height. We children called him "ghost giant." He rarely said a word, but when he did speak, it came out in a smooth, low voice.

He was said to be a healer. One morning, at my mother's urging, I fetched him to come and examine my father. He put his nose to my father's hip and inhaled. The smell of the infection sent his head back sharply. Then he nodded at my mother and said, "Doctor. He must see a doctor."

Here we were, far from the nearest hospital, with no transportation and no hope of finding a surgeon. My father needed the kind of medical attention that nobody in the village had ever even imagined, let alone seen. Without it, he would die.

Chapter 5

The rainy season's heavy showers had left
puddles and swamps around the village. Mosqui-
toes bred now that the rains had ended. We'd burn
dung so the smoke would drive them away, and I
rubbed dung ashes on my skin, but nothing seemed
to work. They were more than a nuisance, because
they carried malaria and other diseases. No one in
the village had mosquito netting. It was horrible at
times, with great swarms of mosquitoes that were
starving at the end of the day, just like us. We'd eat.

Alek

Then they'd eat. Night after night, huddled with my family in our hut, I'd battle the mosquitoes. In the morning I'd wake up with welts and bloody smears from where I'd swatted them. We'd burn more dung, and then the daylight would drive them into hiding.

To my father, the mosquitoes symbolized his failure—which none of us perceived—to protect his family from the war and to provide them with a good place to live. Whenever anything went wrong, he took it all on his shoulders. He wanted so badly for us to have a better life, but he had enough troubles of his own without taking on everyone else's. His hip was killing him and he was desperate to leave the village, but we couldn't return home until the fighting stopped.

Since we had no radio, we joked that my sister in London probably knew more about the progress of Sudan's civil war than we did. Everything we learned came from the bush telegraph. My mother sought news from every outsider who came through the village. Usually it would just be someone from a nearby village, who didn't have much more information than we did, but once in a while a relief worker, or a missionary, or a trader would come through. For months the news was always bad. The battle was still raging in Wau and people were still fleeing to the countryside. It looked like we were going to be in the village for a while, no matter how sick my father got. Rather than giving in to despair because the situation was hopeless, my parents began building a hut so we wouldn't have to borrow one any longer. My mother swapped some of her precious salt for the thatch and other materials. We collected sticks for the frame and mixed mud with straw and dung for the walls and, little by little, our new home started to take shape.

Curiously, just as we were getting ready to start thatching the roof, a textiles trader appeared in town. He was a coarse man, not

from a Dinka clan, with leering eyes, rust-colored hair, and a rough manner. But he was respectful to my mother when she approached him for news of our hometown: he saw that she was serious. They talked, and he told her that he had recently passed through Wau. The fighting had destroyed nearly everything, he said, but most of the militias had retreated and the battles were largely over. The government controlled the airport and most of the town.

My mother and my father sat outside our hut and had a long talk. My little sister and I spied on them through a gap in the wall, wanting to know every detail of what was going on, but they spoke too softly for us to hear. My parents had their own particular ways of listening to each other. My father's eyes homed right in on my mother's face as she spoke, concerned yet excited. She, in turn, held my father's wrist as he talked, listening intently to each word he said.

"I see you looking, Alek," my mother said when they'd finished talking. She laughed. "Come on out here, all of you."

Deng, Athieng, and I squatted before our parents, and Mayen, Adaw, and Akuol stood behind us.

"Children, we will be leaving the village soon," our father said.

"We got some news from the redheaded trader," our mother said. "He was in Wau, and he says that things are better there now."

None of us said a word. As we were children, it wasn't our place to speak, but we must have looked happy, because our parents smiled.

"It's going to be difficult—there's no doubt about that," said our father.

"But we must go home so your father can fly to Khartoum and get his hip fixed," our mother said.

Alek

"I'll help him," said Mayen.

"Me too," said Adaw.

"We'll all pitch in," said Akuol.

It all sounded so wonderful. As soon as we got home, we'd work out a way to get him on a flight to Khartoum, and my uncle, the doctor, would get him into the hospital. My mother and we children would follow as soon as we could. We'd stay in the relative safety of the city until the war ended. We'd get an education. We'd eat sweets! Our lives were going to be great. I was so pleased, but I was also worried about my father. He couldn't take more than a few steps without grimacing in pain. It was frightening to see him like this. We couldn't stay in the village and, of course, we couldn't think of leaving him behind.

My mother decided to buy a donkey to carry him back. Yet, while the village had plenty of cows and chickens, there wasn't a single donkey anywhere. The villagers just weren't donkey people. My mother walked three hours in the blazing sun to another village she thought might have a donkey for sale. She arrived only to find that everyone gave her the same answer:

"You want a what? For what?"

It seemed that none of the tribes in the area used donkeys. One man was very sympathetic after my mother explained that my father was barely able to walk and that we had at least two weeks of travel ahead of us. He even ran off to ask some of his friends if they had any ideas, but he returned with his palms outstretched, asking forgiveness.

"The closest donkey is five days' walk that way," he said, pointing in the direction opposite to that of Wau.

My mother returned to the village and her husband's downcast face.

A week after the trader left, my mother made us a special breakfast of a cup of tea and some boiled millet.

"Today we leave," my father told us.

We packed everything into our blankets, rolled up our long straw mat, and set off. No one made a fuss when we left. We just walked away into the bush.

Within an hour, my father was barely able to move his leg, so my brothers helped him along. It was clear that our walk back was going to be very, very slow.

It was the same routine going home as it had been getting to the village: we'd gather provisions during the day and sleep in an abandoned hut or clearing at night. It no longer seemed strange; this was our life.

One morning I woke up shivering, even though it was already a hot day and I was sweating. I felt that my body had been invaded by a heavy force that prevented me from rising. All I could do was shiver. I could barely raise my hand to wipe the sweat from my forehead. My family woke up and began collecting our things, but I couldn't move.

"Alek, get up," my mother insisted.

I rolled over and pushed myself to my knees. Standing was difficult. My head ached and my muscles felt like they were filled with pins.

"Are you okay?" my mother asked.

"Yes."

I didn't want to drag the family down. We already had enough to worry about. We started walking, but I could barely keep up. All morning I shuffled along, hanging back with Deng and my father, who was always the last in line. The others never went more than about ten minutes ahead. With all the time we'd spent living so

closely in the village, and our fears of running into militia or other soldiers, we never wanted to be far from each other. We traveled as a pack. But, between my father and me, we were going awfully slowly.

"Something is wrong with you, child," he said to me.

"No, I'm fine." We kept walking. At one point I had to stop and lean over to retch bile.

"Alek? Even I'm walking faster than you."

"Baba," I said, using the name I'd called him when I was a toddler. "I'm so tired."

"I think you've got malaria," he replied.

Malaria is endemic in southern Sudan; each year it sickens, and sometimes kills, thousands of people because so few can afford the netting that could prevent the mosquitoes from depositing malaria parasites into your bloodstream.

The parasites travel around your body in red blood cells until they reach the liver, where they reproduce. After a week or so, though sometimes not for several months, the infected red blood cells burst and the parasites attack other red blood cells. As more and more cells rupture, they release toxins that make you feel like you have the worst case of flu imaginable. I just kept walking with my father. There was nothing I could do. My mother had some medicine in a syringe that she could use if the malaria got really bad, but my father didn't think my case warranted it. So I walked on, all the time feeling like I was dying. Now and then I'd throw up near the trail. I felt dreadful, yet close to my father: he and I were the invalids in the back of the line, struggling to get through the day. Finally the sun began to set and we made camp.

"If you still feel sick tomorrow, we'll take a break," my mother said.

That night I slept and shivered. I woke up in a hot sweat and the sky was filled with stars. It was a clear, bright night and I thought, This is unbelievable. I was comforted to see constellations that my mother had pointed out when I was younger. The stars always gave me solace.

I fell asleep again, and when I woke to the sound of my mother washing up after breakfast, I realized that I felt better. She'd saved me some stew from the previous night's supper, so I ate that and then we began to walk. By this time, my flip-flops were pretty floppy. The straps had broken and I'd replaced them with twine that cut into my toes. There were holes in the soles. Half the time I carried them and just walked barefoot, as my feet had developed thick calluses from wandering the village barefoot. I wanted to save my flip-flops for rocky parts. At times our route would take us through a type of tall, sharp grass that could even pierce through the sole of a flip-flop. When a blade of grass hit one of my psoriasis sores, I'd yelp.

"Oh my God, this is crazy," I said as we crossed a field of this grass.

"Just imagine me as a child," my mother said. "We never had any kind of shoe at all. We just walked barefoot through everything. The soles of my feet were like leather."

I loved when it rained, because the water felt cool on my feet, but the storms were rare and brief, since the rainy season was coming to an end. When it rained at night, we'd sleep right through it and wake up in wet clothes, knowing that it wouldn't take the morning sun long to dry everything. If it rained during the day, we'd twirl and jump in the heavy drops. The water was warm and felt like a bath. We would collect as much rainwater as we could carry. When we stopped for a rest, my mother would light a small fire and

boil the water to kill any parasites. There weren't any people around to contaminate the puddles we collected the water from, but there were plenty of animals in the area. No matter how thirsty we were, we had to wait for the water to boil. That's part of the reason we didn't get very sick. We would drink just a little bit of the boiled water, and then carry the rest in a bottle. Late one night I heard my older sister Adaw crying out for one of her old teachers. It made no sense at all, and when I shook her, I realized she was still sleeping. In the morning she didn't get up with the rest of us. She just stayed under her blanket, shivering.

"Malaria," my mother said.

She had it about twice as bad as I did. We spent the whole day fanning her and putting damp cloths on her forehead. Nothing seemed to help. That night she kept us all awake with her feverish nightmares. Early in the morning, just as the sun sent its orange glow over the horizon, my mother decided to inject my sister with the single ampoule of medicine that she had been carrying. A nurse at the German mission hospital where I had been treated for psoriasis had given it to my mother before everyone fled Wau, and she had been saving it for an emergency.

She sent me to fetch water from a pond that we'd passed the night before. Then she boiled the water and the needle over the fire for ten minutes. My sister lay on her side on the sleeping mat and stretched out her long, bare leg, turning her head away as my mother, who'd never injected anyone with anything, jabbed the needle into her leg. She must have hit a nerve or something, as my sister suddenly jerked her leg and the needle moved sideways. My mother injected the medicine slowly, but as she withdrew the needle, blood spurted out of my sister's leg. We wiped it with a cloth and water.

The drug worked. My sister's fever subsided, along with her other symptoms, but her leg hurt where the needle had entered, and as the days passed, the wound became gray with infection. At night, pus seeped from the wound onto her sleeping mat. With no doctors for hundreds of miles, my sister ended up hobbling at the back of the line. Once we reached Wau, we would have to find a way to get both her and my father to Khartoum. I was ten, and I didn't imagine my father or my sister could die. But the situation was clearly dire.

Six months earlier, we had left nothing, arrived at nothing, and were now leaving that nothing for nothing again. We didn't even know if our house would still be standing. We had nothing to be happy about, yet we were happy together as a family.

Nearly four weeks passed this way. It was the beginning of the dry season, and our days were sunnier, with more fruits and edible plants along the trail. In some ways, the walk was much easier, but as my father and sister were in such pain, it took us twice as long to walk home from the village as it had to get there. My sister could still keep walking all day, albeit slowly, but my father was now at the point where he'd have to stop in the middle of the day to rest. My mother would sit with him and look him right in the eye to see how bad he was feeling. I never heard him complain, not once, but she could always tell. Sometimes she would decide that we'd wait and let him rest for the entire day. We would spend the night where he'd stopped. He really felt like he was letting us down.

On his better days, my mother pushed us to move along, in her gentle yet insistent way. She was torn, however, between trying to

hurry him and my sister so that we could get them medical treatment as soon as possible, and not wanting them to suffer so much now.

We probably added to the delay by taking a different route home—that's typical of any Dinka, in the country or in the city. A Dinka person always changes his return, especially in a time of trouble. You just never know who has followed you, or who expects you to cross their path. There are plenty of bad people in the world. I still drive around Brooklyn, where I live now, on different streets each day. It's ingrained.

Finally, we reached the grassy area that bordered the Jur River, near our home in Wau. I was so excited that I ran ahead of everyone with Athieng, our feet getting sliced up by the sharp grass, which seemed much dryer and rougher than we remembered. We didn't care. We just wanted to see the water, and the far bank, which, to us, was home.

We charged down the path, which soon led into a tunnel of six-foot-high grasses that would whip against us as we ran, and we were laughing and calling out to each other. Suddenly the path opened wide: there was an expanse of gray dirt, stone, mudflats with long-legged egrets stepping about. The river was dry. The treacherous river we had crossed months before was, now that we were in the dry season, nothing more than a trickle. We'd be able to walk across it easily. Even my father. It seemed magical.

I turned back to tell my mother, and then I saw them: three men in raggedy clothes, carrying Kalashnikovs, staring at us from a little bluff just ten yards away. The leader wore sandals and a pair of amber aviator sunglasses. The others were barefoot. I froze. My sister looked at me, and then she saw the men. She gasped. The men stared at us and we stared at them, all of us unmoving.

"Who are you, little girl?" the leader said.

I didn't answer.

I was terrified. I guessed that they were rebels, but even the rebels would kill Dinka if they needed something. I knew that soldiers raped girls. I knew they stole children. At that moment, I hoped that they would hate me because of my ugly psoriasis and so would not want to come anywhere near me.

Then I heard my mother's voice from about thirty yards away.

"Alek, what are you doing up there? Why did you stop? Let's keep moving. We've got to get to Wau before sunset."

Right then the men started coming down toward us and I felt the life drain out of me. I would have peed my knickers, except I'd hardly had any water to drink all day. Any words that I had left me; I went completely silent.

My mother and I had always communicated well, even if it was sign language, but suddenly I all but blacked out, couldn't talk, couldn't move. She picked up her step until she reached me. Immediately she locked eyes with the rebels. They stared at her like she was an apparition. She looked so fierce. I was grateful she was so tough.

"Oh, I see why you stopped," she said to me.

She was so cool. Nothing fazed her.

I, on the other hand, was sure we were going to be left to rot in the hot sun.

Then she recognized one of the guys. They were Dinka, from Wau.

"Aren't you Anok Deng? I know your mother."

The leader nodded. He suddenly seemed sheepish.

"Oh my goodness. If your mother only knew. How is she?"

"My mother is good, madam. She's in Congo."

"She's safe?"

Alek

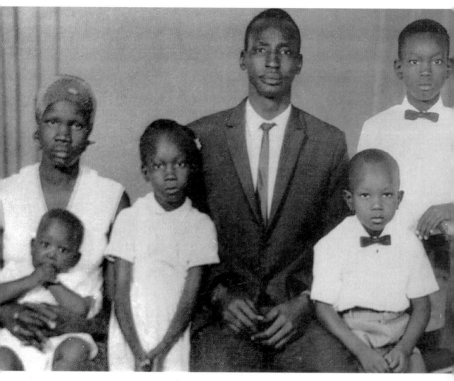

Mayen, my mother, Ajok, my father, Wek, and Athian.

My brother Deng and my nephew Lual were born the same year. This is my mother posing with her grandson, left, and her son.

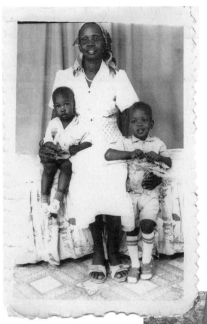

My brother Athian had this portrait done in a studio in Wau in the early 1980s.

My sister Ajok and her husband Anik at their wedding in the church in Wau in 1982.

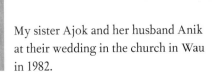

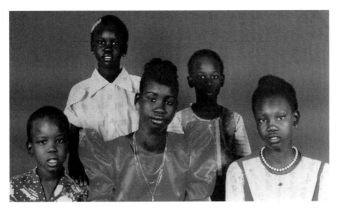

Not long before my father died in 1988, Deng, Adaw, Athieng, Akuol, and I posed for this photo at a portrait studio.

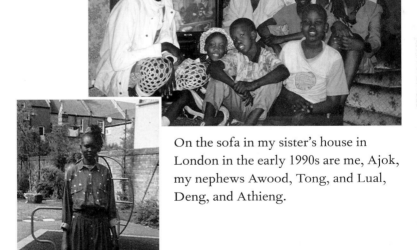

On the sofa in my sister's house in London in the early 1990s are me, Ajok, my nephews Awood, Tong, and Lual, Deng, and Athieng.

I was sixteen years old in this photo, having just graduated from secondary school and wearing my finest denim in this playground in Kilburn, near my sister's house.

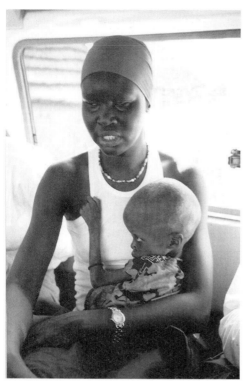

This child's mother handed her to me and we drove her to the feeding station in El Tonj, where the doctors and others saved her life. I'd seen suffering before, but I'd never seen so many children who were near death from malnutrition. It was overwhelming. That's when I realized what a toll the war had taken on my country.

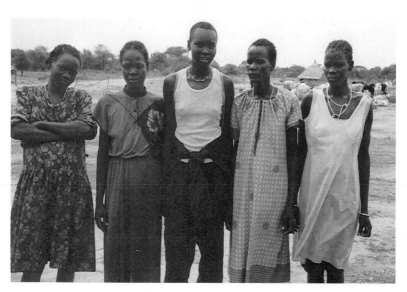

These four women are married to one of my uncles.

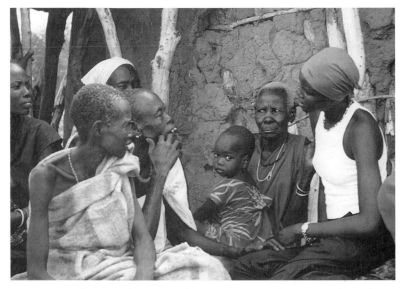

Here I am with some of my cousin's wives, my grandparents, and Amel, the woman who raised my mother after her own mother died when she was young.

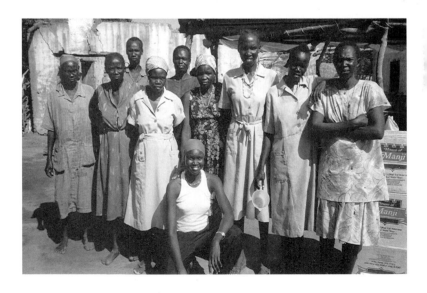

These women worked at the feeding center in Tonj that was run by Doctors Without Borders. Most of them are Dinka women, like me.

My first agent,
Mora, and me
on the border of
Sudan and Kenya
in 1998.

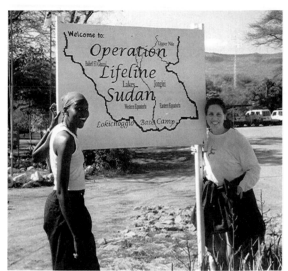

My mother on the sofa of her
London apartment in 2003.

Soon after I bought my house in
Brooklyn, I started painting again.
This portrait of my late father,
Athian Wek, painted from memory,
was one of the first paintings I
finished, in 2000. It was the first
portrait I ever painted.

A friend gave me this sewing machine, which I used to whip up my first sample bags in the living room of my Brooklyn home.

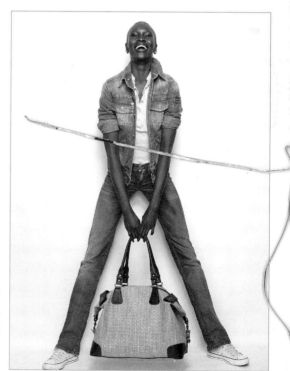

Me with one of my designs from my handbag line, Wek1933.
(© *Warwick Saint*)

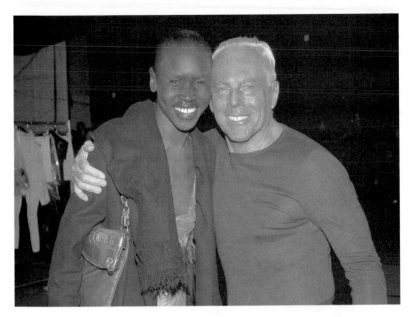

Backstage with Giorgio Armani at his Spring/Summer 2005 collection show. *(© Dimitrios Kambouris/Giorgio Armani/WireImage.com)*

Me wearing a Diane von Furstenberg piece from her Fall 2007 collection. *(© Randy Brooke/ WireImage.com)*

"I think so, madam."

"Are you going to rob us?"

"I don't think so, madam."

My father appeared behind my mother. He smiled at the men. He knew them too.

We ended up giving them all of our goods—our salt, a little bit of soap, a cooking pot, and our food—but as a gift, not because they demanded it. We hoped that we wouldn't need the stuff once we got home. From the look of these rebels, they needed everything and anything that they could get their hands on. The rebel army was full of young men who came from nothing. It wasn't like the SPLA had a big, rich government supplying them with uniforms and food. The soldiers were lucky if they had guns and ammunition. They had to scrounge for food themselves.

I actually felt sorry for them. The rebels even carried my father and sister across the muddy parts of the river, where it was really hard to walk. I've always been really grateful to them. They could have been horrible to us; they could have killed us right there, which was what happened to so many other people when they met soldiers—the army, the rebels, the militias—yet these guys took a chance and treated us as fellow human beings. It was a blessing. I'll never forget their faces.

Across the river, we came to the brewery and my parents' friend. He had stayed there during all the trouble but luckily hadn't suffered too much. He'd given all the beer away, of course, and after that nobody came near the place. It was too far from Wau to be of any use, really. We walked into his house, which had a cement floor, clean drinking water, and a big yard, and I said to myself, We're out of the bush. Finally. He and his wife served us a magnificent meal of *kissra* and stew made from dried fish. I hadn't eaten that in so long.

I felt like I was in heaven. It was getting dark, so we spent the night at his house.

The next morning we set out for Wau with great expectations. It was so exciting to think about being home again. I wanted to listen to the radio and find out what had been going on in the world while we were away, but as we reached the outskirts of the city, we learned exactly what had been going on, and it wasn't good.

The first group of houses we came to had been burned down. All that was left were concrete block walls and broken windows. A cooking fire burned in the exposed living room of one house and an old man sat in the dirt, staring blankly at us as we passed. The road was pitted with deep tracks that tank treads had dug in the dirt. At one point, a group of trees had been cut in two by mortars so their tops hung toward the ground. The police station had been wrecked; there was a huge hole in the wall. Wau was now an empty, scary place, and I was very puzzled: how could I feel sad to be returning to my home?

"Everything is different now," my mother said.

We arrived at home to find the front gate broken. Looking into the courtyard, we could see that another family had moved in. I didn't recognize them.

"Kick them out, they have no right," Adaw said.

It was shocking to think of other people in our house.

"Wait right here, children," my mother said.

She went into the compound with my father and they politely yet firmly explained that we had come back. I saw the man look downcast. I thought he was going to get angry. My father pulled him to the side and said something in private. They shook hands. There was something so powerful about the way my father dealt with

Alek

people. He was always polite and quiet, yet he had a strength that people respected. The family left within an hour. Later, my father told me they had a house on the edge of town, which had been partially destroyed. They'd figured we were gone for good. They were going to return to their own place now.

Amazingly, my mother's stores of peanuts and grain, and even some planting seeds, were still there, buried under straw in a huge clay pot.

There were no police in town to speak of, but neither were there many people. Most of our neighbors had left, although a few had straggled back. At night it was scary, with army tanks rolling up and down the streets, and frequent gunfights between militias and the army. You couldn't trust either side.

We tried to resume our old lives as best we could. It was difficult, because my father's job at the Department of Education didn't exist anymore, as there weren't any state-run schools left. I started going to a Catholic mission school run by nuns. My mother had decided to leave the cows in the village, because it was still so dangerous, and she wanted us all to go to Khartoum if we could, but she planted corn, vegetables, and peanuts in the yard, and greens that grew quite quickly. We were very poor, really, but I didn't feel bad about it. We had one meal a day, usually, which kept us going.

It wasn't a good life, because we were, basically, imprisoned. Aside from going to school, I wasn't allowed to leave the house, especially at night. The militias would wrap their heads with scarves and come out in the dark to rob and kill. You didn't want to cross them. We'd hear gunfire every night.

Every day my mother would get a backyard account of which of our neighbors—there were not many left—had been killed. I'd always know when someone died. In Sudan, death provokes great

sadness in people, and they express it with a lot of moaning and cry-ing. The women make a trilling sound that's otherworldly.

Even if I had been allowed to go out, there was nowhere to go. All of the after-school clubs had long since ceased. There weren't any sports to play. There was nothing to do at all. Wau was filled with refugees from the countryside, strange-looking people from deep in the bush. Even the part of town where the rich people had lived, with their cars and gasoline-powered generators, had been overtaken by refugees. Despite the people, however, Wau felt empty. It was a dark place. The most fun we had in the weeks after we returned was taking the batteries that my father used for his radio and hooking them up to lightbulbs we found for sale in the market. Suddenly, we had light. We stayed up later. We sang and talked. It was great fun and we were all really excited about having lights just like the rich people. All my life we'd used candles and kerosene lamps.

All this time, however, my father needed to leave, to go to a hospital, and my mother wanted the rest of us out of Wau so we could go to decent schools. My mother and father talked about it every day.

They were so determined to get us to Khartoum that I knew we'd do it. Even though we were struggling, I knew that if we had a chance, we'd make it. My mother and father always gave me that confidence.

There were no buses or trains, and no one had a car. Anyway, going by road was out of the question. There were too many land mines, and a lot of bridges had been blown up. Warriors, some of them still children, set up roadblocks here and there, and they would shoot you if you didn't give them what they wanted.

We couldn't just walk to Khartoum, either—Sudan is the biggest

country in Africa. It would have taken us months, passing through dangerous territory.

The only way out was on an airplane. We devised a plan: All the airlines had long since stopped landing in Wau, but there were military planes. Every couple of days a giant C-51 transport plane would arrive with supplies for the army. You could get on one of the return flights to Khartoum if the soldiers were in the right mood, or if you had a large bribe.

The military controlled the airport, which was on the outskirts of town, about thirty minutes' walk from my house. If I was at school and heard a plane coming in, I'd jump up and run home. We'd rush to the airport, slowed by my sister and father. We would try to put them on the first available plane, hoping to follow as soon as we could.

Every time we heard a C-51 in the sky, my mother would gather all of us together, along with a few clothes, and we'd walk out to the airport, hoping to escape. There was tall grass alongside the muddy road, and a choking wetness to the air, which made me feel even more desperate. At the airport, the soldiers stood around in their fatigues, their berets cocked on their heads, their eyes bloodshot and nervous. We'd stand in the hangar along with hundreds of other people, and no one, including the soldiers, seemed to know what was going on. We'd only know that we didn't get on the flight when the plane pulled out onto the runway without us.

I despised the soldiers, but since they were the same men who shot up the town every night, we were respectful toward them for our own safety. If you complained, they'd get angry and start shifting their guns around in their hands. They liked to see people beg— it made them feel strong.

It was a shock when they finally showed a little grace.

My father's hip was so bad that anyone could see he desperately needed help. My sister's infected leg was turning black. She couldn't sleep well, and walking was incredibly painful. There was no one in Wau who could treat them.

On our third trip to the airport, my mother begged the guards to put my father on a flight. She pointed to his hip. She called my sister Adaw over and showed them her leg was poisoned. She really begged. Finally, the guards said, "Fine, they can go. The rest of you will stay."

When they flew off, there were five of us children left. My older sister Ajok had married a Dinka man and gone with him to London, where he was studying architecture. They had wanted to return with their children, but my parents told them that the war was too severe and that the future of the family depended on them staying in England, where they could earn money to help us out or apply to get us refugee status, if possible. My oldest brother was studying in Juba. My mother had told him never to return to Wau. Ever. We were going to leave ourselves. There was nothing left for us. We had no father. We had no money. We had no idea what the future held. We went home and wept. It was one of the few times I'd seen my mother cry.

A few days later, I heard another plane, and we returned to the airport but they wouldn't let us on. And the same thing happened the next time. We were turned away again and again, because there weren't enough seats. We were still the Wek Army—there was no way we were all going to get on a flight. Finally, one day, while we were walking to the airport, I turned to my mother and said, "I'm

leaving today, no matter what. Even if we have to split up." I was twelve years old.

For a moment, my mother looked at me as if I was mad, but I could tell she believed me. Something told her to trust me.

At the airport, it was the same old scene. Nasty soldiers. Hundreds of people wanting to get out. A line of people who, for whatever reasons—bribes? connections?—were being allowed to board the plane. This afternoon, like all the others, it looked like we wouldn't get on. I wished we had money for a bribe. As we struggled to persuade the soldiers, I spotted one of our neighbors getting ready to board the plane. I didn't know him at all well. He could have been a child molester, for all I knew.

I made a decision. Without saying a word, I left my mother's side and walked over to him. He was nearly a stranger, yet I told the guards he was my father. Amazingly, he nodded in agreement. I was going to get out!

My mother looked at me with great pain in her eyes, but she understood. In that moment, she confirmed her faith in me. I felt scared but very, very strong. I was going to help my father. With me gone, it would be easier for the others to get on the plane. One less Wek in the army.

My mother couldn't talk, for fear of revealing to the soldiers that I was an impostor, so she kept silent. But her face said everything: "I love you, I'm proud of you. Be safe."

As the line began to move, she whispered to my new "father" in Dinka: "Take her to my family in Khartoum." She gave him my aunt's address. She didn't know the address of my uncle's house, where my father was staying.

The man nodded. But who knew? What if he sold me? What if he took me as one of his wives? What if I never saw my mother again?

As the line began to move toward the plane, I glanced over at my mother and smiled. I suppose my face gave it away, because a soldier suddenly stepped in front of me.

"Who are you?" he demanded. "What are you doing here?"

I acted offended. I acted as tough as I could.

"That's my dad," I said, pointing to my neighbor.

My neighbor kept his cool and just nodded his head.

"Come along, girl," he said. "Keep with me."

I was twelve years old, alone in the world, fleeing a war with nothing more than the clothes on my back. As we headed to the plane, I turned to see my mother again. Her eyes were puddles of sadness. I wanted to cry too, but I didn't.

We climbed the metal steps into the cargo hold. The massive old plane was used for hauling supplies to military bases around the country, and it didn't have any amenities. But it had propellers, and all I needed was to be lifted over the vast desert to where my father waited in Khartoum. I took a seat next to my "father" on a wooden plank, and figured out how to strap myself in. There was a parachute underneath the plank, but I doubt it would have stayed on a skinny kid like me if I'd had to use it. As soon as the plane started taxiing down the runway, the pilot turned all the lights off, so we wouldn't be shot down by surface-to-air missiles. We flew in total darkness for three hours. The other passengers were completely silent; I felt like we were on a death watch. Finally we landed in Khartoum.

Chapter 6

My pretend father led me down the steps to the tarmac, where the heat hit me like a wall. In the airport, the man's wife and three children looked shocked when they saw us walking up together.

"And this girl . . . ?" his wife said.

"Don't worry about her."

The children glared at me.

"Don't you remember Alek? She lived down the street from us in Wau."

Then they relaxed.

Walking through the airport, I was dazzled—by all the uphol-
stered furniture, the lights, and the people wearing nice clothes.
Despite having left my family, it felt really good to be here.

We drove on a crowded road a few miles into the city, where they
left me at my aunt's house.

"Alek—I can't believe it," she said when she opened the door.
Nobody had any idea I was coming.

She lived with her husband and their two children in a two-story
house with painted walls and lots of furniture. They even had a tele-
vision, which I'd seen only a couple of times in my life. Since it was
late, she told me to spend the night with her. I hardly slept, because
I was so lonely for my mother and so excited about seeing my father
soon.

In the morning, my brother Wek came to collect me. I hadn't
seen Wek in a long time. He was taller than I remembered, but I
felt right at home with him. In daylight, my aunt's neighborhood
looked dry and dirty, with unpaved streets lined with brick houses.
I almost got soaked by a bucket of water that a woman threw out on
the street after washing her dishes.

We caught a bus along the road that was jam-packed with carts
and people and cars and buses, to a terminal in the center of the city.
Everything in Khartoum was huge. The buildings were all two and
three floors high, with metal gates painted turquoise and blue, and
curtained windows. I didn't remember ever seeing so many people
in one place. Most of the men were wearing long white djellabas
and sandals, and the women wore *topes*, a three-meter length of
wide fabric—either brightly colored or just plain white—they wrap
around their torsos and up over their heads.

We waited at the terminal in the tremendous heat, my eyes tak-
ing in everything. A rich aroma filled my nose and I turned to see

that a man had spread a striped blanket on the concrete and was lay-
ing out baskets of freshly baked bread on it. Nearby, a vendor sold
watermelon slices drizzled with lime juice. A man wearing a brown
suit over a T-shirt, with fat red and white beads against his dark
neck, stood puffing on a three-foot-long pipe, the smoke obscuring
his creased face.

"Would you like a Coca-Cola?" my brother asked me.

"Sure," I said, trying to be cool about it. I'd seen the Coca-Cola
signs around since I was a child, but I had never tasted it. He bought
two bottles and handed me one. It was ice-cold and felt so good on
my hand in the heat. The bubbles tickled my lips as I raised it for a
sip. It tasted so rich! But the bubbles—how could I swallow the bub-
bles? I gagged and the Coke came out of my nose.

"The same thing happened to me my first time," my brother
said.

I drank the rest of the bottle very carefully.

A beat-up, brightly colored bus pulled in. We forced our way
through the crowd that was clambering to get on, and found seats.
We sat on the bus for half an hour, past block after block of dirty
whitewashed buildings with the occasional palm tree or high shrub
rising up above the walls.

"Just to warn you—Daddy's not well," my brother said.

My heart sank. I had pictured my father as cured, walking tall
and able to lift me high above his head.

We got off the bus and walked along a dirt street to the house of
our uncle, Deng Tawnch. My brother banged loudly on the metal
gate before we opened it. There in the courtyard was my uncle's
wife. Or rather one of them—he had three. She led me inside to see
my father, who was lying on a camp bed in the living room.

"My darling," he said, sitting up to give me a hug.

I was upset by seeing him in such bad condition, but he was glad to see me, and my uncle was taking good care of him. Since he had three wives and about a dozen children, the three-room house was overrun with people, but there was a good atmosphere. It's common in Sudan for men to have several wives, and my uncle's wives, at least, had worked out a good rapport. One of them did most of the cooking. Another took care of the house. The third managed the provisions.

My uncle had tried to use his connections to get my father treated by a good surgeon, but nothing had come of it. Everyone wanted more money than we had to perform the necessary operations, so my father languished. Meanwhile, my uncle arranged for me to see a few dermatologists about my psoriasis, which just seemed to get worse and worse. None of them had any new ideas. Just the same old creams that the German doctors had given me, which were expensive and didn't have any long-term effects. So, with my father sick and no new doctors to see, I spent most of my time just sitting around the house. I felt safe there, with no thoughts of guns and soldiers.

I missed my mother and my brothers and sisters terribly. Every once in a while we'd get a message from my mother: things are rough; we're still trying to get on a flight out of here; do not, under any circumstances, return.

Whenever I could, I'd tag along with my brother or another adult when they went out into the city to run errands. The city itself had about a million people, but when you added in Omdurman and Bahri (where we eventually moved), which were reached by bridges

across the White and Blue Niles, the metropolitan area had about four million people. Refugees had poured in from Ethiopia, Chad, and elsewhere in Africa during the 1970s and 1980s, and then, when our own civil war started up again, people from all the tribes of the south flocked to Khartoum. It was definitely an Arab city, with a Sunni Muslim government, but also a cosmopolitan place with many different types of people.

Still, even as a twelve-year-old girl, I could feel that the Arab Muslims in Khartoum looked down on me, a little Dinka girl. I spoke Arabic with a heavy accent, since Dinka was my first language and what we spoke at home. Still, all my schooling had been in Arabic, which was mandated by the state, so I could communicate well even though the words I used marked me as a real country girl. I couldn't help but notice the stares as I walked down the street.

The most beautiful buildings in the city were mosques, with their minarets rising above the other buildings. There was a small mosque near my uncle's house, which I loved. It was a squat building, painted mint green, with small white triangles along the roofline. A fat brown ice-cream-cone minaret rose up from the roof, wrapped with a band of white that, to me, looked like sugar.

Five times a day the muezzins would climb to the top of the minarets and in a wavering, pleading voice call the faithful to *fard salah*, or mandatory prayer, with the Adhan, in Arabic:

Allah is great, Allah is great
I bear witness that there is no God but Allah
I bear witness that Muhammad is Allah's Messenger
Hasten to the prayer, hasten to the prayer
Hasten to real success, hasten to real success
Allah is great, Allah is great

The men would race to the mosque for prayers, or drop to prayer rugs right on the pavement or in the market. It was quite beautiful to see this level of devotion to God. I remember one somnolent afternoon my brother and I came across a gathering of Muslim Sufi mystics dancing and praying in a square in the old part of Khartoum. One of them, a man in brightly colored rags, broke from the others and started spinning, pieces of his torn clothes flowing like streamers as he twirled around and around.

There were aspects of the Muslim world that I couldn't abide. For instance, sharia often seemed outrageous. There was a sixteen-year-old boy who regularly sat on a street corner near my aunt's house. His left arm and his right leg ended in useless stumps. He'd wave them about and demand coins, though I never saw anyone give him any. My aunt told me that he had been caught robbing a small shop and, in accordance with the current interpretation of sharia, punished by having his opposite hand and foot amputated.

The country was steadily becoming Islamicized. The National Islamic Front had started making children learn radical chants at school; the morals police began to insist that women wear veils. Young couples couldn't walk down the street holding hands. A girl wearing a skirt would be called a whore by strangers. People were arrested and then tortured by prison wardens who had been trained by the Iranian Revolutionary Guard. Sudan, once a tolerant land, with peaceful Sufism as the main form of Islam, had become a harsh place where young thieves were mutilated. In a way, I hated the city, but living there was better than getting shot at in Wau or having a bug crawl into my ear in the village.

. . .

After three months, the rest of my family arrived. My uncle, Deng, who was not technically my uncle but rather some sort of second cousin whom we just called uncle, was very generous to us.

"Hey, do you mind if my wife and six of my children join us in your little three-room house?" my father had said to him.

It was stressful. Uncle Deng and his three wives and their children slept in the two bedrooms. The Wek Army got the living room, which was fine for us, considering that we had nowhere else to go. We put thin mattresses on the floor and all slept together there. One person would crowd up to the next person, and that person wouldn't like the way the person on the other side moved around or talked in her sleep, and there would be a lot of complaining, because there was only a limited amount of room. Somehow we figured it out every night.

In my uncle's house, the men and women always ate their meals separately. Of course the men got more food. I wasn't used to this, because my family had always eaten together, and at first it bothered me. After a while, I started to like it. When just the women are gathered around, you can talk about girl stuff that you know the men wouldn't want to hear.

No matter how useful we aimed to be, how we tried to help out with the cooking and the cleaning, it always came down to the fact that we were about twenty people in a three-room house, with two verandas and only one latrine. I'm amazed that they invited us to stay at all. It's a real testament to my uncle's kindness, and to Dinka generosity in general. Without their help, we never could have resettled in Khartoum, and my sister's infection probably never would have been cured. In the end, however, it was too much for my uncle's

family to take. His wives started bickering with each other, which I hadn't seen when my family first arrived. One of the wives was from another tribe, and the other two would berate her constantly for not being Dinka, and not doing things the Dinka way. My mother just said to us: "Mind your own business."

We knew we had to get out of there quickly. Neither of my parents had jobs, but my sister in England worked various jobs. She started sending us a hundred pounds or so each month. Since there was no mail, and we couldn't trust the banks to give us any money she wired, she'd send a letter with cash via a courier service used by one of the luxury hotels in Khartoum. We had a friend there, whom we could trust to give us the money. It was like a James Bond film. We'd take the bus to the hotel, where we would meet him clandestinely and he'd hand over the cash.

Once we collected enough money, we went out every day to find a house that we could afford, which was tricky, because Khartoum was much more expensive than Wau. We knew that if we didn't find a place, we'd end up in the refugee camps on the far edge of the city, and living in those tents was no joke. I went out there once with my mother, to visit some of her distant relatives who'd settled in the camp. We walked into the Sahara for half an hour or so until we reached a vast wasteland where the government had settled the penniless refugees. Nothing grew there. Water was scarce. There were no toilets. Some of the people had tents, but most lived in shacks they had put together from sticks, plastic sheeting, and cloth. Her relatives were doing comparatively well: they had a compound of tents and were searching for a way out. But people kept coming. The camp just got bigger.

When we left in the late afternoon, the sky was clear. Within a few minutes, a massive windstorm blew up.

Alek

"Oh my God, the haboob," said my mother.

The haboobs are powerful windstorms that sweep up vast amounts of red dirt and black out the sun. They can come any time of the year, but there are more of them in winter. This one was quickly bearing down on us.

"Quick, Alek, behind that rock."

We ran to a boulder and crouched underneath an overhang. The haboob arrived with a screeching sound. I couldn't see my hands in front of me. The dust filled my eyes and ears. The grit hurt my teeth. We crouched for an hour until the storm passed, and then we walked home, red with dust. We looked like we were wearing makeup. When we got home, there was dust in the water; dust in the beds. Red dust everywhere. I thought about the refugees in their flimsy tents and worried that we would end up there.

But we found a two-room house on the edge of town.

The new house was walled off from the street. It had an intermittent electricity supply, from which we could power lights and the radio. Since we had almost no possessions, moving in wasn't difficult. We bought a charcoal stove, some cooking pots, and a ceramic jug to keep the drinking water cool on the hundred-plus-degree days.

There were two large rooms for sleeping: one for the girls and one for the boys. We had cotton mattresses, which were a real treat. I'd never slept on a bed like that before—in Wau we'd always used string beds. My sister sent us beautiful sheets from London, so we felt like we were living in luxury even though our floors were made of hard-packed dirt.

We had a latrine with a pit, and we had running water, which was a first for me. Curiously, there was no drain for the water. Instead, there was a holding tank. When you took a shower, the runoff would

go into the tank, which held about three showers' worth. When the tank was full, we'd scoop the water out and spread it out thinly over the street. For some reason, Khartoum's soil didn't absorb water well, so if you just dumped the water, it would puddle up and take forever to drain. We spread it out thinly on the street so it would evaporate quickly in the sun. There were people down the street who didn't bother to do this, and there would often be a disgusting puddle of soapy, scummy water in front of their house. My mother couldn't stand the way they lived.

One day we were walking home when a car drove through the muck and splashed it up on us.

"I've got to go back to Wau," my mother said.

She was a stickler for order, order that seemed impossible to find outside our house. In her house, children did chores. We swept; we washed; we cleaned the yard; we filled up the bucket, washed our laundry by hand, and hung it to dry. Every weekend it was work, work, work. But we always had clean clothes. To her, disorder was a sign of laziness.

"How do you feel about yourself if you're messy like that?" she'd say.

Khartoum is an uncomfortable place, and we had to struggle to make our lives decent. For one, it's such a hot place we'd often take the beds outside to sleep. From the backyard we could look into the neighbors' house, which was like a palace. It had big windows, and we could see their beautiful tiled floors, which were covered in intricate rugs. The sound of the television would come out of their rooms. They ran their air-conditioning on hot nights.

Alek

I'd never been so close to such wealth. Not that I got to know them—they never spoke to us. I'd lie on my bed outside in the sweltering night, listening to their air-conditioning and looking up at the stars while sweat dripped off my chin. Khartoum would get so hot that plants couldn't live, except along the riverbanks where there's always a wide green strip of grass and shade trees, but the river was far from our home. Once, we tested the heat by cracking an egg on a stone on the terrace—it fried right away. We ate it, too.

Even though we were far from the war, we always lived in fear of death. One morning, I woke up shivering. My mother tried to get some hot tea in me, and some bread, but I refused. Then I started vomiting. I kept that up until bile came out. It was malaria again. I have no way of knowing if it was a new bout or a recurrence of the old, but it happened several times. There were diseases all around. Our neighbors got typhoid. Someone across the road died of diphtheria. Vaccinations were rare. Death was a reality we saw daily. It was always around the corner.

My father, for one, was dying, although none of us could admit it. He'd had a stroke. He'd fallen. He was paralyzed on his left side and, in addition to his broken hip, he had broken his left shoulder. He just got weaker and weaker until he stayed in his room day and night because moving was too painful. We didn't have the money to get him treated in Khartoum. Though he never said it, he was miserable. We all spent a lot of time trying to cheer him up.

We got the idea to improve his life by improvising a carpet in his room, which was also where the boys slept. The dirt floors were just too awful. You couldn't help but get dirt on your clothes and feet while walking around. Sleeping could be a dusty nightmare. One day my mother found a freshly dug well not too far away. The workers had shoveled sandy soil out in search of water and left the clean

sand in a pile. My mother sent her Wek Army over there with every container we had to bring back sand. We spread it across the floor to make a clean carpet. That little idea of my mother's improved our lives immensely. After that I loved sitting on the sandy floor talking to my father. Despite his illness, we all felt safe from war.

I always feel for the poor, because I know what it's like to be poor. The life is forced on you. You feel you have no way out. You don't always have food. You can't buy clothes. You don't go out. The worst part is that you can't afford to stay healthy. You can't see doctors. You know you're sick, and that you're going to die, but there's nothing you can do about it. That's what happened to my father. My father died from poverty.

It broke my heart to hear my mother and father talking in the dark about what they could do—or couldn't do—to help him get better. My sister wanted him to come to England for treatment, but he couldn't get a visa. He would have lived if he'd gone there, but they needed proof that, as an adult, he could care for himself. He couldn't. I remember praying for someone to help us out, but Khartoum had millions of people who needed help. We were just one family in a vast field.

It was awful to see him suffering. I'd go to his bedside and talk to him about my day at school, about the food we were cooking. I'd hold a cool cloth to his head and wipe his lips. His eyes were still bright, even to the end, and he would look at me with such love. He never complained, not once. I remember him smiling at me. He died, in bed, at about fifty-six years old. No one knew exactly when he'd been born, but he was a young man. Athian Wek, my father. My mother was at his side when he passed. Children weren't allowed to see the body or attend the funeral but, curious as I am, I sneaked into the room and saw him lying there, peacefully, and my

mother sitting next to him. Then they whisked me away to another house. My mother wore white for forty days, because that's what a Dinka woman does when her husband dies. Then she gets on with her life. That's something I learned from my mother: remember, but move on.

After my father died, we stayed in the house in Khartoum. Our kitchen was a typically ramshackle affair at the back of the house, with some plates and about five pans. Since there was no refrigerator, we had a large clay container that we could put food into to keep it relatively cool. We also had a clay water jug in the corner, with a tin cup always resting on a plate nearby. I'd be super hot and would walk into that dark kitchen where it was such a pleasure to dip the cup into the water and take a long, cool drink.

All the girls helped with the meals. We cooked *kissra*, eggplant with peanut butter, and grilled meats over a charcoal brazier, and washed the dishes in a tub. There was a table where we could sit and eat. Everyone in that neighborhood grew food, like okra, arugula, and tomatoes, because nobody had much money to spend. When we shopped, it was only at the open-air market, where different vendors would set up tables with meat and produce. There were little stores around the neighborhood, which sold cold drinks and the like, but we could rarely afford them.

One of my favorite meals was peanut butter salad. I'd chop up some tomatoes and onions and mix them with arugula to make a really dense salad, and maybe add some chopped green peppers. Then I'd mix salt and vegetable oil, along with freshly squeezed lime juice, and stir in a few spoonfuls of freshly ground peanut

butter. I'd slice a baguette in half and fill it with salad. That would make a delicious dinner—especially with a few shakes of hot sauce.

We didn't eat breakfast, and I usually ate bean stew at school, but we'd always eat the evening meal together as a family, which I really enjoyed. We'd have okra and dried beef stew, or lentil soup, or, if we were really lucky, chicken, or rice, which was even more expensive than flour. We'd have great conversations out there in the yard, laughing and carrying on. The yard was pretty stark, with the bare dirt and cement-block walls, so we collected used oil containers, painted them bright colors, and planted lovely red, white, and purple flowers. We had to water them at least once a day to keep them from dying in the Khartoum heat.

My mother was very strict about whom we saw and where we went. Often, in the afternoons, we'd go to a friend's house and watch an Egyptian comedy show on the television. But Khartoum only had television broadcasts from about five in the afternoon until nine at night, so our options were pretty limited. On Fridays, the Muslim day of rest and worship, the television showed nothing but prayers in Arabic. Sometimes I'd pass the time doing schoolwork or reading a magazine, but the one thing we used to do that I really loved was getting together with my sisters in the yard to make up new lyrics to the songs we learned in school. Or we'd play dodgeball. But mainly life in Khartoum was very dull.

I had one close girlfriend, an Arab girl who lived nearby. My mother didn't mind if I went to her house, so we'd spend a lot of time together. She used to teach me how to write Arabic better and we became part of each other's families. Her mother always gave us nice drinks. I liked spending time at their home. Then, one day, I knocked on their door and her mother answered, and I asked to see my friend.

Alek

"She can't come," her mother said. She looked really nervous.

"Why not?"

"She's sick."

Something in her mother's face made me frightened for my friend. I could tell something was wrong. I wanted to see her but I didn't want to be disrespectful. Still, I thought, she'd been so healthy the day before.

"What happened?" I asked.

Her mother didn't reply. I felt really scared.

"I want to see her."

Her mother shook her head.

"Please, only for a moment?"

Her mother turned her head as if to say, "Go ahead, but don't pretend that I let you."

I ran past her and found my friend lying in bed with a terrified look on her face. She wouldn't say a word to me. There were bloodstains on her sheets.

I said, "What happened?"

She just looked at me with a blank expression, tears in the corners of her eyes. Then her mother came in and she turned her head to face the wall. I looked up at her mother, unable to figure out what was going on. Her mother shooed me out of the house. I stood outside in the street for a while, hoping for some kind of answer.

At home, I asked my mother what was wrong with my friend.

"Those people can do awful things to their girls," she said.

I asked her to explain but she didn't want to talk about it.

I couldn't get it out of my mind.

The next day I went back, and her mother said she wasn't well enough for visitors. I went back home and pleaded with my mother

to explain what happened. I told her about the bloody sheets. She looked furious, not at me, but at her family.

She told me that some of the Muslim families have a tradition of circumcising their daughters when they turn thirteen. They take a knife and cut out the girl's genitals—her labia and clitoris—and then they sew the vagina shut with a needle and thread. I could barely understand what she was talking about because I knew so little about women's bodies. When my mother said that circumcision left only a tiny opening for the pee to come out, I felt faint. And when she said that the women had to be cut open again when they had babies, I felt furious.

"I want to kill her family," I said.

"I know what you mean," my mother said.

She told me that the girls don't get painkillers before being circumcised, and that often they die afterward from infections. It's all part of "becoming a woman."

How could they do that to my friend? Imagine growing up like that. Going through puberty. It's horrible. They cut you up and throw away pieces of your body.

"Who does it?" I asked my mother.

"Often, a woman," she said. "A woman comes and does it with a razor blade. But the men insist on it too. A man like that would never marry a girl who wasn't circumcised."

"Do Dinka do this?"

"Don't worry. No one will ever do that to you. It's not the Dinka way."

My friend healed, and we remained friends. She never talked about what had been done to her but after that I couldn't look at her mother. I never wanted to play in their house again. There's a reason God gave women everything they have. To this day, women all

over Africa are circumcised. It makes it hard for them to go to the bathroom, to menstruate, to have children. They are at risk of infections and countless other problems. It messes up their minds. Just learning about it messed up mine. I became quite rebellious after that.

My brother Mayen, who was twelve years older than me, used to boss me around. Like most Sudanese men, he felt that he could order any woman about. One day, not long after my friend was mutilated, he told me to get in the kitchen and clean the dishes. I said I'd had enough and told him off using curse words, which were forbidden in our house. He was shocked and angry, but instead of telling me not to curse he pulled off his belt and started beating me with it. There was no way I was going to take that, so I ran. I ran out of our yard and into the street, where I sat on a wall and cried, furious. I stayed outside for hours, until it got so dark that I became frightened. When I went inside, everyone was asleep except my mother, who had waited up for me. She gave me something to eat and held my hand as I fell asleep.

We got money from my sister in London each month, and my father got ten pounds a month in government pension but that stopped when he died. My mother had to hustle. Since Khartoum was under sharia law, liquor was absolutely forbidden and the penalties against it were stiff. But, of course, people still liked to get drunk, as they do everywhere in the world. My mother saw an opportunity.

She rigged up a simple still, like the one she'd used in Wau. It produced about one small bottle a day from different grains. One of my aunts offered to sell it to people she knew. When the time came to deliver the bottles to my aunt, we were all frightened that my mother would be arrested by the morals police and thrown in jail.

We couldn't risk losing her. I volunteered to take it across town.

"They'll never suspect a girl of smuggling liquor," I said.

My mother agreed. We poured the liquor into small bottles and wrapped them in paper so they wouldn't clank. Then I put them in the bottom of a bag with a cloth on top, so it looked like I'd just come from the market. I was sweating with nervousness as I left the house with one of my brothers. Carrying the bag, I walked toward the bus stop. There at the corner was a policeman. I almost turned around and ran back home, but I forged ahead. As I passed the policeman, he stared at me. I lowered my head submissively and looked at the ground. He didn't say a word.

After a while, I started to feel pretty powerful, knowing I was doing something so forbidden. People who drank were lashed in public with leather whips.

We reached my aunt's house without incident.

"Such a young girl to be doing a man's job," she said.

When I returned home, my mother looked sick with worry.

"You'll never do that again," she said. "And I won't be making it anymore, either. We have to find another way to make money."

I had been infected with the entrepreneurial bug, so I looked around for other ways to turn a profit. My friends and I were always scraping pennies together to buy roasted pumpkin seeds, called *pasali*, from street vendors. I realized that there was no reason to throw my money away on the seeds. Why not just roast them myself, sell some, and eat the rest?

I bought raw seeds, prepared them, and then sold them in little paper sacks at school. I was surprised at how easy it was to make money. Every day I'd bring the money home and give it to my mother. She thought this was a much more sensible way to bring in extra cash.

Alek

. . .

My psoriasis continued to ravage my skin. Every day my mother would take a sharp knife and cut off the flaking bits, because I shed my skin like a snake. My head was particularly bad. She shaved it and coated it with Vaseline and medicine. Nothing helped. My palms were so cracked they bled. That was difficult, especially at school.

I went to a school for immigrants at the edge of town, about forty-five minutes' walk from my house, in an area where people lived in shacks made of cardboard and corrugated metal. It was a poor school, haphazardly put together, though it was better than the school one of my sisters attended. There, you had to carry your own folding chair back and forth to school so that no one would steal it during the night. At least at my school we had benches that stayed in the classrooms. But that neighborhood was much worse than where we lived. I felt rich each afternoon when I arrived back at our house, having walked by the shacks filled with people whose faces were marked by desperation.

My school taught in Arabic, with an emphasis on Muslim teachings. They punished us with canes. If I was late to school, or I did anything wrong, the teacher would ask me to stand erect and hold my palms out so he could whip them with a stick. This happened fairly often. Of course, the whip would make mincemeat of my psoriasis and I'd return home with bleeding palms. It was so bad that one of my tendons was damaged enough to ruin the forefinger of my right hand. I haven't been able to straighten it since, because the tissues healed so awkwardly.

My mother worried herself sick about me. Although we were all planning to go to London when we could, she decided that I should

be the first, so that I could get treatment for my psoriasis. Since I was a child, it was relatively easy for my sister to get me a refugee visa. I didn't have the same problems my father had. I was excited about seeing my sister. It was like a dream—going to London! But first I had to get a passport. And to do that I had to figure out when I had been born.

Alek

Chapter 7

I don't know my real birthday, other than that it was during the rainy season. My people don't usually keep track of birthdays. But, about fourteen years after my mother gave birth to me in Wau, I needed an ID card and a passport to go to England. For that, she and I had to choose a date. We decided on April 16, but for no particular reason other than that it was in the rainy season. A street photographer took my picture, which my brother Wek took to the police station in the Khartoum business district to get my ID card. They

never saw me in person and, looking at the photo of a tall, skinny kid with short hair, assumed that I was a boy. My formal ID card listed me as male, with an invented birth date. My world has always been a bit unpredictable. Fortunately, my brother was able to change the ID card, and eventually I got my passport.

With the passports in hand, my sister Athieng and I applied for the refugee papers that would allow us to leave Africa and fly to London to stay with our sister Ajok. I hadn't seen her since I was a youngster. The plan was that we'd go to school near Ajok's flat in Hackney, East London. I would also help with her children and eventually I'd learn English, get a job, and help my sister save money to bring over the rest of our family.

There was little for me to stay for. The economy—after decades of war—was in ruins. My father was dead. It wasn't hard to pack for the trip, because Athieng and I owned next to nothing. I had a dress, flip-flops, and underwear, and that was about it. Anything else I'd gathered over the years I left for my brothers and sisters. I was going to the land of riches. They wanted to share what I left behind.

"Leave it, Alek, leave it—you're going to get everything you want when you get to London, while we'll be stuck here," one of my older sisters said as I was packing my stuff to leave. She wanted a little metal hair clip I'd had for years.

"Get yourself a coat quick when you get there. London will be freezing," said Adaw.

My last night with my family was sweet but sad, because I was so attached to my mother. We talked and Athieng and I sang some silly songs. We had a good last meal of *kissra* dipped in stew. I was going to miss them all terribly. After dinner, my mother told me to take a shower. She believed in good grooming. It didn't matter if

I was going to visit neighbors or travel halfway around the world. She wanted me to look good in order to represent the family well. I dressed in a purple shirt and skirt that my mother had purchased for the occasion.

Properly attired, I joined my siblings and my mother in a neighbor's car and set out for the airport in the desert night, the stars above lighting the streets of Khartoum. The city had no streetlights to speak of back then, and hardly anyone was about at night. It felt like another planet, a planet of the lost. I was fourteen and starting a new life again, for the third time in my short time on this earth.

As we drove through the dark streets, I had no inkling of just how far my journey would eventually lead me. We passed shacks and tin-fronted commercial buildings, vast empty markets with wooden stalls and the cheap rubbish of Sudanese commerce scattered on the ground. There was no one in sight. At one point, I panicked, thinking I didn't really want to go to London. I looked over to my mother and almost cried, but that would not do. I put my face to the window so the breeze would cool my feverishness. The hot wind offered no relief. It was 105 degrees outside, down from 110 in the daytime. Dust still hung in the air from the most recent storm. It rarely rained in Khartoum. We just had haboobs, with their great clouds of choking sand and red dust. By the time we reached the airport, the windscreen was streaked with dirt. My skin and clothes were dusty.

Athieng and I carried almost nothing, other than our family's hopes for our future. As I hugged everyone good-bye, my brother Mayen said, "Alek, do not lose your passport or this ticket. You won't get to London without them. They'll send you back here."

Sudan was the country of my ancestors, the soil where our cattle grazed, the land where our spirits lived, but I had no desire to return.

Now I was officially a refugee, with only a small bag, a passport, a ticket, and a little bit of money.

I was fleeing a place where soldiers, militias, and rebels killed each other and anyone—men, women, or children—who got between them and their quest for power. I'd seen enough dead bodies, like the ones that went putrid on the hillside above the well where I used to gather water back in Wau. I didn't want to see any more corpses, or become one myself.

At the gate, Athieng and I said our final good-byes.

"I'll see you in a few months, Mother," I said.

Clutching our documents as if they were jewels, I shooed my little sister ahead of me.

"Tickets and passport, please," the flight attendant said to me.

"No," I said. "These are mine."

"What?"

"My brother told me not to lose these."

"I just need to see them for a second."

I was afraid she'd take them and never give them back, but in the end I handed them over. She looked me up and down like I was a country girl, which, in a way, I was. I didn't know much about international flights, passports, and the like.

The flight attendants tried to make us feel right at home. They brought us croissants, but Athieng and I weren't used to that kind of food and we got stomach cramps. When I went to the bathroom,

I realized that there was something else I didn't know anything about. The loo might as well have been a scientific laboratory, for all I knew. It was a complete mystery. I'd seen perhaps two flush toilets in my whole life, so I understood the concept, but—my God—I didn't understand the layout. Where was the flush? The directions were in English, not Arabic, so I couldn't read them at all. And the paper—at home we always used newspaper or leaves. I wasn't used to this fine tissue. I was too embarrassed to ask for help, but I was desperate, and also worried about my sister, who was sitting by herself. Finally, to my relief, a flight attendant showed me what to do.

For the rest of the night, I sat in my seat, wide-awake, looking out the window at the light on the wing as we flew through the deep darkness. I thought about Ajok and how I hadn't seen her in so long. I thought about the possibilities for my future. It was going to be so different from my past.

We landed at Frankfurt and changed onto our connecting flight. When we got off the plane, the cool spring air frightened me. I'd never experienced anything like it. I was wearing only my Khartoum heat wave clothes, with nothing to keep me warm. A stewardess took us to our next flight, which we never would have found otherwise: the airport was vast, and we only spoke Dinka and Arabic. When we landed in London, they brought steps to the plane and we walked down them into the wet, chilly air. I hadn't a clue about what we were supposed to do. So Athieng and I followed everyone onto a bus. I feared we'd done the wrong thing. It terrified me but I didn't show it because I didn't want to scare my sister. At immigration everyone was white. I hadn't known that there were so many white people on the planet. The officers showed us into a room where my sister was waiting, overcome with emotion. She hadn't seen her family for so many years.

Outside, as we walked to the train, the air felt like ice.

"But it's June," I said. "I thought it was supposed to be warm."

"In England, this is warm," my sister said, laughing.

"I'm not used to freezing."

"You'll never get used to it."

We caught the train into the city and I sat and stared, soaking it all in. I couldn't believe how high up the train was running, on elevated tracks. The people were really strange. All of a sudden a man got on, carrying his bicycle, wearing tight trousers and a tight shirt. I felt embarrassed for him. How could he walk around like that? Everything was just so different from Sudan. And also so different from what I'd expected.

At home, when I'd see pictures of Europe and America in magazines, everything looked the same: the people, the buildings. Everything was so unusual I couldn't really see the differences between, say, England and Italy. It was all just clean, luxurious, and strange, and full of abundance.

On the train it hit me that my thoughts about England had been way off target. I could see, just on the short journey from the airport, that some parts of the city were rough, with crumbling buildings and broken streetlights, while others were cleaner, more orderly, rich. It dawned on me that this was also what happened to Westerners when they thought about Africa. Their ideas were based mostly on pictures they'd seen. They assumed all of the countries were the same. They saw us all as poor and illiterate villagers; they thought we were all out to kill each other; they thought we were all chewing *khat* and walking along dirt roads. They didn't see our individuality.

Looking around, I observed one other aspect of the cityscape— the billboards. It was exciting to look out of the train window. There

were hundreds of advertisements. I didn't think about the models who had posed for these photographs, because I was too busy trying to figure out what the pictures were selling. It certainly never occurred to me that one day I would be up there too.

My sister lived in a third-floor flat. Athieng and I were amazed to be living so high up and, that first night, spent a lot of time just staring out the windows, taking in the view of the streets below. When I wasn't doing that, I was looking around the flat at the heaters, the stove, the sink, the bathroom. I spent a lot of time in the bathroom, which seemed so luxurious to me. I'd wash my hands slowly; take a bath in hot water. I just couldn't believe it.

I was overjoyed to be with my sister. She cooked a stew, and Athieng and I ate it with her, her husband, and our nieces and nephews. After a couple of days' rest, I wanted to start helping the family, so I volunteered to go shopping. My sister gave me twenty pounds and sent my little nieces and nephews to help me buy food. By this time, I'd taken to calling them "the little terrors," because they could be so unruly, but we adored being around each other.

I was stunned when we walked up to the supermarket and I saw all the provisions. I hesitated to go in, because in Sudan you wouldn't think of entering a store. Most of them were just little houses with a window. You'd go up to the window and say, "I'd like some soap, please," and they'd give it to you. "It's okay, Auntie, we can just walk in there and pick out our stuff," said my nephew.

I walked in there and thought, This is unreal—there is so much to choose from! I didn't understand why anyone could need so much. I just wanted okra and onions, but all of a sudden there were

seven or eight different kinds of onions. Different kinds of celery. A whole row of chocolates. I'd only had chocolates about once a year, on special holidays, and here was a whole section devoted to them! I had to tell myself to focus, to calm down. I said to myself, Alek, this is your world now. You've got to learn.

We found what we needed and my nephews showed me the checkout. I'd been so overwhelmed by all the choices that I somehow had lost the twenty-pound note my sister had given me. I was so embarrassed, and also terrified of what my sister would say when we got home. But she didn't hit me or anything. She just said to be more careful next time.

I ran into the room Athieng and I shared and told her what I'd seen.

"Chocolates piled as high as a doorway!" I said. "You wouldn't believe it." Her eyes lit up, but she was too scared to come back to the supermarket with me.

The food in England blew my mind. I loved eating three times a day. I loved the lunches they served at my school. There would usually be a choice of a meat pie or a vegetarian dish, along with chips on the side, and boxes of juice to drink. A lot of the kids at that school weren't satisfied with that, though, so they'd go out to fast-food restaurants for lunch. That made me think that the English children were rather spoiled. They couldn't make me out too well either. Of course, I looked different. They used to call me "Midnight Black," because I'm so dark. They would be laughing at me about everything, even though a lot of them were from African families who grew up in England. They weren't all native English people, but they all spoke English, which I had to learn quickly.

The school placed Athieng and me in the normal classes. Fortunately, though, they gave each of us an assistant teacher to

help us. My teacher was a real gem and I was soon talking and reading. I was studying English literature before I ever even heard of Shakespeare. I found math challenging but I was eager to learn and to take advantage of the opportunities I was being granted.

In the beginning, the kids teased me about my scaly skin, which, admittedly, did make me look like a lizard. Amazingly, within three weeks of arriving in London, my psoriasis, which had plagued me since I was a baby, just started to disappear. Every day I would stand in front of the mirror and look at my face. I almost couldn't believe what I was seeing—my skin was getting smoother. My legs cleared up as well. After a few months it was gone completely. Some doctors have told me it was due to the change in weather, from dry Sudan to wet England. Others have said it's because many of the stresses in my life disappeared. It also could have been because I went through puberty at that time.

Whatever the cause, I was relieved. It was hard enough to be a teenager in a strange city. I had a few friends—maybe two—but mostly I felt isolated. While the other people in my class were going to parties, I was at home babysitting. I felt less awkward once my skin cleared up. It became easier to make friends. There weren't many Sudanese in England at the time—not anything like the twenty thousand or so who live there now—but my family knew some of them and there was a good community. If one person got married, all of us exiles were invited to the party. I made friends with some of the girls, and my older sister, who watched me like a hawk, trusted that they wouldn't get me in trouble. The Sudanese girls understood what I was going through and taught me the ways of London.

Not that I got out that much. My sister and her husband had four children, two girls named Aman and Awut, and two boys named

Lual and Tong, and they both worked nights. My sister was now working at a hotel and her husband was a security guard. They needed me to help. I'd come home from school, make dinner for the children, and look after them. They were family, but they were anything but easy. When I tried to get them to do chores, such as clear their dishes from the table or clean their rooms, they'd threaten to tell their mother that I hit them. Sometimes they'd just walk away from me while I was talking to them. It was mentally and emotionally exhausting. I was only fourteen years old. But my sister needed me, so I didn't complain.

In addition to the stress of adapting to life in a new city, it was becoming clear that my mother wasn't going to get out of Sudan for a long while. It was hard to get the necessary papers, and even harder to get the money. She didn't have a telephone and there was no reliable mail service in the country. The only way we could communicate with her was by sending messages via our friend who worked in that fancy hotel in Khartoum, through whom my sister had been sending money.

Soon I started feeling bad about eating my sister's food and living in her house without contributing any money to help her, or my mother, so I took a job working mornings and weekends stacking shelves in a supermarket. I was the lowest worker there, and one day the floor manager played a joke on me. He gave me a T-shirt that said STAFF CHIEF on the front. I didn't understand the joke, and when the boss saw that, he got angry and said, "Why are you wearing that shirt?" About a year later, they did put me in charge of people, and I got the shirt back.

Alek

After that job, I worked at a photocopy shop for a while, which taught me to keep things neat, and I also learned how to use a computer. I was sixteen by then and, at about that time, my mother escaped Sudan, along with two more of my brothers and sisters. I was delighted to see her, after two years without so much as a word on the telephone.

She seemed well, and surprised to see how much I'd changed. My English was good, so she relied on me for that. Athieng moved in with her but I stayed with Ajok for a while to help her with the children. I was sad not to live with my mother, but my sister needed me. Finally, after about a year, I left my sister and at last moved in with my mother.

It was great to have so many family members around. Sadly, my brother Mayen and my sister Adaw were by then over eighteen and so could not be included in the family's application for a refugee visa along with the other children. When Mayen applied on his own, he was refused. He had to stay in Khartoum and, since the government knew his family had fled, the police persecuted him for being part of a family of "traitors." He was jailed and beaten. I know it was dreadful for him, although he's never talked about it. Years later he and Adaw made it to Canada, but the violence Mayen had suffered really scarred him.

My mother settled in quite well, although it was harder for her to adjust, given that she was fully grown. She met a number of other Sudanese women and they became fast friends. They shared their feelings and experiences in ways that they wouldn't have been able to do with English people or immigrants from other countries. My mother felt less lonely with these other women around, many of whom had also lost their husbands in Sudan.

They even re-created many of their African customs. I was

surprised when they figured out how to make dried okra. I mean, England isn't famous for its bright sunlight. They devised a method of drying it slowly above the stove. I was so happy to have dried okra again, after being away from Sudan for so long. I tried serving it to my nephews and nieces, who'd never set foot in Africa. They turned up their noses.

"Auntie, what's that?"

"Dried okra stew."

"Oh no, we don't like it," one of them said. "We won't eat that."

"Okay. But you don't know what you're missing."

During my last year of school, my class was taken to visit various universities, including Oxford and Cambridge. It was during our visit to the London Institute that I suddenly realized I knew exactly what I wanted to do. I'd always drawn pictures or made little sculptures out of clay and here I saw people who were devoting their lives to making art. That touched something deep in my heart, and I decided to apply. My mother didn't really understand why I would want to study art instead of medicine or finance, or any of the other fields that immigrants usually push their children into, but she didn't interfere.

I was accepted into the London Institute with a scholarship and started classes in 1994. It was such a fantastic place. I loved painting and would spend hours every day working in the studio. I also started taking singing lessons at night. My family approved: if I'd asked to go out to a club, they'd have said no, but since I'd found a

hobby, they were more comfortable with me being independent. It wasn't like I was hanging out in South London at all hours, but still, it was a chance to get out.

I needed some way to pay for my art supplies, which were expensive, so I took a job at the BBC, which sounds great, except that I was cleaning toilets. Every morning I'd get up at four and get ready for work. My bedroom never seemed to warm up, even when the heating was on, so it would be freezing in the early morning. I hated getting out of bed to scrub toilets. I had to be disciplined. By then I understood that if I wanted something, I had to go and get it myself. That job was my trust fund. But that doesn't mean I liked it.

Some days I'd walk into the toilets and think, My God, how can anyone be so filthy? You would not believe how dirty they got. The supervisor was a mean woman who'd scowl at me as if I were worth less than nothing. Once I'd finished my shift, I'd go to college for the day, then come home to take care of my sister's kids. Finally, one cold morning, I said to myself, "I can't take this anymore," and quit my job.

I found a new job, working in a hair salon. I would get coffee and tea for the customers, sweep up the hair, and lug supplies up from the basement. The owner was a Cockney man with a heavy accent and the tough attitude of a guy who'd fought for everything he had.

"This will be brilliant," he said when he hired me. "I'm really glad you're working here."

He appreciated hard workers like me. Maybe he saw some of himself in me, a little Dinka girl who came to London, taught herself English, and got into art school. After all, he'd grown up in the East End and worked his way up. Now wealthy people would fly him out to

Los Angeles or New York just to cut their hair. But, in truth, given how English society works, no matter how rich he got, he'd always be seen as a Cockney. Just as some people would always see me as nothing more than a backward African girl, no matter what I did with my life.

I never spoke much at the salon, and the other employees didn't really know how I'd ended up in London. Some of the customers spoke Arabic, and a few times I heard them gossiping about me: "Who is that skinny girl, anyway? She brought me tea with a hair in it." They got the shock of their lives when I replied, in Arabic, "Don't you speak about me that way." Soon, the owner promoted me to shampoo girl, which was, at times, disgusting: some of the women had the filthiest hair I'd ever seen. But it was a job, and it was a step up from cleaning toilets.

My mother was very strict with me and didn't like me to go to parties. Of course, I didn't have any boyfriends. She wouldn't have allowed that at all. I did have one good friend, an English girl whom I'd met at school.

I remember she once said to me, "So your mother won't let you go out with boys? She won't let you go to parties? You can't do anything?"

I thought she was criticizing me and I became very defensive about it. Later I realized that actually she was saying how wonderful it was that my mother watched over me. Her parents weren't like that at all. Her mother was from Singapore and her father was Indian; she was really beautiful. She was also really bright, so you'd think she had everything going for her. But her parents were divorced, and preoccupied with their own issues, so really, she had

to raise herself, without any guidance. I think that filled her with a sadness that influenced every area of her life. Even when she was having fun, there was a sad part of her that she had to hold back.

We'd have such laughs together. I understood her, and she understood me, and we adapted our friendship to each other in a really beautiful way. She always gave me the best advice.

One weekend in 1995, she invited me to join her on a visit to Crystal Palace Park in South London, where one of the local radio stations was hosting a street fair. We took the bus there and were walking around, thinking about getting a hot dog or some cotton candy, when all of a sudden a short, blond woman walked over to me and said, "Have you ever thought about being a model?" Embarrassed, I blushed—she probably couldn't see it because my skin is so dark, but I tell you, I was turning red. My friend looked shocked. We always thought she was the pretty one, not me. "Here's my card," she said. "I really think you should come in and see us. I'd like you to meet Nigel—he's an agent I work with."

"I don't know if my mother would let me," I said.

"Well, I think you'd be really good. I'm serious. Do you mind if I take a snapshot?"

She snapped a Polaroid and wrote my phone number on the book, and as she walked away, she mimed holding a phone to her ear and mouthed, *Call me.*

I almost melted, right there in Crystal Palace Park.

"Wow, what do you think?" I said to my friend.

I didn't know the first thing about modeling, but she looked at the card, which said MODELS 1.

"This is a super agency! This is brilliant!"

"What do they do?"

"They turn you into a supermodel."

"What?"

"A supermodel, Alek. She's going to put you on the covers of magazines. You could be in adverts."

For a second, I could see myself on the television. Oh, that would be nice. But I didn't say it.

"That's ridiculous," I said. "Me?"

I'd never imagined being a model. I didn't even know they existed before I arrived in London, I thought as I paid for some cotton candy for both of us. Later, as I said good-bye to my friend, she gave me a strange look.

"You aren't going to call her, are you?"

"Well . . ."

"If you don't call her I will kill you dead, and then I'll kill you again," she said. "You're crazy, Alek."

"I'll check with my mother."

I went home and told her what had happened. She just gave me a look that said, "Don't be a fool. Stay in college. Get your work done and don't think ridiculous thoughts."

I was an emotional wreck. My friend had raised my hopes and now my mother was dashing them, though I knew I'd rather listen to my mother than anyone else. Even though she was strict, I knew she'd never want anything bad for me.

I went back to school. I worked at the salon. I watched my nieces and nephews and, as always, I behaved like a good Dinka girl. I put the card in my bedside drawer and never called the agency. It just wasn't meant to be.

Two weeks later, my mother said that the scout from the agency

had called. They wanted me to go down to their offices. I could see that my mother had softened somewhat. She wouldn't tell me to do it, but she wasn't exactly telling me not to do it.

Then the phone rang again. It was the scout.

"What happened?" she said. "I thought you were coming by."

It wasn't often that a girl got scouted and didn't follow it up.

"Are you really serious?" I said.

"I'm serious, Alek. I think you could do very, very well," she said in her cut-glass accent that I loved.

So, I said to my sister, "Let's go and see." We went to the offices and sat on nice leather chairs in the waiting area. Magazine covers from *Elle* and *Vogue* were all over the walls. I went from being curious to being excited to thinking, Look at all these girls, these famous models—are you sure I should be here? Reading my mind, my sister took control. "Alek, calm down."

The scout came out and took us into a large room with a round table surrounded by chairs. My palms were sweating and my heart was beating fast. Then a man came in, handsome, about forty years old.

"Alek, it's such a pleasure to meet you," he said in a brilliant Scottish accent. "I'd like to represent you."

That's when it all started to become real. He said that he wanted to put together some test shots to start sending me out on "go-sees"—a term I'd never heard, which he picked up from my blank expression.

"For advertisements," he explained. "On television."

I was shocked.

"Me? On TV?"

"We've got to get a book of your photos together, and then build it up with some work. Then you're going to have a career."

I looked at my sister and she looked at me. Suddenly, Sudan, with its haboobs and boy soldiers, seemed very far away.

"When do you want to start?" Nigel asked. "We'll get going with ads, magazines . . ."

I left their offices with a hundred crazy thoughts in my head. Should I or shouldn't I? Was the agency real or were they trying to trick me? Could I be a famous model? Probably not, but what did I have to lose? I was sick of babysitting every night and washing old ladies' hair on weekends. A few days later, with my mother's blessing, I told Nigel that I was ready to start. He turned out to be wonderful. He was down-to-earth and not too pushy, and he had that great accent. I couldn't have been happier.

All of a sudden, I was a model, although I definitely wasn't an overnight success. I was still going to school, still watching my nieces and nephews at night, still washing old ladies' hair on weekends. But now my agent would call and tell me that I had to see a photographer who thought he could use me. It was a surreal life. There I was, a girl from a little town in Sudan. I had spent most of my life covered with psoriasis, which is not the prettiest disease and definitely not what you'd expect from a cover girl. In the blink of an eye, I was nineteen years old and in the heart of London, with people interested in my "look" and photographers wanting to take pictures of me. Yet no matter what my agent would say, no matter how flattering the photographer might be, I'd still go home to my mother's house to eat okra and talk Dinka.

It wasn't long before I decided that I couldn't work at the salon anymore. But the owner wouldn't let me quit; he kept persuading

me to stay. I found that flattering and didn't want to hurt his feelings, but I didn't want to work there anymore. In the end, I came up with a little lie to help me out. One Saturday morning, I wrapped bandages around my ankle, hobbled into the salon, and told him that I'd sprained it. He looked me up and down with some suspicion.

"That's okay," he said. "I won't make you go up and down the stairs anymore. You can stay up here with me."

No, I thought. My little ploy had gone a little wrong.

I limped over to him and said, "Really, I can't work with this knee."

"I thought you said it was your ankle."

"My ankle, right. I can't work on it."

"Well then, come back when it gets better."

I limped away, feeling guilty for lying. Once I was down the street, out of sight, I unwrapped my foot and jumped for joy. I was nineteen and starting another new life.

I didn't go back to the salon until years later, when I had my driver stop as we were passing the salon where I used to work. I went inside and said hello.

"Alek, look at you!" my old boss said, greeting me warmly.

I told him the truth, that I'd lied to him before.

"Hey, don't worry about that," he said. "You're a supermodel!"

Chapter 8

The children at school in London had made fun of me for having such long legs, for having such dark skin, for having a round, African face and short, reddish hair. Everything. It was therefore quite a surprise to become a fashion model. After all, I was the girl who'd been covered with lizardlike skin for most of her life. But the agency wanted me, and I wasn't going to argue with that.

My mother had different ideas. In Sudan, we just didn't see that much media, other than televi-

sion once in a while. I'd never really considered that I could make money from my looks, and my mother had thought about it even less than I did. All she knew about women who posed for pictures was that they were generally up to no good.

We were standing in the kitchen one afternoon, the smell of beef stew filling the flat, when I told her I had a job the next day, posing for an editorial in a magazine. Her face twisted up.

"And what will you be doing?"

I could tell she was picturing some man taking advantage of me, talking her little girl into taking her clothes off for the camera, or worse.

"It's a story on dresses," I said. "New dresses."

"And you're sure you'll be wearing those dresses?"

"Mother," I said.

"Don't 'Mother' me. You don't know what these people can be like."

"My agent set it up. He's not going to do anything bad."

"What is an agent but someone who makes money off you?"

"It's legitimate," I said. "And I'm not stupid. I won't do anything that I wouldn't think you would approve of."

She was silent for a moment. She looked into my eyes and her face softened.

"Of course you won't, precious," she said. "You're a smart girl, and you're right. I trust you. Just be careful."

But I could see behind her eyes. She was thinking that I would end up as a pinup. My mother was worried that I'd end up taking my clothes off and putting myself in bad situations. It's very much to her credit that she didn't just lock me in the closet and throw away the key until this whole modeling thing passed.

My very first assignment was a portrait test with a photogra-

pher named Mark Mattock. I did it for free, of course, since I was new, but two of the images were later published in *Vibe*, an influential New York music magazine, and that got other people interested in me. For instance, a casting director thought I'd be perfect for the video of Tina Turner's theme song for the James Bond film *GoldenEye*. That was the first of many times that I was cast because, not in spite of, my African features—they wanted someone "exotic" who lived in a jungle.

I met Tina, but I didn't get to hang out with her or anything. That video was a lesson in how complex the industry can be. They had me posing in a leopard-print bikini and high leather boots, with wild tribal makeup, in a dark room, while lights flashed across my body. I was thinking, Maybe my mother was right, maybe I am just being exploited. It turned out well after all: in the final video, I'm an elusive, dark, exotic creature who appears for about ten seconds, if that. It's not a nudie show, but people noticed and I started to get more work.

Then the creative director of *i-D* magazine hired me to pose for a Burger King advertisement he was styling. He must have liked me, because he mentioned me to other people in the business.

This was a lot better than scrubbing toilets at the BBC! I didn't mind the pay at all, which could be hundreds of pounds a day. When I worked, I earned at least as much as I did in my other, less glamorous jobs. The problem was that the work was irregular.

Models are paid by the job. The highest-paid work is when you are under contract to a certain beauty or fashion product and you become the "face" of that company. Those contracts can pay millions of dollars a year. Then there is the runway work, which can pay anywhere from five hundred dollars a day to tens of thousands of dollars, all for about five hours of work. Often a model can do several runway shows in a day.

When a model is hired by the day for an advertising job, as opposed to having a contract, she'll get the same rates as runway work, and often these jobs last three or four days. Modeling for television also pays the same, but there's even more money to be made if your agent negotiates a royalty, so that you receive a fee every time an advertisement airs. It's a crazy business, and the models' wages seem really high until you discover that these days the top fashion photographers can easily earn upward of $125,000 per day. So, really, models aren't even near the top of the heap.

The pinnacle is very narrow: only a very small group of models, photographers, fashion stylists, makeup artists, and hairstylists belong at any given time. To earn the top money, they've got to keep themselves in the public eye as well as be on the very cutting edge. That means they have to produce fashion spreads for magazines that are much more creative and risky than anything they might do in advertising jobs for corporations. It's a game, really, where the corporations only want to hire supercreative and edgy people for their campaigns, but then don't really want to be too outrageous, as they still need to sell their product.

The result is that the creative teams and models must do "cool" work in magazine editorials in order to keep their credibility, so that they can attract the lucrative work offered by corporate advertisers. Since magazines such as *Vogue, Elle,* and *Harper's Bazaar* don't have the bottomless pockets of companies like Hermès, they don't pay much at all, by comparison. Models, makeup artists, and even photographers will do editorial work for these publications that pays as little as $150 a day, knowing that if their presentation has an edge, it will help them earn money in the future.

These jobs are also good for new models who want to establish names for themselves. In my first few months, the only jobs I got

were editorials, or photographers' tests that I'd do in exchange for a little bit of money, if I was lucky, and sheets of photos that my agency could use to build up my book. This was the portfolio—essentially a photo album—that they'd circulate to photographers looking for new models.

The thing about modeling is that you can become very well known very quickly. Just as there was a bush telegraph back in the villages of Sudan, there's a fashion telegraph. A stylist will see a new girl and tell a makeup artist who'll tell a casting director who'll tell a photographer who'll tell a magazine editor, and pretty soon your name will be buzzing back and forth across the Atlantic. I was lucky enough to have that happen to me early on. It didn't translate into big money, because I was still a black African model and advertisers didn't think their consumers would respond well to that image, but the people who made the images—the stylists and the photographers—liked my look.

One day, about six months after I'd done my first test, my agent called to say, in a trembling voice, that the photographer Richard Avedon wanted to shoot me in New York for something called the Pirelli Calendar. I thought going to New York would be pretty exciting, since I'd never been anywhere other than Sudan and London.

They gave me my tickets and I headed out to the airport. Since I hadn't flown anywhere after arriving in London from Khartoum, I had a little trouble navigating the airport. I eventually made it to the check-in desk, but when I handed over my ticket, they made a face.

In order to be admitted to England as a refugee, I'd had to surrender my Sudanese passport to the British authorities and take

something called a United Kingdom travel document. It was much thicker than a passport, and the cover was blue with black writing, as distinct from the standard maroon British passport. It really stood out and, to me, looked suspicious. Also, I hadn't traveled to any other countries since arriving in England and so didn't know that holders of travel documents were required to get an exit visa.

The officials told me that I couldn't travel without one. I ran to a pay phone and called my agent. He wasn't in. I wasn't able to get my papers in time for the shoot, which was to take place the next morning. So, I missed it.

Later, I was shocked to find out that Richard Avedon was perhaps the most famous and respected fashion photographer in the world, a man who'd been shooting portraits since the 1940s and who had produced brilliant journalistic books with writers such as James Baldwin and Truman Capote. What a missed opportunity! Then, when I learned that the Pirelli Calendar featured movie stars and top models and was one of the most coveted jobs a model could get, I had to sit down and collect my thoughts. Not so much because I had missed it, but because this great photographer and incredible publication had decided that I was good enough. It was a total affirmation of my career. In 1999, when I was shot for Pirelli by Herb Ritts, I thought about Avedon. What a way to start a career—by blowing a job with him!

After the Avedon fiasco, nothing much happened for a while. The work was so irregular that I couldn't predict how much I'd earn, but I still had my expenses. My art supplies for school were outrageously high-priced, but I had to buy them anyway. I also needed to contribute to rent and food at home. I had to find part-time jobs, as well as continue going to art school, and, in the evenings, I babysat my sister's children.

In between all this, if I got a booking or a go-see, I'd have to rearrange my complex schedule, sometimes missing classes or getting a friend to cover for me at work. I never knew what to expect when I arrived at the studio. I remember one shoot, for *The Face*, where the photographer had me wear black rubber clothes and a mask, and prance around the studio like Dracula. If my mother had known about that, she would have stopped my modeling immediately!

I really wanted to do well as a model, and my agent was a great support. He really believed in me, although after nine months of doing shoots and go-sees, my career wasn't going as well as I'd hoped. I needed money and, frankly, I was exhausted by all the running around. Yes, my agent was telling me that everything was going swimmingly, but he wasn't living my life. I found it a real struggle, and the glamour of being a model was quickly wearing off. I called him to schedule a meeting.

On the bus over to the agency, I rehearsed my monologue: "I've been very happy working as a model, and you have been great in terms of encouraging me. I really appreciate that, but I don't think I can continue working in this piecemeal way, never knowing how much I'm going to earn from one week to the next. I need stability. So, unless you're able to guarantee me a monthly salary, I will have to stop modeling. It's just a matter of practicality."

Of course, by the time I sat down in the conference room with my agent, his assistant, and a couple of other people, I was feeling rather nervous, and my well-rehearsed speech came out as more of a plea than a demand. Nonetheless, I got my point across. They were shocked. And I was shocked at how shocked they were.

Alek

"Alek, do you realize that no other girl has ever asked us to do anything of the kind?"

I said no, but I also said that I wasn't any other girl. I was me. And I was having trouble with the way things were going.

I now know that it was to my great advantage that I'd never been desperate to be a model. It was never something I dreamed of, so the thought of failing at it didn't really bother me.

"Alek, you know you've had an amazing career already," said my agent, mentioning Avedon, Tina Turner, and *Vibe*. "We see you doing lots of television work, getting contracts with the big cosmetic companies in the future. We see you getting billboards. Magazine spreads. It just takes time. It would be very unusual, to say the least, for an agency like us to guarantee you a certain level of income before your career is established. We really love you, but I don't think we could do that."

I told them that, in that case, I was going to stop being a model. I don't think they believed me at first, but then I walked out and didn't get in touch with them again. I felt okay with it—life goes on.

I guess they didn't feel okay with it, as a few weeks after I quit the agency, my agent invited me in for a meeting. He told me that, because they saw so much potential in me, they were going to make an exception. They guaranteed me enough money to live on. Just a few hundred pounds a month, but it enabled me to quit my other, menial jobs.

My agent also told me that he thought it was time for me to go to New York. Wow, I thought as I walked to the bus. New York?

My mother was pretty impressed that I was going to New York, and didn't show that she was worried. She trusted me to do the right

thing. She'd sent me across the world by myself before, although this time there was no one at the other end to protect me, except for the agent in New York, from the Ford Agency, who would be representing me in the States.

Descending into JFK at night was an incredible experience. I thought I'd seen everything, after living in London, but clearly New York was on a whole different level. After we landed, I grabbed my small carry-on bag, with just about enough clothes and stuff for three or four days, and headed off. The immigration officials had other ideas. They took one look at my refugee passport and dragged me off to a holding room, where they questioned me.

"What is the purpose of your visit to New York?"

"I am a model."

The man gave me a quizzical look.

"A model?"

I guess I didn't look much like a typical supermodel.

They took my fingerprints and photographed me. The officers were cold and unhelpful; I was frightened. After two hours, they finally let me go. The airport was a chaotic mess that reminded me much more of Africa than tidy London. I hailed a yellow taxi and set off into the New York twilight, toward East Sixth Street and Avenue B, where the agency was putting me up in a "models' apartment," with some other wannabes.

Approaching Manhattan, I couldn't believe the size of the skyscrapers: the World Trade Center, the Empire State and Chrysler buildings formed a twinkling dreamscape against the setting sun. The second the taxi rose out of the Midtown Tunnel, I felt as if I'd entered a jungle of sorts. The summer air was hot and wet, and strange sounds came out of doorways, cars, and people's stereos. I

started to get nervous, breathing heavily. I didn't want anyone to see the sweat stains on my shirt. I wiped my forehead with my sleeve.

A young woman was looking out the window of the apartment building when I arrived.

"Alek, you made it!" she called. "Come right up."

She seemed friendly, but my heart was beating so fast when I got out of the taxi. I said to myself, What on earth have I got myself into? She buzzed me through the door and welcomed me to the apartment. Her name was Mora Rowe, and she was the agent assigned to look after the girls. She was going to become one of my most cherished friends in the world, but at the time, she seemed like a particularly excited alien, greeting me with a big smile and the craziest Californian accent I'd ever heard.

"Like, wow, you're here," she said. "I'm, like, so glad to see you."

Her enthusiasm was infectious.

There were two other girls in the apartment. I took the center room, which only had a skylight, because it was more private than the other rooms. I didn't mind the lack of windows—I'd certainly seen worse on my travels.

On my first day in New York, I walked out of the models' apartment into the street and felt the full force of New York blow right over me. The apartment was in the East Village, which, at the time, was still quite rough in places. I turned left out of the building and headed east, which was generally seen as a risky proposition. A man brushed past me and stared right into my eyes, then moved his gaze up and down my body like I was for sale. So brazen! That just didn't happen in London. At the corner, a huge spray-painted mural honored someone called Tyrone. His face was painted on the wall,

festooned with flowers and crosses. He died when he was just seventeen. Why? I wondered.

Farther down the block, I came across two young men injecting each other with drugs. I'd heard that people did this, but I'd never seen it in London. Believe it or not, one of them whistled admiringly at me as I passed, the needle still dangling from his vein. I decided this really wasn't for me, so I went around the block and walked in the other direction. I heard such a mix of music on that walk: salsa, reggae, even Fela Kuti, the famous Nigerian musician. The streets were filled with people selling used clothes, cassettes and CDs, books, jewelry, anything you could imagine. I loved it.

That night, Mora wanted to take me out.

"Like, put this on," she said, handing me a colorful sarong. "We're going down to Puerto Rican world."

I had no idea what a Puerto Rican was, but she made them sound very exotic. We walked down to the Lower East Side. It was a hot night and there were a lot of people in the streets, some of them dancing to salsa music. It was all really festive and I kept saying, "Are they Puerto Rican? Is he Puerto Rican?"

Mora just laughed. In time, I learned that half the people in my neighborhood were actually Puerto Rican. They were just New Yorkers, like everyone else.

We went to a little Mexican restaurant at the corner of Stanton Street and Ludlow Street. It was such a funky place, with all kinds of friendly people. The conversation flowed; Mora and I flirted with a couple of men and had a really good time. That was quite an experience for me, because I was still very callow and naive about men.

I went back to the models' apartment feeling very positive, with great hope for the future.

In the morning, Mora gave me some subway tokens and showed

me how to get to my first go-see. I was worried that my clothes weren't good enough. I was wearing some old jeans my sister had given me. She'd bought them secondhand at a market in London.

"Oh my God," said Mora. "Where did you get those vintage Wranglers? They're unbelievable!"

That made me feel pretty good. In fact, those jeans got me a lot of comments those first few months in New York. One woman offered me two hundred bucks for them. I was wondering, What is this strange world I've entered?

I went to the subway and somehow found my way uptown to the address Mora had given me. I entered the dingy hallway and climbed three flights of dirty stairs to the office of an advertising casting agency. A middle-aged woman sat at a little desk. She snapped her gum at me, grabbed my "look book," and gave it a quick once-over. Then she handed it back to me. She looked down at her desk and kept working. I stood there for a minute. I cleared my throat. She looked up.

"You're new, right?"

"Yes," I said. "You're my first go-see in New York."

"Well, that's it. You're through here."

"You don't need me?"

"Don't need you. You're not what we want."

Whoa, I thought. This is brutal. How was I going to get used to this New York brusqueness?

Then she looked at me admiringly, which took me by surprise.

"Hey, where'd you get those Wranglers? Those are dope!"

I left on a high.

That evening, I put the sarong on again, with a skimpy top I'd brought from London, and went out for a walk. This was the kind of outfit I could wear in London with no problem, but the East Village

was a whole different story. There were groups of young muscular guys on most of the corners, wearing tank tops and bandannas, big sneakers, and gold chains. They liked the way I looked.

"Hey, what's holding that skirt up, girl?" one of them called out.

"Hey baby, did it hurt when you fell down from heaven?" said another.

I turned around and went home to hide in my room.

"What's wrong, Alek?" Mora asked me.

I told her I was still a virgin, that I'd never really had a boyfriend, and that I was shocked at the way the men in the city spoke to women on the street. I said they'd never do that in Sudan or in London.

"That's just you in that sarong," she said. "With legs up to here."

The next time I went out, I wore jeans, but I didn't really go out much at all. Instead, I liked to turn on the fan in my room and blow the heat around, telling myself, "This is the weather of Sudan."

There was an ever-changing procession of girls coming in and out of the other rooms. Many of them would stay out all night long, night after night. I'd see them in the morning, hungover and looking rough. I would think, Thank God I got some sleep, because I've got a lot to do today, honey.

My days were filled with go-sees. Mora would give me a list of appointments in the morning, but more go-sees would come in during the day. I'd run all over the city with my book—sometimes to offices, sometimes to photographers' studios or magazines.

Alek

Sometimes I'd be there for less than two minutes and other times they'd ask me to do a test photograph. I never knew what to expect, except rejection. That seemed to be the only consistent part of the experience.

At the time, supermodels ruled, with slender but curvy bodies and long, thick hair. Most of them had fair skin and fair hair. This look was what sold cosmetics, clothes, everything. The advertisers were afraid to try anything else, and so were the magazines. Sure, Avedon had wanted me. But Middle America didn't.

On the rare occasions when someone actually took the time to talk to me, I found it completely disorienting. I went on these go-sees, sometimes sixteen of them in a single day, for two weeks straight. Every night I'd return to the apartment and cook some noodles or soup. Once in a while Mora would make some Italian food, like spaghetti, and I loved that. For a huge treat I'd buy a Chinese takeout for a couple of dollars, from a place on the corner. Mostly I tried to save money, as I wasn't earning anything yet and had to depend on advances from the agency to cover my rent and expenses. I didn't want to get too far into debt.

Two hundred dollars would last me at least a month. I never went to the cinema; I didn't go to museums. I bought just one piece of clothing in that first year. I was walking down the street wishing I could buy some more clothes. All of a sudden I came across a junkie selling stuff from a blanket laid out on the pavement. He had an amazing 1970s rayon shirt with a big pointed collar. I had to have it. "Wow. I'll just take that home and wash it," I said.

He gave me a funny look, and I realized that I'd hurt his feelings by suggesting his clothes were dirty. He took my dollar anyway and I got my shirt, which felt very fancy. I still have that shirt—I'll never throw it away, as I love it so much. Meanwhile, rather than

going to the Laundromat, I'd wash my underwear out by hand, back at the models' apartment at night.

The people at the Ford Agency definitely thought I had something special, but they weren't sure they could convince photographers and advertisers to take the risk of using such an "exotic" creature as me. By "exotic" they always meant black African. I was blacker than most, and they seemed very scared of that. While the agency took some of the other girls in the apartment shopping for clothes, they never offered that to me. I guess it was because they didn't want to risk losing their small investment. Still, Mora believed in me enough to send me out each day.

Nothing came of it and, eventually, the agency was discouraged. They just didn't think anyone was going to be interested. They told me to leave the models' apartment. I cried, feeling very disappointed that it had all come to nothing and I was going to go back to London. Mora, however, stuck by me. She even invited me to stay in her apartment in Brooklyn for a while. I moved out there and kept going on go-sees.

"You've just got to find the right person who understands your look and then you are going to be huge. I know it!" Mora said.

One day she sent me to a test shoot on the roof of a building in SoHo, for a new line of products being put out by François Nars. I'd never heard of him, even though he was a hugely successful makeup artist. He said, "I've heard about you. My friend at *i-D* magazine mentioned you." That made me realize how connected people in fashion are, and how small the community is. Finding out that an editor in London had been promoting me started to make me feel a part of the fashion world. I put on a white T-shirt, and Nars himself applied some deep red lipstick called "Times Square" to my lips. That was all the preparation we did for that photo. He ended up

using it in his ad campaign. Well, the Ford people were very pleased by that, and realized that yes, actually, people would use an African model as dark as me to sell makeup. That was a big coup, and suddenly they were more interested. An even bigger coup came a few weeks later, when my agent got a call from Steven Meisel's office.

This photographer was famous, not least for the photos he took of Madonna for her book *Sex*. He was the hottest thing going and shot regularly for American *Vogue* and lots of other magazines. He was well known for seeking out the newest girls to shoot for his clients. He had made Linda Evangelista into a star. His call was clearly a big deal.

Suddenly, the people at Ford took an even greater interest in me. They sent me to the go-see with a male representative of the agency, who made a big fuss of buying expensive flowers to take to the meeting. I was very embarrassed, because it's really not my style, but I was a new model, so there wasn't anything I could do about it.

It turned out that Meisel never sees the models on the go-see. Instead, his people took some Polaroids of me and sent me on my way. They didn't seem too impressed with the bouquet. Not long after, I was booked into a shoot for Italian *Vogue*, which is absolutely the most prestigious place for a model to appear. And I was to be shot by Steven Meisel himself.

It wasn't quite perfect, however.

"They think you're too fat," Mora told me. "They want you to slim down."

What? All my life I'd been told I was too skinny. I'd nearly starved, literally, a few times over the years, yet they were telling me I was too fat? What was the world coming to? This definitely is the model's curse, and it's only worsened in recent years. No

matter how thin you are, someone always thinks you could be thinner. I've known so many models who have literally starved themselves for weeks at a time to prepare for the runway or photo shoots. It's always clear when someone has been hungry for a long time, because they tend to become depressed and listless. I've felt that, not because I needed to fit into a dress but because I was a refugee. I don't ever want to feel like that again.

"Really, don't worry about it," Mora said. "They think you could lose five pounds, but I think you're fine. You eat the right things; you exercise. You're still a teenager, so don't sweat it." I didn't lose any weight.

When Meisel called me in for a face-to-face meeting, I just dressed as well as I could and tried to keep from looking too nervous. He turned out to be a wonderful guy, shy, good-looking, and really polite. He seemed to like me. And he didn't say a word about me being fat.

When I went back to the agency, the Ford people were thrilled. Suddenly, I had everyone's attention—my first lesson in the fickle nature of fame.

The shoot itself, at Meisel's studio in New York, was an amazing experience. We were doing a collection of Versace dresses, and I was the only model in the story. I was nervous as hell. I walked into the all-white studio and was met by the stylist, a beautiful woman in her midthirties, who was impeccably stylish. Leading me to a long clothes rail, she pulled out a crimson dress and held it up against me. She frowned. Then she pulled a blue top and skirt off the rack and held them up. She smiled, but then her assistant, a mousy young man, frowned. So she reexamined the look and then frowned too. Finally they settled on a simple yellow dress. I loved it, but before I could dress, I needed my makeover.

The hair stylist put a long, shiny wig on my head. It just didn't feel right, especially after I put on the dress. I'd been told that Steven was very good, so I tried not to worry, thinking that he must know what was right. I stood on a white backdrop with lights shining on me while he sat silently in a chair, staring at me.

"You know what?" he said after a while. "Take the wig off."

The stylist took it off. Then Steven picked up his camera and looked at me.

"You're set," he said.

"What?"

"As soon as they put some gloss on your lips, you're ready. You are perfect."

The makeup artist came over and did her magic.

"I want you to do whatever you want," Steven said.

His assistant put some music on.

"Are you serious?" I said, laughing.

"Hell, yeah."

I suddenly felt free. I started dancing and that's when I saw what a genius he was. He just let me be me. I didn't hold back. We shot picture after picture with me dancing around wearing hoop earrings, short dresses, one-sleeved, two-sleeved. I had no idea where it all came from, and the pictures were great. That relationship between the model and the photographer can be a fantastic source of energy that just flows through the shoot and can be seen in the pictures.

After that, I flew home to see my mother and catch up with my agent in London. All the other bookers at the agency were suddenly quite respectful of me. It was as if I'd married a prince.

"You did Italian *Vogue*? With Steven? I can't believe you did that so soon."

I was thinking, You didn't think I could do it, did you?

At about this time, Mora decided that she wanted to leave Ford. She didn't have another job, so soon she was broke. Now it was my turn to help her: I had recently gotten a few good jobs and saved a lot of money, so I gave her several thousand dollars to tide her over. I've never seen anyone more grateful. Mora was always my champion. She'd given me everything, and watched out for me through it all. I felt I owed it to her.

I was pretty disillusioned with Ford myself. I felt like they never quite understood me, even though I was doing some good projects. It was as if they weren't sure what to do with the Dinka girl.

When Italian *Vogue* came out a few months later, I couldn't believe how Meisel had made me look. He's an incredibly talented photographer and a very generous spirit.

"I haven't seen anybody that interesting, that black, and that beautiful in a long time," he told a reporter.

Steven had shot me wearing Versace, but I didn't meet Gianni Versace himself until several years later, at an after-show party in Paris, when he told me how much he loved my work in the Italian *Vogue* story. He was such a warm man. Just a few months later, I was in a studio in New York when the radio announcer said that Versace had been gunned down outside his lavish home in Miami Beach. I was getting a makeup touch-up after having changed into a new outfit when I heard the news. The makeup artist dropped his brush to the floor. Everyone was very shocked, and we didn't know whether he had survived the shooting. We continued with the shoot but everyone's mind was elsewhere.

Even after it was confirmed that he was dead, no one could accept the news.

I had seen plenty of death and destruction in my life, but this was different. It made me think again about how crazy people are. It

Alek

made me realize that life is very fragile—you can be here today, and the next minute something terrible happens. He was such a passionate man, but his life was stolen from him.

I'd never been afraid in London or New York, because I associated violence with war. After that, I started watching crime shows on television and got really scared if I heard the slightest noise at night. It took me a long time to relax.

It so was great to be back in London. I settled right back into the Sudanese lifestyle, living with my mother and eating dried okra stew. All the things I loved. My mother and her friends were starting to see that my career was real, and it wasn't exploitative. They started to feel proud of me. I was even invited to the Sudanese community center to talk to some girls about modeling. There are some younger Sudanese girls now working as models.

For a while, I commuted from London to New York whenever there was a job. I tried to schedule the editorial jobs, which didn't pay much more than a hundred dollars a day, around advertising work that sometimes paid me eight thousand dollars a day—out of which I had to give the agency their cut. That way the airfare would cover both jobs. It was more economical to fly back and forth than to rent an apartment in New York. I could live at home in London when I wasn't working and stay in hotels, or at Mora's, when I was in New York. Often the companies who hired me would pay my airfare, so it worked out well. After a while, as jobs kept coming in, it became apparent that I needed to be in New York full-time. The traveling was becoming too much.

I left Ford Models and moved to International Management

Group, or IMG. Mora was working there, and I decided to follow her, as I felt she understood me more than any other agent I'd met.

I was so busy that I quickly rented an apartment about the size of a minivan, on the Lower East Side. I slept on a blanket on the wooden floor for six weeks, as I didn't even have time to buy a bed. It felt like being back in the village, in the hut, and I didn't like that at all. I bought a futon at a shop on the corner. They wanted to charge me thirty-five dollars to deliver it, so I just picked it up and carried it by myself around the corner and up the stairs, earning cheers from some guys walking by on the street.

"You're a damn strong sister," one of them said admiringly. After that, he called me "Strong Sister" every time he saw me.

Since my income was so erratic, and I never knew when I would get another job, I tried to save every penny. Really, I saved too much. I've always been a bit of a miser, preferring to have money in the bank for a rainy day than to live an outlandish lifestyle.

I also kept pounding the pavement for work. The thing about being a model is that everyone thinks you can just sit back and be glamorous as the jobs and money roll through the door, but the truth is that you must work hard and treat it seriously, as with any career. I went on so many go-sees that I can't remember half of them. While I've always loved New York, the city really did feel like the jungle to me. I'd be walking around wondering who was going to leap out from behind a bush and attack me. Which agent was going to eat me. Who was going to ruin my career. It was really stressful. I'd been in the bush, and this, really, wasn't any easier. But that kept me focused.

Over the years, I saw many of my fellow models get consumed by partying. When you are a pretty girl in New York, there's always someone who will take you out and give you drugs or liquor in

exchange for just being with you. Lots of girls get lost, partying their lives away. It was all too easy. I remember one afternoon I was walking down Broadway when a guy with dreadlocks came up to me, talking fast. He was good-looking and wanted me to come to the party he and his band were holding. He gave me the information and when I got back to the apartment, Mora and I looked at it. It turned out that he was one of the guys from the Wu-Tang Clan, one of the biggest rap groups in New York at the time.

I was flattered, but I didn't go. I had too much to do the next morning. I didn't want all my work to be for nothing. I always had my mother in the back of my mind, saying, "What are you doing wasting all your time? Get to work, girl!" I remembered my father, too. He'd always say, "Look, Alek, you don't have to be a scientist, or a doctor or a solicitor. But whatever you choose to do, you should really love it. You should focus on it and you must stick with it. Life is not a game, although it can be fun."

I had a good time and I got good jobs. And, though I didn't know it, I was about to change the face of beauty and modeling in America.

Chapter 9

Whether I like it or not, my skin defines me. The first thing many people notice about me is how dark my skin is. Not just in America and Europe but also, to a lesser extent, in Sudan. In Khartoum, my skin marked me as a southerner, probably a Dinka, and many of the lighter-skinned residents of the city looked down on me. Racism exists everywhere.

If I were living in Darfur, where the Sudanese government is committing unspeakable atrocities, my skin would mark me as a *zurqa*, a "dirty black." The Arab

militias that are funded and directed by the brutal leaders in Khartoum would single me out, perhaps dropping oil barrels filled with explosives and shrapnel from airplanes onto my village, or riding in on a camel to rape, brand, and terrorize me. All because I'm black. And they are less black, though darker than most Europeans.

Skin tone is a tricky thing.

I've found that in America many darker-skinned African-Americans both idolize and criticize lighter-skinned African-Americans. What is this obsession with pigment? Scientists say skin pigment is largely a matter of geography; people who live in sunny areas, such as along the equator, will, over generations, develop darker skin as protection from the sun. People who live in northern areas will develop lighter skin as a more effective way of using the sun's limited rays to manufacture vitamin D. The biology is really quite simple. Unfortunately, the sociology is not.

My skin has both helped me and hurt me in my career. In 1997, the Scottish photographer Albert Watson offered me a job. He has shot everything, from portraits of Keith Richards to dogs looking out from the back of an old station wagon in the Las Vegas desert. When I got to his elaborate studio on Washington Street in Lower Manhattan, I found a gigantic white espresso cup, bigger than a car, resting on its side in the middle of the studio floor. The shoot was for a calendar being published by Lavazza, the Italian coffee company. I was meant to pose on the edge of the cup. My skin was to be the espresso.

Albert was a wonderful man, and I immediately felt a rapport with him, but when they asked me to take off my clothes, I got very nervous. I was uncomfortable with the idea of posing nude. Albert promised me that it would be tasteful, and that I could keep my knickers on. The makeup artist rubbed some sort of oil into my

skin to bring out the shine, and the hairstylist put a huge white lily on my head, which made me look like Carmen Miranda. I had to remind myself that this was my first big job—I was earning eight thousand dollars for the shoot, which would be enough to pay my agency the six thousand dollars I owed them for backdated rent and cash advances.

As I walked onto the studio floor, it crossed my mind that my mother's fears were being realized: I was posing nude for money. I almost walked off the set. I was so nervous that I couldn't really think, so I just sat down in the cup and crossed my legs. My hands were sweating, and I struggled not to shake as Albert took the photos.

They are beautiful pictures, and I am grateful for the chance I had to work with Albert Watson so early in my career. But as time passes, and I become more aware of race relations in America and Europe, I can't help but compare them to all the images of black people that have been used in marketing over the decades. There was the big-lipped jungle-dweller on the blackamoor ceramic mugs sold in the 1940s; the golliwog badges given away with jam; Little Black Sambo, who decorated the walls of an American restaurant chain in the 1960s; and Uncle Ben, whose apparently benign image still sells rice.

I'm sure no one set out with these exploitative images in mind, but we all carry unconscious inspirations, and I think the Lavazza ads reflect the ways in which we typecast people. But hey, I didn't have to do it—I was grateful for the work. After a while, however, I got tired of being seen as just a "black beauty."

For instance, in Tina Turner's *GoldenEye* video, I appear as a shadowy, mysterious figure, like some apparition from *Heart of Darkness*. For other jobs, the photographers wanted me to pose

on leopard-print couches straight out of some interior decorator's Tarzan fantasy, or pose with spears. I noticed that journalists often liked to say that I'd been discovered in "the bush," in Africa. As if I had been a primeval innocent afoot in the forest when the great model agent plucked me from the muck and tamed me, without destroying my savage beauty. I mean, I was wearing jeans in Crystal Palace Park when I was "discovered." The closest bush was a well-manicured azalea. I am African, but I am not primitive.

At first, people in the industry never seemed to believe that I could do anything but work that called for "black" features. That really hurt my feelings. I'd look around the streets of New York and see that "all-American" meant frizzy hair, straight hair, dark skin, light skin, big lips, small lips, skinny, and curvy—everything under the sun. As far as I'm concerned, there are beautiful women all over the world, whether they're brown-eyed Indians, blue-eyed Americans, or green-eyed Mongolian-Swedes. I also knew that most people weren't so limited in their worldview that they'd only respond to images of people who shared their skin color.

No one ever said to my face that my eyes were too wide-set, or that my body was too long, or that my hair was too nappy, but on go-sees I'd often be greeted with a bemused expression. The people would mutter under their breath and shake their heads. In my heart, I said, "I'm going to prove all of you wrong. One day you will see that I am not just a model for a certain look. I am no freak, you know!"

That's why it was so great to have Mora in my corner. She really believed in me. When I told her that I no longer wanted to answer any calls from photographers seeking "black girls," she understood. There's something so disrespectful about that kind of cattle call. I

didn't want to go on jobs that discriminated on the basis of skin color, or that lumped all black girls together. Think about it: which models would spring to mind if someone asked for all "white girls"? It would be hard to pick them, right? I wanted to work with people who were creative enough to see beyond that one-dimensional view of the world. Mora agreed. Why bring it all down to black?

Beauty is such a subjective notion. When I was growing up, I never saw myself as beautiful. I looked like my sisters, and like most of the other Dinka girls. We were all dark, tall, and lithe. I had the added problem of psoriasis: the few times I took a look at myself in a mirror, I wasn't pleased.

I am amused these days when people refer to me as having an "African" look. Africa is not a country; it's a huge continent, filled with many different types of people. Egypt is part of Africa. Madagascar is part of Africa. We're all different. For instance, Ethiopians, in general, would never be mistaken for someone from the Ivory Coast. We have light-skinned Africans and dark-skinned Africans. Short people and tall people. There is no one standard of beauty for Africa.

At last the big designers seem to understand that there's beauty in Africa. They all draw inspiration from Morocco, from the Nubian mountains, from all over the continent. The African influence surfaces every couple of years in the collections of Galliano, Ralph Lauren, all of them. They use the inspiration well, so it shouldn't be such a stretch to use models that aren't blond and pale.

· · ·

Alek

The photographer Gilles Bensimon recognized this, in 1997. At the time, Gilles was the creative director of American *Elle*. The magazine was at the forefront of fashion in those days, and constantly challenged accepted notions of beauty and commerce.

Gilles and I met one day when we were both working in Los Angeles. Neither of us knew that we'd eventually create a photo that would change my life, and the standards by which beauty was judged in America.

He'd heard about me from a go-see I did at *Elle* in New York. Periodically, I'd visit every major magazine. They'd take Polaroids and put the pictures on their wall. When they came to do a story, the editors would get together with the photographers and choose the models that would work best with the clothes. Gilles saw the pictures in New York but called me when he had a shoot scheduled in L.A., in an old diner with an elaborate jukebox. Gilles kept putting Elvis records on the jukebox and doing wild dances. I loved it—I thought he was hilarious. Normally I'm quite shy when I first work with someone, but Gilles and I really hit it off.

He was a really down-to-earth guy in a way, despite his high-flying lifestyle. After that shoot, he kept requesting me for work he was doing. I went to St. Barths a couple of times, and out to the Hamptons for a shoot on the beach. On one of those beach shoots, a stylist almost stepped on a snake and the whole crew freaked out. I just laughed. Snakes no longer scare me. I think Gilles liked that.

He was a painter like me, and we talked often about how satisfying it was to use oils and brushes. Every time I went to his studio, I noticed one particular painting that he was working on. I told him

that I liked it very much. Years later, I went back to the studio and it was still there. He said, "You always liked this—why don't you take it?" He signed it and now I have his really bright, lovely painting in my home.

We kept working, and my image was constantly in the pages of *Elle*, which was great. But, curiously, it seemed that the other girls he regularly worked with kept getting covers. A cover is a huge deal in the fashion industry. It means you've really arrived, and it gets you lots of work. People who wouldn't normally notice you on the pages of a magazine will see you on the cover. They'll think you have a buzz. If the CEO of a big company likes what he sees, he might base a campaign around you. It's very important to get covers. And I'd never had one. Mora and I started to get very frustrated. A year passed. Almost every cover of *Elle* featured a very light-skinned girl. My agent made a call.

"I want to see a cover, Gilles," she said. "It's time. She's done so many interior layouts. It isn't fair. It's just because she's African. You guys are too afraid."

We all knew that the marketing people were afraid to put dark-skinned girls on the covers of fashion magazines. They had research data that they believed showed that people wouldn't buy the magazines unless the cover girl was white or had "traditional" American features. In 1968, the model Katiti Kironde II was the first black model to appear on the cover of *Glamour College*, and there hadn't been many since. *Elle* had run black women, such as Naomi Campbell, a couple of times, but they'd always had more or less "acceptable" features. None of them looked like me.

We kept nagging Gilles. He had great influence at the magazine but it wasn't his decision. Obviously, he liked the way I looked,

because he used me so often for the inside pages, but the management was afraid of losing money by putting me on the cover. Finally, they decided to take a chance.

Gilles called Mora. Everything just fell into place and it was the quickest shoot I'd ever done. He dressed me in just a pure white Armani jacket, open to my navel. He was joking around as usual and I was smiling and laughing.

"Don't stop smiling, but stay still for one second," he said.

I stopped.

He took the shot.

And that's the one that ran on my very first cover. I was quite proud of how I looked. In the photograph, I'm standing at an angle, so you can see my chest beneath the open jacket. Not that it reveals anything but skin. I'm looking right at the camera with a half-smile on my face. It was elegant and fresh at the same time. Gilles made no attempt to hide my natural features—my full lips, my skin, my tightly curled hair. It was a magnificent picture, printed on an all-white background, with gold type.

The issue sold like crazy and it seemed that every newspaper and magazine in America wrote about how the cover challenged our traditional conceptions of beauty. The *New York Times* interviewed Gilles.

"The statement is, 'Nobody is out, everybody is in,'" he said.

The reader response was overwhelming. Thousands of women, and more than a few men, wrote in to praise the cover. They were Chinese, Native American, African-American, Caucasian, Indian, Brazilian, Guatemalan, French, English, and Icelandic. Almost all of them said they found the cover shot liberating.

"Hey—thanks for putting *me* on the cover. Finally I have someone I can identify with," wrote one girl.

"Cool," wrote another. "I'm a white teenaged boy but I felt like having Alek Wek on your cover means that the world is becoming a bigger place—keep it up!"

Oprah Winfrey even invited me on her show. That was one of the high points of my life, because she is such an intelligent, gracious woman. She talked about what it had been like for her to grow up in a culture that didn't value blackness, and that encouraged everyone, no matter what their natural attributes were, to conform to the image of white American beauty. "This is a new day, America," she proclaimed to the television audience. "When I was growing up, if you'd been on the cover of a magazine, I would have had a whole different concept of who I was."

That cover raised me to a level of fame that I never could have imagined. It felt like such a positive thing: I really had a strong voice now. Suddenly I symbolized a kind of freedom from fashion tyranny for a lot of people. I remember that I was walking along Fourteenth Street in New York one afternoon, when a nurse ran up to me and said, "Normally I don't like models but you are just amazing. You are real."

Near my house in Brooklyn, girls would stop me and give me a hug. Total strangers. There were stories in all the magazines and reports on TV. Even people who didn't care about fashion were talking about that cover. I was so surprised. At times I felt like a bit of a freak.

Doors began to open wider after that, but I still faced a kind of institutional racism within the fashion industry. It wasn't that most of the people were consciously racist—they didn't go to KKK meetings or anything like that. Rather, it was that they followed a set of assumptions that had been passed down to them. For instance, during my second season on the runway, I wanted to work with Karl

Lagerfeld, but the people in Paris said I wasn't right for him, meaning, of course, that I was too "exotic." They felt that Chanel was not about being exotic—or dark-skinned.

I finagled a go-see, and Lagerfeld said that I was perfect. Karl is a creative genius and he never stops working or thinking. He's definitely not someone to get stuck in the past. He told me that he felt my features and my look represented the future of fashion. He put me on the runway, for Chanel. I did a lot of work for him, and later, when I started my handbag business, he gave me advice.

A few years ago, Karl asked me to work at the Chanel shows in Paris. It was such an honor just to be there again, and so I was completely blown away when he fitted me for the wedding dress that traditionally closes each fashion show.

"The standards of beauty changed, and she is the expression of modernity in beauty," Lagerfeld told a TV reporter who had come to his atelier in Paris. "It's important to have her, because the world is not just basic blond."

A similar thing happened with John Galliano, the wildly creative British designer. I worked with him several times, and we got along well. After I'd been in the business about four years, he took the helm at Dior. I'd never done anything with Dior and I thought it would be a great opportunity.

I kept telling my Paris agent to try to get me a booking. Again, people thought I wouldn't be right. I couldn't understand it. I thought they could at least see me wearing his designs before they wrote me off. So I badgered everyone until, finally, they said, "You know what? Great. Send her over for a look."

I arrived to find them deeply involved with lace. Everything was white and pink and baby blue lace, along with hats from the 1930s and cameo brooches. They had me try on an outfit with a baby blue veil covered with sequins, along with a hat and lots of jewelry. I walked out to where John and the others were, and they said, "Walk up and down."

As I moved, I felt it. I knew I looked great. It's just a sensation I get once in a while.

I could see their eyes. They were looking at each other. I was hoping they'd book me. Then Galliano smiled and I almost swooned.

They didn't say a word. Just took a Polaroid of me and sent me on my way.

My phone rang as I was heading for the subway.

"He loved you!" said Mora.

The *Elle* cover helped a very great deal, but it didn't make being a black model a rosy experience. Still, my career progressed rapidly after we broke that cover-color barrier. And why not? It's a business, really. People started to see that money has no color. My image could sell as well as that of any of the other top models. In time, I would be named "Model of the Decade" by *i-D* magazine; one of *People* magazine's "Fifty Most Beautiful People"; and one of the "Fifty Most Influential Faces in Fashion" by both *i-D* and *Frank* magazines.

I don't like to complain. I've done really well in my life, but I can describe what it's like to be a black woman in the modern world. In Sudan, I didn't notice race that much, until I got to Khartoum. When I moved to England, the children at school called me "Midnight

Black," and most of the white people would either ignore me completely or treat me as some exotic specimen to be feared or pitied.

In New York, I get such a variety of reactions that it's hard to predict what will happen on any given day. Lots of people—men and women, young and old, of all races—recognize me and say positive things to me. There are a number of African men who sell things on the street, like counterfeit watches and handbags. When I walk along Canal Street, they'll call out to me in languages I don't understand. They think I'm one of them, but I'm Dinka, from Sudan. In Paris, an African guy ran up to me and said, "You're from Perl. You're from Perl." And I said, "No, I'm not." He was convinced, just based on my looks, yet he was totally wrong. I didn't even know where he was talking about. When I spoke with my mother about this, she said that some people believe the Dinka people are distantly related to the Perl.

The strangest things happen. In a train station, once, a woman came up to me and insisted that I was Waris Dirie, the Somalian model who wrote a book called *Desert Flower*. I said I was flattered, because she's beautiful and wrote a wonderful book, but that I wasn't her. People constantly confuse me with Naomi Campbell. That, to me, is ridiculous—we don't look a thing alike.

Not long ago, I was walking up a street in Fort Greene, Brooklyn, not far from my house, with my boyfriend Riccardo Sala. He's Italian, light-skinned, and about six feet tall. He's a really nice guy, and he's used to people staring at us like the odd couple when we walk down the street. That day we were heading off to brunch, holding hands, when a car full of men with dreadlocks slowed down as it passed.

"Traitor! Sellout!" one of the men shouted at me in a deep West Indian accent.

He didn't like to see an African model holding hands with a white guy, apparently.

Riccardo was fine about it. He understands. We just walked on, keeping our heads high.

Sometimes the stereotyping becomes more serious, and disrespectful to the point of making me really angry. Once I landed at JFK after doing several jobs in Europe. I travel with a British passport, but I've got a green card, which allows me to live and work in America with most of the rights of a naturalized citizen. I pay a lot of taxes; I own a house; and I run my handbag business here. There's no question that I'm legitimate.

When I reached the immigration booth, the officer of Homeland Security looked me up and down and studied my passport with extra care.

I thought, Not again. I have learned not to say anything in this situation. There's nothing you can say to help yourself, and plenty you can do that will irritate the officials. I've been detained many times. I've come to realize that as a successful black woman—and a tall one at that—I represent something that triggers hostility and suspicion in a lot of people, black and white, male and female. It still surprises me that it happens in America and Europe, where people are supposed to be well educated and sophisticated.

Anyway, the immigration official sent me off to the little room they have for suspected terrorists, illegal immigrants, and the like. I've been there before. They took my picture. They checked my green card again. They double-checked my fingerprints. They acted really tough, cold, and suspicious. They kept me for two and a half hours. I'd just flown business class from Frankfurt. I was wearing nice clothes,

carrying a bag that I'd designed, which even had a little brass tag with my name on it. I had all my papers. Yet still they had to detain me for all that time. Was it because I'm a black woman? I can't prove it, but experience tells me that my skin figured in there somewhere.

A few weeks later, I was on my way to another job. I had to fly to Munich, then Frankfurt, and then back to New York, all in the space of six days. I was tired, so I ducked into the business-class lounge at JFK, looking forward to having a cup of tea in peace while I waited for my flight. The man at the desk looked me over as I handed him my boarding pass. He swiped it through his machine and said, "Have a seat."

I put my bag down and made a cup of tea. As I took my first sip, a voice came over the loudspeaker:

"Miss Alek Wek, would you please come to the desk."

I looked in my bag to make sure I hadn't left my boarding pass at the desk. It was there. So I walked up to the desk.

"You called me?"

He didn't look up from his computer. I stood there for a moment. Finally, he looked up, with a condescending expression on his face.

"I've been examining your information," he said.

"Yes?"

"Let me see your boarding pass again."

I handed it to him.

"Are you certain that you purchased or upgraded to a business-class ticket?"

"You saw it. I checked in with it."

"I'm not certain that you are allowed in the business-class lounge," he said, looking me over. I could tell it wasn't my ticket he was worried about. It was me.

"What are you saying?"

"I'm saying that I'm not certain that I can allow you to stay in the lounge."

For a moment, I was speechless.

"Where are you from?" he asked.

"What does that have to do with anything? I have a business-class ticket and I want to have a cup of tea and then I'll get out of here and you can go about your business however you want. But for now, just leave me alone."

I was furious. I walked back to my seat so I wouldn't start shouting at him. I always travel with the same airlines. I use the same travel agent. This guy was looking for a problem. He was trying to find a way to devalue me, to make me small. I didn't like that one bit. It was degrading and I don't think he would have tried to pull that on a man, especially a white man.

I sat there for a few minutes. I was livid. Suddenly the guy appeared and handed me my boarding pass.

"It's okay," he said.

"No, it's not okay," I said.

"What?"

"You do not have a right to question me like that. You imply that I don't deserve a good seat. That maybe I can't afford to pay for it. That I might not be good enough to fly business class to Europe. Why is that? Why have you chosen me out of all these people? Because I'm an African woman?"

He was silent. Then he walked away. I finally got to finish my tea. As I waited, the man's shift must have ended because he wasn't at the door when I left the business-class lounge. Instead, there was a young African-American woman with long, beautiful hair.

"Alek Wek!" she said, excited, when she saw me. "How are you?"

I'd seen her many times before while waiting for flights. She was a lovely girl. I had a pleasant flight to London after that.

Believe it or not, when I came back from that marathon trip, the Department of Homeland Security detained me once again. I was tired. I felt insulted. I didn't understand what was going on. I had just been through this a couple of weeks before. It was the same guy who'd questioned me the last time. This time he grilled me about my travels. Why was I in Africa? He looked at each page of my passport. Why had I been to Egypt the year before? Why this? Why that?

"I'm a model. I travel for work," I said.

He looked me up and down like he didn't believe me. I wondered if Cindy Crawford had these kinds of issues.

"Why are you interrogating me?"

"It's for your own protection, you know."

"I don't feel very safe."

It's like a jail in there. You can't use your phone to call for assistance. They won't tell you why you're being detained. Another hour passed. I went up to him and told him that I knew my rights.

"Your rights?" he said with a smirk.

Finally, after two and a half hours, he stamped my passport.

"I thought you were Naomi Campbell," one of the other officials said.

I just shook my head and walked out. I couldn't bring myself to say thank you.

While I was waiting for my luggage, a woman came up to me and said, "You know, you look just like this model. She's from Africa. She's got really short hair and she looks just like you."

"Really?" I said.

"Really," she said. "It's amazing."

I was too tired to talk to her. But I appreciated her interest.

I got in the car and put all the bad exchanges I'd had during this trip behind me. I didn't want to revisit those negative thoughts. I try never to take the same road twice. It's the Dinka way. If you follow the same path, you'll end up in the same place, or worse. I let others deal with their issues, and move ahead. I've got a life to live.

Alek

Chapter 10

Mora called one crisp Saturday morning and we started talking about apartments. Real estate is an obsession shared by all New Yorkers, since good apartments are so hard to find. It was early winter and I was paying over a thousand dollars a month for a ten-by-fourteen-foot dump on the Lower East Side. The landlord had slapped up a tissue-thin wall across a studio, called it a one-bedroom apartment, and hiked up the rent. The kitchen had a chipped sink and a three-burner stove. The building was so

flimsy I could hear my neighbors clear their throats. It felt like I was just pouring money down the drain.

"Come out to Brooklyn and have a look," Mora said. "The places are great out here and a lot cheaper."

The idea excited me. I'd always liked her neighborhood. I was earning more money than I'd ever seen and maybe I could find a great place out there. On the spur of the moment, I caught the A train out to Clinton Hill, which, at the time, in 1998, was just in the initial stages of a gentrification process that would end up making it and neighboring Fort Greene one of the coolest places in Brooklyn. Of course, back then we had no way of knowing what would happen to Brooklyn real estate prices in the coming years. In those days, most Manhattanites still saw the borough as a rough, distant place, not the desirable center of cool it has become.

Mora and I shared a love of driving around the city, listening to music and checking out places we'd never before seen. It promised to be a pretty great day, even if we didn't find a house. We piled into her Jeep and drove down to a junction in Fort Greene where Realtors posted listings in their windows. For some reason, my eyes were drawn to just one category: Buildings for Sale.

"That one looks nice," said Mora, pointing to a redbrick town house that was listed at $395,000.

"Are you kidding? You know I don't have anywhere near that much money in the bank."

"You borrow it, Alek. You get a mortgage."

"No way!" In Dinka culture, it's almost unheard of to borrow money. My mother had always stressed that a person should never buy anything they can't afford or pay for outright. This idea of getting a mortgage was so foreign to me that I couldn't even begin to understand it: you borrow a hundred thousand dollars and end up

paying the bank two hundred thousand dollars over the life of the loan? That seemed ridiculous.

"Let's just get a list of houses and we'll go see some of them," Mora said. "There's no harm in looking."

"Okay. But I'm not buying anything I can't afford."

We drove around and looked at about ten houses that morning. We got a lot of laughs, because most of the houses were terrible. We couldn't imagine how people lived in them. One house stank so badly from the ten cats the owner kept I couldn't go into some of the rooms. Another one was leaning so far to the left I thought it might fall over. One was so dodgy-looking, with windows right at street level, I was afraid a robber would break in as soon as the moving van pulled away from the curb.

All the time I was wondering how I could possibly pay for a house. Mora made it sound really simple, if daunting. If I put 10 percent down, I could pay the rest off monthly until I was over fifty years old. It sounded crazy, but I realized that it wasn't as crazy as paying rent.

As we pulled up to the last house of the day, I realized it was the redbrick one I'd admired in the real estate office window. For some reason, it made me think of my childhood home in Wau, even though they didn't look at all alike. There was a feeling, an energy about the place that spoke to my heart. The house said "Home."

As we walked to the entrance, the real estate broker said, "Now be aware that this is a very little house. Most of the others on this block are huge. I don't want you to be disappointed."

We entered on the ground floor and my eyes opened wide. Nice, I thought.

"Look, it's completely renovated," Mora whispered to me.

"Wouldn't it be brilliant to own a house?" I said.

I could feel my fears giving way to desire.

We went upstairs, and when I saw the living room with its high ceiling, beautiful fireplace, and the sun pouring in through the floor-to-ceiling windows, I said, "Oh my God!" out loud. The Realtor smiled. She could see how much I loved it.

"Let's go to the top floor," she said.

I gave Mora a puzzled look.

"You didn't know there was another floor?"

I couldn't believe it. I thought we'd already seen the whole thing. Mora took me aside and said, "Alek, you've got to live in this house. It's, like, totally you."

"Too bad I can't afford it," I said. "It's nearly four hundred thousand dollars!"

"So? You're working so hard. You should own your own house."

The Realtor told us someone else was about to make an offer, and that the house was going to go quickly.

In the Jeep, Mora said, "You are going to get this house."

It was right before Christmas, and I'd planned to go to London to see my mother.

"Cancel that trip," instructed Mora.

So I did. Mora walked me through the process of buying the house. We got a surveyor to check it out, and then I got my accountant and business adviser, who lived in Cleveland, to start on the paperwork. I learned about mortgages as we went along. Fortunately, I trusted him.

He was shocked at the price.

"In Cleveland, you'd have a swimming pool and a four-car garage for that price," he said.

"Well, this is New York, not Ohio. I'm sure that if we went to

Timbuktu, we'd get a whole city block for that kind of money. I don't want to live in either of those places."

He wouldn't let me bid on it until he saw it. He was such a nice guy that he flew all the way out from Ohio to have a look. He climbed the ladder up to the roof, looked around, and said, "This is too much responsibility for you."

I told him that I was already paying twelve hundred dollars a month in rent, plus utilities and everything else, for a tiny apartment in Manhattan.

"You really want it, don't you?"

"Yes. I'm not going to give up."

I was even surprised myself by how much I wanted that house.

"Okay then, let me get to work on it." Once he saw the appraisal, he realized I was getting a fair deal.

In the end, the other potential buyer went away for Christmas. I stayed in New York, put my 10 percent deposit down, and got the house. Suddenly, I had a mortgage that was costing me more than my rent. Later I was able to refinance it and get it down to a fifteen-year mortgage. Wow, I thought, when I'm forty, I'll own this place outright. All of a sudden, I was an upstanding member of the community, with a mortgage to pay and pipes to fix.

I bought furniture, but not very much. Then, when I was doing a shoot for Coach, the leather goods company, I suggested they pay me in furniture. They gave me two incredibly beautiful leather couches for my living room. The house gave me a lot of impetus to work on my career. I started to realize that if you need money, you will make it. Your needs will be met. I also devoted more time to my painting, as I had enough space to set a whole room aside as a studio.

Once again, my life was changing rapidly. It quickly became clear that since Brooklyn was such a vast place, I'd need to learn

how to drive, as well. I'd ridden in cars only a few times when I lived in Sudan. I'd never driven one. I signed up for lessons with a driving school. I found it very hard, but fun too. I must have scared the instructor half to death, but I learned in the end. Once I passed my test, I got my own Jeep and became the first person in my family ever to own a car.

When my mother came for a visit and saw my house and my car, she said, "Welcome to America, Alek." She couldn't believe it. We'd always dreamed about owning a home. And here it was. It was very humbling. I'd attained what so many immigrants hope for when they come to America. On the wall in my home, I keep a portrait of my father that I painted. It's black and white and gray, about four feet tall. Whenever I look at that painting, I feel grounded, at home.

Despite all this, something was missing from my life. I'd see stories about Sudan on television, especially a spate of reports about the Lost Boys, and my heart ached for my home country. The Lost Boys of Sudan was a program run by the International Rescue Committee to resettle boys from Sudan who'd lost their homes and families in the war. The boys had gathered in large groups and escaped into the bush to avoid the government-supported militias that were bearing down on all the villages in the southern Sudan.

Some of them made epic journeys across the country into Ethiopia and Kenya, usually with no money and little food—one boy walked naked for hundreds of miles because he couldn't find any clothes. There were more boys than girls, because the girls were more frequently kidnapped, or killed with their families.

About four thousand of these boys were eventually resettled in America. I really felt for these children, and as I was getting so much publicity, I thought I might be able to raise awareness of Sudan's plight in this country and Europe. So many fashion magazines and newspapers were beginning to write about me. I realized that I was very lucky to have a public voice, and I didn't want to waste it. I knew I couldn't just sit in my nice house, enjoying the fruits of my hard work and very good luck. I also felt guilty: why was I alive and doing so well when so many of my countrymen were suffering?

At the time, in 1999, the situation in my country was absolutely atrocious. Government soldiers and militias were burning down entire Dinka villages, sometimes with the women and children forced to remain in their huts and burn to death. The killers would charge on camels into groups of tribesmen and hack their limbs off. It was terrifying. I felt hopeless, and, having been a refugee myself, vulnerable despite all my success. Once you've been threatened by soldiers and forced from your home, you never quite feel that the world is a safe place, no matter where you end up. I had seen so much death and destruction that I could never believe tomorrow was guaranteed.

I didn't want to live a life where everything revolved around me. That wasn't my style, but I wasn't sure how I could exploit the publicity I was getting to focus attention on Sudan. My friends were always fascinated when I talked about what was going on there:

"You mean people are starving there?"

"Yes. And they are being murdered. Their homes burned."

"Why don't I ever hear people talking about it?"

I thought this was a very good question. I decided to change that.

Every time anyone interviewed me, I'd start telling my story and talk about Sudan. The journalists would usually want to know about the runway, the shoots, the glamour. I'd give them a bit of that, to keep their interest, but then I'd submerge them in talk about Africa. They started printing it. An article in the *New York Times* caught a lot of people's attention, including someone at the U.S. Committee for Refugees and Immigrants (USCRI).

They wrote me a letter asking for my assistance. They were offering hope. They too believed in the possibilities for the future. It was heaven-sent.

"These people are incredible," Mora told me when she read the letter.

I met with the group, and they asked me to be a spokesperson. They even said that we might go to Sudan together. I began by telling my story at schools in the New York area. The children were always mesmerized by what I said, and asked a lot of questions. They rarely seemed to understand why something so terrible had happened. That made me realize that I didn't really understand it either.

I was sure that we could make things better. I remembered the time when I was a child, and UNICEF came to Wau to build the well pumps that provided clean water for the whole town. It made such a difference to our lives. More wells were needed, all over Sudan, and especially in the rural areas, where people still sometimes have to walk for two hours to collect drinking water.

Mora and I went to Washington, D.C., to meet with the president of USCRI, a man called Roger Winter. I was very nervous. My background hadn't given me much preparation for dealing with important people, and I wasn't sure that it was going to go well at all. He turned out to be wonderful. He was passionate about Sudan,

and knew far more than I did about the situation in my own country. I just loved him.

When he offered to take me to Sudan, so that publicity would raise worldwide awareness of the situation, I told him I couldn't go. I had surrendered my Sudanese passport to the British, and I thought this might anger the Sudanese government. I was afraid that if they caught me, they might not ever let me leave, given that I was a high-profile refugee.

I broke down and wept in his office when he started talking about going back to Sudan, because it brought back such a flood of memories. It had been nearly ten years since I left Khartoum, and the idea of traveling there frightened me. Mora wept with me, out of empathy, but the more I thought about it, the more I realized that I needed to face my country again, to deal with my fear.

The situation there was terrible. President Bashir had recently clamped down even harder on non-Muslims, and soon after, he declared that women were no longer allowed to work in public. President Clinton had recently ordered the bombing of a pharmaceutical factory that the Americans believed was connected with terrorists. I couldn't help but think what would have happened to me if I'd stayed in my country: rape, murder, enslavement. I wanted to scream, but I realized that the best way to scream would be to do it so others could hear, all around the world. I could accomplish a lot by going back and generating publicity for USCRI.

Roger Winter told me to take some time to think about it. Then, while Mora and I were still in Washington, we went on a private tour of the White House. We didn't meet President Clinton but we got an insider's view of that incredible place. Another day, a congressman invited me to discuss flights to and from Africa, and I met Hillary Clinton at that meeting. She struck me as a really strong

woman and I admire her very much. I thought of all the difficult things she had faced. I decided to say yes to the trip to Sudan. The USCRI officials said that, unfortunately, the trip wouldn't include visits to any areas where my family were living. Also, since it was illegal for me to return, we'd have to go through Kenya, with the permission of the SPLA soldiers who controlled that border.

On the flight back to New York, I thought about Sudan, and how far from home I was. There isn't much of a Sudanese community in New York, so I hardly ever saw my countrymen. I missed them. In London, my family had a great group of Sudanese friends. On my last trip home, my mother had gathered a group of women together, and we'd celebrated with songs and conversation. They knew I was a success now, but they didn't treat me any differently. They were happy and proud, of course, but they didn't make a fuss. The older ones were still living pretty traditional lives, even in London. For my mother, the community served as an anchor in her life. She had friends who grew up the same way as she did and understood all that she had been through. They didn't talk about walking through the forest with their children to escape murderers, or what it was like to watch your husband die from lack of medical care. Rather, they shared their tips for how best to dry okra on tin pans above the stove instead of in the tropical sun. They got together and cooked stews and *kissra*. It was very important for them to have those connections.

I'd also been really pleased to see all the people I used to hang out with. I still felt very much a part of that community. Psychologically, it was so important for me to connect with my fellow Dinka, even though people my age were doing all kinds of things as they adjusted to the new world. For instance, one of my many cousins came from a village to London and ended up going to college and meeting a

man from Ireland. They married and had a beautiful Irish-Dinka baby. At first, the older Dinka women, of my mother's generation, gossiped about her, as she had married outside her culture, but eventually they accepted her, and now her baby is considered a true Dinka too.

One night, I went to see some young Sudanese musicians, who were making music in a London recording studio. A girl was singing, while a man ran some beats through the board. It was great. She was over six feet tall and gorgeous, in a Diane von Furstenberg wrap dress and red shoes. I felt like a little shrimp next to her. She'd just had a successful meeting with a record executive and had bought a bottle of champagne to celebrate. I realized how far we were from where we all grew up. Then a guy from Zimbabwe walked in. He'd just finished a recording. He'd been a boy soldier back in Africa, and he showed us where he'd been shot. It was crazy. We were all living in the modern world, but we had all experienced the violence of the old world, in Africa. Early the next morning I flew to New York. After the plane landed, I headed straight to my house to take it easy until the morning, when I had a shoot. Mora called to tell me that she had decided she wanted to go with me to Sudan, and that USCRI and World Vision International would team up to send us. I called my mother and told her the good news.

"Alek, you stay at home," she ordered me.

"But, Mother," I pleaded. "I have to go."

"It's too dangerous. They'll kill you and Mora."

"We'll be safe. It's important."

Finally, she relented.

"Try to see my sister if you can," my mother said.

I didn't have the heart to tell her that USCRI had said that wouldn't be part of the agenda.

My twenty-first birthday was coming up and people were getting excited about it. I'd never celebrated my birthday in Sudan; first, because I didn't really know the actual date of my birth, and second, because we just didn't celebrate birthdays back home. In England, we'd adapted to the culture by serving little cakes on birthdays, but nothing extravagant. In New York, I'd been to a few big birthday parties and had always been a bit puzzled by all the champagne and celebration. People, including Mora, were pushing me to celebrate too. I decided to host a birthday fund-raiser for USCRI.

The club impresario Amy Sacco offered us her new venue, Lot 61, and Mora persuaded a DJ from Hot 97 to donate his time and equipment. My model friends, such as Carolyn Murphy and Bridget Hall, came, but best of all, my sister flew in from Canada, and my seven-foot-tall cousin, who just astonished everyone, drove up from Washington, D.C. There were USCRI people there, along with people from various other charitable organizations, so it was a real mix of people: fashion, media, and relief work. We projected pictures of Sudan onto the walls and we danced late into the night. Everyone had to pay twenty dollars to get in, as a donation. We raised over six thousand dollars that night.

Not long after that, the USCRI people told us we had to get some vaccinations before going on the trip.

"But I'm from Sudan," I said. "I don't need any jabs. I've already been exposed to everything."

"Talk to the doctor," they said.

Mora and I visited a tropical medicine clinic in New York, and the doctor literally scared the pants off us. He told me that I'd been gone so long I needed to be protected. Any natural immunity would

probably have worn off. Mora definitely needed protection. They told us about all the horrible diseases in the area we were going to visit. There's mycetoma, a chronic inflammatory disease that ruins your skin; schistosomiasis, an infectious disease that can put caramel-colored ridges all across your swollen belly; tuberculosis, one of the main health problems in the country; leishmaniasis, a parasitic disease passed by flies; leprosy; malaria—well, I knew all about that—and . . . Mora's eyes were on stalks.

"Give me whatever you think I need," she said.

The doctor looked at me.

"I'll go along with that," I said.

Our arms were swollen from all the vaccinations, and we had to take our trousers off so they could stick huge needles into our thigh muscles to deliver gamma globulin, which helps prevent hepatitis. We had to return to the clinic two more times. It was crazy. I'd hardly ever had an injection in my life, and now I was full of holes.

Finally, we were ready to go.

"What should I pack?" Mora asked.

"It's going to be hot," was all I said. "And it's not going to be fancy."

Mora, Roger Winter, and I went out to the airport after work one day to head for Africa. By this time, I was used to flying business class, or even first class, on long flights. It's amazing how quickly I had become spoiled, and I have to admit that I loved the pampering. For this trip, however, we didn't want to waste USCRI's money, so we flew economy class. We were bound for Nairobi, with several stops at airports along the way. After a stopover in Nairobi, we caught a small propeller plane to Lokchikia, near the border of Sudan. From there, we drove in Land Rovers to a smaller airport, where we were to catch a flight over the border. The plane had to

fly at a high altitude, in case the Sudanese military decided to shoot it down, but soon we found ourselves descending to a dirt landing strip in a town called Marial.

As we got close to the ground, a group of children started running toward the plane. I was afraid we'd run them over. When we got out onto the landing strip, the children yelled at me and Mora.

"Awai, awai, awai!"

"What are they saying?" Mora asked me.

"'Salt.' They're saying, 'Salt, salt, salt!' Salt is like gold around here."

Then they started laughing, saying *"kawaje"* and pointing at Mora.

"That means 'white,'" I told her.

They looked at me in my Timberland boots and my jeans, my bright blue tank top and Louis Vuitton headscarf, and their jaws dropped.

"I can't believe she's a Dinka," one girl said.

"That's right, I'm Dinka," I said, "but not her," I continued, pointing to Mora. "She's American."

We smiled, to mask how painful it was to see these children, who looked desperate, frightened, confused by the war.

"We have to hurry along, Alek," said the leader of the trip. "We've had a change of plan. Our original route is too dangerous, so now we're going to El Tonj."

"El Tonj? But that's where my mother's family is from!"

I was so excited. Maybe I'd get to see my aunt.

"Radio ahead if you can," I said. "Tell them we're coming."

Alek

The journey out to El Tonj was a very curious affair, because we were heading through territory controlled by SPLA rebels rather than the Sudanese government. Rebel groups are usually portrayed as being vicious thugs outside the rule of law, but these men, in their simple uniforms, were more polite than many immigration officials I've encountered at airports around the world. They even filled out travel papers for us so we wouldn't be detained by SPLA members inside the country. They understood that our goal was to help the powerless people within the country. We weren't really interested in the politics of the war.

Our first day out, we got so stuck in the mud that we all had to get out and push the Land Rovers to firmer ground.

"Can't they call a tow truck?" Mora asked.

I knew she was kidding, but it was true that we were out in the middle of nowhere, with no one to help us.

Mora was a tough girl, who hiked a lot and enjoyed camping. Once she even invited me to bungee-jump off the Brooklyn Bridge with her and some friends.

"No way," I said then. "I left Sudan to save my skin—I'm not about to risk my life with a bunch of lunatics in New York!"

"Chicken!" she teased me.

The southern Sudan, however, showed her she wasn't quite as tough as she thought. Africa was more than she'd expected, and she freaked out. On our first night, we slept in a dirt-floored concrete hut used by relief workers. They'd dug out holes under each hut, which they could dive into if planes started bombing the camp. As Mora was falling asleep, a lizard fell onto her sleeping bag and she screamed blue murder. The bugs terrified her too.

"Oh my God!" she said every time she saw something strange.

I just laughed. Welcome to my world.

The next day, we drove across an endless stretch of parched earth, brown and cracked from the sun. Our heads banged against the windows as the Land Rover rumbled over the ruts and bounced off rocks. Then we entered the forest, where we drove slower, because the road was curvy and wet. Finally we reached El Tonj. There were thousands of refugees living in the stone buildings, under tables in the market—which had nothing much for sale besides cigarettes and soap—and in flimsy tents. A tall, thin man wearing a turquoise boilersuit stood nearby, chewing on a stick. A few women in long loose-fitting dresses and headscarves sat on a bench. There were feeding centers for starving children.

We drove on for a further one and a half hours until we arrived in a small village where I hoped to run into some of my family.

"This is it?" asked Mora, looking around at the collection of huts and stone buildings, and the large cattle camp.

"I lived in a place like this for six months when I was a girl," I said.

This village, which usually had about one hundred people, was different from the one my family had stayed in. The air was thick with smoke from the cooking fires; the scent took me back to my childhood. My emotions were thick in my body, and I felt like sitting down and clutching my knees. I missed my mother for a moment.

We weren't there for more than half an hour before I saw an old woman approaching on the path. She looked frantic. As she got closer, I realized it was my mother's younger sister, Alwet. She was older now, but I still recognized her. She used to come from the village for weeks at a time and take care of me. She still stood tall, though her hair had streaks of gray. "Auntie Alwet!" I cried out in Dinka.

Alek

It was so lovely to see her.

We held each other and cried with deep sobs. She had thought she'd never see us again. I felt so much emotion; I'd never expected it to be this deep. This was the aunt we all loved so much, who had suffered so badly. Not just during the war, which, judging by how thin and wizened she looked, had caused her a lot of hardship, but also before the war.

When I was young, Alwet married a rough man. After two years, they still hadn't been able to have children. Of course, the man blamed her—a Dinka village man would never even imagine that infertility might be due to his own physical problems, not hers. In his frustration, he beat her, demanding that she give him a child. Then he decided she was useless and returned her to her father, demanding back the cows that he had given in marriage payment. That was a great humiliation for her and the family. Alwet accepted her husband's rejection and started living by herself and raising her own crops. She was an outcast in the village, but through it all, she retained a quiet dignity. Years later, I helped her get to Kenya, to escape the oppression she faced in the village. She adopted two children who had been orphaned, and emigrated to Australia, where, slowly, she learned to adjust to modern life.

That day in El Tonj, she said that when she heard through the bush telegraph that one of her sister's daughters was on the way, she gathered some of my other relatives, whom I didn't know, and walked for hours. She didn't know which girl she was going to find—me or one of my four sisters. She looked so thin, so tired, and so worn-out that I began to sob. She put her arms around me and said, "Don't cry, Alek. Why are you crying? Life is good."

We stood in a circle, catching up on all the news. Mora stood to the side, unable to understand a word.

Then I told Mora that my relatives wanted to sacrifice a goat in order to bless us and unite us once again with my ancestral spirits.

"You're kidding, right?" she said.

I told her that animal sacrifice is central to Dinka rituals. We rarely slaughter animals just for food, but on important occasions we will kill them to please the spirits that surround us. Mora couldn't bear the thought of watching them kill the goat that they'd brought with them. She begged me not to let them do it.

"Look at that animal," she said, pointing to the dusty, long-haired goat. "We can't have them kill it just for us."

"Mora," I said. "This is what we do."

"I can't watch."

"I'll ask them to use a chicken instead. Will that be all right?" She bit her lip and nodded. My relatives agreed. We'd only been standing there talking for about fifteen minutes when a woman appeared out of the bush, leading one child by the hand and holding a baby in her other arm. The woman had a terrified look on her face. Her clothes were rags. The boy had sticks for legs, his forehead and eyes jutted forward unnaturally, and his belly was swollen with thick veins coming up through the skin. The baby girl in her arms was almost unconscious, her eyes rolling back into her head. She was dying.

"Help me," the mother wailed.

Flies nipped at the baby.

"My baby," she said.

The baby looked nearly dead from malnutrition. A yellow crust surrounded her eyes. She was listless, rotting in soiled clothes. I'd never seen anything so awful.

"We haven't had any food in weeks," the woman said, and fell to the ground.

Alek

"We've got to get this baby to a feeding station," I said.

Relief groups ran centers in the area, to help starving people, but to find help, you had to get to their tents. I wanted to stay with my family, but I couldn't bear to see this child die.

My family, however, had other ideas. They'd seen this kind of child over and over. To them it was a fact of life.

"It's just what we live with every day," my aunt said. "It's so frightening but there's nothing we can do about it. We must proceed with the sacrifice, or else the spirits won't be appeased."

When I told Mora what my aunt said, a horrified look crossed her face.

"We must," my aunt said. "Or the spirits will be angry."

"Okay," I said, asking the starving woman from the bush to sit under a tree with her children. We gave her a tin cup of water while one of the men who had come with my aunt took a chicken in his arms and recited some incantations, invoking the ancestors. Then he sliced the chicken's neck with a knife so the blood spurted out. It was so awful. This woman was about to die, and here we were doing a ritual that really didn't mean that much to me, since I'd grown up so far from it. I'll never forget that scene. I kept glancing at the child and saying to myself, "Please, God, don't let her die."

My family didn't want to see her die, either. They rushed through the sacrifice. One of the men held the chicken by its legs and cut off its head with a spear. They set the body on the ground and it started running around headless as the elders chanted prayers to reintroduce me to the spirit world, which I'd left behind when I moved to London, and to protect Mora and me on our journey. Then one of the men dipped the chicken in some water and, holding it by its legs, whirled it around to spray water and blood everywhere.

A few minutes later, I picked up the baby and was carrying her as

quickly as I could to our vehicle so we could rush her and her sibling to the feeding center at El Tonj. To call it that makes it sound almost like a place you'd fatten livestock. Sadly, it was far worse than that.

The place was run by Médecins Sans Frontières, or Doctors Without Borders. They immediately took in the family and put special bands on the children's arms, around their biceps. The bands, called "bracelets of life," were marked with bright gradations of green, yellow, red, and orange. When the doctor pulled the bracelet tight, the color that was left would tell them how seriously malnourished the child was. These two were red, meaning that, without treatment, they would die very soon.

We left the mother and her children at the feeding station. Since we had the Land Rovers, I asked if we could take my aunt and other relatives back to their village. The drive took over an hour, past the village where we'd met, through desolate country, so you can imagine what an effort they had made walking to see me. It was nearly dark when we arrived at their little village, but the USCRI officials wanted us to return to El Tonj for safety reasons. I said a tearful good-bye to my aunt. It had been so great to see her.

We returned to our tents in El Tonj and tried to sleep. I lay awake, thinking about the starving children, wondering what had happened. I figured the doctors were giving the kids Nutriset, a milk formula to build up their strength, but I was still afraid for them. The next morning, we drove back to the feeding station to check on them. They were listless, but vastly improved. The baby's eyes were back, focusing on the world. It gave me the chills to see her alive once again. The mother seemed about the same. The doctors said she had been starving for so long that she could only take in the tiniest bits of food. She told us stories about walking for weeks, carrying her children, with nothing to eat. How her friends had been raped. How

she'd lost her three other children to hunger while trying to reach the feeding station. How militias had stolen or destroyed everything she'd owned. They'd killed her husband, running him straight through with a sword. But she was alive.

And here were these magnificent volunteers risking their lives to help families like this one. The war seemed so senseless, and the doctors were so selfless. They were spread out all over the country-side, in the tiniest villages. Some of them lived in the underground shelters, to protect themselves from the government's bombs.

Other relief agencies had also set up centers in El Tonj. The Red Cross had a center that served hundreds of disabled adults two meals a day, of corn porridge and beans. Another served people who, though starving, were otherwise able-bodied. They would arrive and wait patiently in lines for bowls of food. Many had no clothes, others wore only a shirt. I saw a teenager lying still on the ground, his bones poking up through his skin as a doctor slowly fed him a cup of Nutriset. In a weak voice, he told the doctor that he'd walked for two weeks to reach a children's feeding center, but because he was a teenager, they'd turned him away. He walked for another three days to reach El Tonj. His parents, brothers, and sisters were all dead. Before my very eyes, he got stronger from drinking the liquid, but there wasn't much more the doctor could do. When he was able to walk, the doctor told him to join the other refugees, who were crowded into one of the nearby buildings. He couldn't even offer the boy a blanket, just another meal in the morning.

I was glad to leave Sudan. It was too much for me to deal with. I felt tremendous guilt because I had escaped and done so well, yet

millions of my countrymen were suffering. I couldn't fathom what the government was hoping to accomplish by waging this war against its own people, but I understood why the rebels didn't give up their fight. How could they give in to domination from the north?

Back in New York, my trip received a great deal of publicity. People kept telling me that before my trip was publicized, they'd had no idea what was going on in Africa. It felt incredibly good to be able to help in some small way. I had a voice, and I was using it. It made being a model worthwhile.

Over the years, I've remained active with USCRI, and also with other organizations, such as the United Nations High Commission on Refugees. I appeared in advertisements for their first "Respect" campaign, with Madeleine Albright, who was secretary of state under President Clinton. That campaign used Aretha Franklin's song "Respect" to highlight the needs of refugees. My work with refugees led me to other volunteer work. For instance, I met with First Lady Laura Bush for the Red Dress Project, which uses images of a red dress as a symbol for the hidden prevalence of heart disease in women. The campaign encourages women to take action to wipe out the disease and protect their hearts. I've spoken in countless schools about refugees, and the need to study hard.

But nothing ever affected me as strongly as that mother and her children, literally dying for the world's attention.

Chapter 11

When I was twelve years old, my father spoke to me from his deathbed in Khartoum.

"Alek, you must go to London. Live in peace for once. Get an education. Do well," he said.

His words fueled me. And now I was a successful model and I owned my own house.

In 1998, Mora left IMG, and I started working with a new agent, Maja Edmondson. I have been so lucky with my agents: Maja turned out to be a great protector of my career, just as Mora had been. I continued working

all over the world, and everything was going well. The only thing that suffered was my painting. After moving to New York, I'd kept it up for a while, but then, when I started traveling so much, it became difficult. I missed it terribly, because painting is very good for my soul. It soothes me and gives me a homey feeling, which is something I love. In that funny way life has of presenting you with opportunities before you even know it is happening, traveling turned out to help me with my art. I always traveled with duffel bags, which were great, because they held a lot of stuff, but they were also very awkward, as they had no pockets. I found myself thinking about bags while I was flying. About what kinds would be best for me. Then I started sketching them.

My father had carried a simple brass-clasp briefcase each day when he left the house for work. It was practical yet beautiful. That bag inspired me when I started drawing bags to pass the time on long-haul flights. It turned out that bag design was perfect for me, as it involved color, texture, and shapes, and I could do it on the run in a sketchbook, rather than having to lug around all my oils and canvases.

One week, when I wasn't traveling, I decided to make a bag at home. I ran up a bag on my old sewing machine, using some dark green cloth. I made a strap out of a black leather belt, with a buckle, so you could adjust the length. It was a very simple version of a messenger bag.

I showed it to some friends, and they loved it, but it didn't even cross my mind to sell it, or produce more of them. Then, one evening, I was having dinner with a friend who was a shoe designer for Donna Karan. I told him about my bag, and he was really surprised that I'd actually made one. He asked me if I'd ever thought of designing more.

Alek

"Well yes, I'm always drawing them," I said.

Later, I showed him my designs. He suggested I make some samples, and introduced me to a factory that could produce them.

"Just be careful," he warned me. "You have to know exactly what you want, and the exact sizes of the bags, or else you might waste a lot of money on mistakes."

I was twenty-four years old and going into business, almost by accident. I realized that it was what I wanted to do. Of course, when you're a model you always wonder what will happen to you when you get too old for the business. From that perspective, I knew the handbag business would be a good idea. I decided to finance it entirely on my own and I named it WEK1933, after my dear father and the year of his birth.

I contracted a factory to produce eighteen sample bags. I drew the patterns for the linings and took all the leather tones—chocolate brown, neutrals, dark red, dark blue, caramel—from my paintings. The hardware—the clasps and chains—was inspired by the brass jewelry one of my grandmothers wore. I searched catalogues and the Internet and sometimes picked up unusual items.

I probably spent too much on the samples, but every bit of the business has been a learning experience, right from the beginning. At first I was the sales agent. I bought a big sample case and dragged it around from store to office to showroom, selling my wares. Amazingly, Barneys bought bags for their New York, West Coast, and Japanese stores. Lagerfeld Galerie bought some. Collette, another well-known Paris boutique, bought some too. It was great. American *Vogue* and other magazines ran photos of them.

As I traveled, I'd keep notebooks of colors and textures I liked, and make notes about what feelings I had when I saw them. When I got home, I'd put a piece of paper on the wall and start gathering my

different ideas—sketches and taped up pictures torn out of magazines. In time, I learned to do the measurements for the bags myself so that so much wouldn't be left to the factories.

I've always run the business from my house in Brooklyn. I have a couple of employees, young ambitious women who are great to work with. We keep it all rolling. The business isn't huge, but it's good. Everything is well made and well designed. I'm not looking to cash in: I want to do good-quality work and have a business that lasts a long, long time. I tell you, it feels good to see someone walking down the street, carrying a WEK1933 bag.

By the time I was twenty-eight, the business was sustaining itself and growing steadily. I'd done a lot of work on my house and it was very comfortable. I had a nice boyfriend, who lived in Italy but came to see me often. All in all, life was very good. But there was still one dream that nagged at me: I wanted to visit my father's grave and pay my respects to the man who was always in my heart, guiding me.

In 2004, a measure of peace had been reached in Sudan. Various parties, including the American secretary of state Colin Powell, had gathered in Kenya to hammer out an accord between the government and the SPLA. The American participation was significant, because Sudan had been a base for Osama bin Laden, and its government also supported Saddam Hussein in the first Gulf War.

The Sudan Peace Agreement was signed in Nairobi on January 9, 2005. The accord was meant to ensure that the south would be autonomous for six years. After that, there would be a vote about whether the south would secede from Sudan and form its own country. If not, then both armies—the SPLA and the government—would merge. The income from the immense oil fields in the south was to be shared equally between both regions. Northern people

would get 70 percent of national government jobs; southerners would get the remaining 30 percent. The north would remain covered by sharia, but the Sudanese General Assembly, which included representatives from the south, would vote on whether to impose sharia on the south. It wasn't a magnificent treaty but, considering all that had preceded the signing, the thought of peace—even for just a few years—was a great relief.

For me, at least.

Even as peace was arriving in Wau and the villages, the government was ratcheting up the violence in Darfur, a western region of Sudan. The area comprises three states, and is two-thirds the size of France. More than seven million people lived in Darfur, but it's believed that over a million have fled in the last few years.

Darfur is populated mostly by Muslims, although there are communities of Dinka and other animists and Christians. Many of the Muslims are dark-skinned Africans rather than Arabs. The Darfuri Arabs, partially inspired by Libya's president Muammar al-Gaddafi's notion of Arab supremacy in Africa, started trying to dominate the non-Arabs, both Muslim and non-Muslim. A famine in this arid, mostly roadless region led to a lot more fighting in the 1980s. Over the next fifteen years, as various rebel forces slowly developed, the government began working with the so-called Janjaweed Arab forces. These Janjaweed forces were built from communities of Arab camel herders.

In 2003, the rebels gathered together in a convoy of thirty-three Toyota Land Cruisers and attacked a government military base at al-Fashir. They destroyed a number of planes and gunship heli-

copters on the ground, as well as captured the general in charge. The rebels lost nine fighters but killed seventy-five soldiers and technicians. This was the most serious loss in a single operation that the government had faced in the previous twenty years of war with the south.

Humiliated by this and other losses, including one where five hundred soldiers were killed, the government supplied the Janjaweed with advanced weapons and support. By the spring of the next year, the Janjaweed had killed thousands of non-Arab Darfurians and driven hundreds of thousands from their villages.

A typical day went like this: the government would identify a village to be attacked. They would send in cargo planes that dropped oil barrels full of explosives. Since these "bombs" were so crude, they had no military value other than to terrorize civilians. The bombs would be followed by helicopter gunships that strafed the buildings and fleeing civilians. Then the Janjaweed would appear on camelback, wielding guns and swords, to finish the job by raping the women and girls, and killing the men. Arab villages were, for the most part, spared the destruction, while non-Arab villages were ruined, even when two villages, one Arab and one not, were only five hundred yards apart.

Every night, the relief camps set up by aid organizations were there for people who walked from their villages to escape the possibility of being killed in the middle of the night by raiders. In the morning, they'd walk long distances back to their land to work their crops and tend their cattle. In time, over a hundred thousand refugees fled into Chad and other border countries. The world responded with rhetoric and not much else. Some people said America was preventing the UN from taking action because it wanted to maintain good relations with Khartoum, so that the government didn't prom-

ise its considerable oil to the Chinese. Who knows? How can anyone explain horrors such as what has happened in Darfur? Perhaps four hundred thousand people have died. More than two million have been displaced. As I pondered the peace brokered between north and south, I wondered when peace would also come to Darfur.

With images of Sudan constantly in the media, I felt a need to return to my homeland. It was like my second mother, calling me.

In 2004, a producer from the BBC asked me if I wanted to go to Sudan with a documentary crew. The phone call seemed like providence. I told them I wanted to take my mother with me. We would visit my father's grave and also search for my mother's sister Anok, whom she hadn't seen in over twenty years. No one knew if she was alive or dead.

I flew from New York to London to collect my mother and meet the crew. Walking out of Heathrow to my car, I felt protected. When I first arrived in London, fourteen years earlier, it seemed like the first place I'd ever really felt safe in my life. London enveloped me with peace. It was good to be back. The next day, my mother and I went to a Sudanese community center in North London to meet with the women she socialized with, along with some of my old friends from childhood. It was such a wonderful scene. The women, who were from a variety of Dinka groups and other tribes from the Sudan, all with their own traditions, sat in a circle. They played the drums and sang, and made trilling noises as we jumped around. It was all in honor of my mother and me: they were blessing us, to send us safely on our way. It would be my mother's first trip home. These women made me proud to be a Dinka woman.

"Sudan is my home. It's where I belong. My people are back there. So my prayers gave me always this hope that one day my country would be okay, that one day I would be allowed to return," my mother told everyone.

I packed my boots and some medicines, and we flew the seven thousand miles to Khartoum. The city was a wreck. The tenuous peace had taken hold so recently that prosperity was still a dream. Drought and famine, in addition to the civil war, had clearly brought untold suffering to the city. As always, men in white robes rode donkeys or pulled wooden carts laden with goods. A family huddled in the decrepit hallway of an abandoned theater, eyes heavy with the dust. The city felt like it had only recently risen from a dark dream.

We met Uncle Deng in a café. He greeted us with hugs.

"Alek, why are you so skinny?" he asked, bemused.

"It's her job," my mother said.

"I'm paid to be fit," I told him.

He laughed and we drank Cokes again in this city where I had first tasted a Coca-Cola. For my mother, it was like she'd never left. She slipped right back into being Sudanese. For me, there was more of a separation. I had grown up, really, in London and New York. But still, you never forget.

My uncle smiled endlessly in his suit and tie. He was so happy to see us.

"I haven't seen my sister Anok for twenty years," my mother said. "Where can we find her?"

"I believe that if she's still alive she'll be in one of the villages near Wau," Uncle Deng said.

It was clear he hadn't been to the villages in a very long time.

We flew in a propeller plane across the White Nile and seven

hundred miles southwest, to land on Wau's red-dirt airstrip. The airport looked so small, so primitive. In my memory, it had been huge and complex, a modern miracle. I'd been in dozens of airports since then, but I'd never seen another one like this, with mutilated helicopter gunships and a massive crashed cargo plane dead on the edge of the runway. A group of men approached as we stepped off the plane. My mother gave them a hug. I had no idea who they were, so we exchanged a Sudanese air hug, barely touching but giving each other friendly little pats on the back. They turned out to be relatives whom I hadn't seen since I was a little girl.

Soldiers wearing camouflage and berets, carrying rifles, stood at the side of the runway. I couldn't help but be wary of them.

On the drive into town, my mother and I were shocked by the damage. The road was pitted; the buildings alongside it smashed. The grand stadium that had always told me when we were getting close to the airport was crumbling. No one played there anymore.

"This is not Wau," I said to my mother.

"Not the way we remember it, no. But this is still our home," she said.

We pulled into the front yard of a low building made of large square bricks. Two policemen stood out front.

"Mother, we never lived here, did we?" I asked as we walked toward the policeman.

"This is the house in which you were born," she said.

I scanned the yard.

"Oh yes. Now I remember, there were flowers there, and a beautiful tree here."

She nodded. The house was now a police station. The policemen let us into the dirty rooms.

"I remember Baba listening to the radio right there," I said.

My mother's face was soft, sometimes smiling, on the verge of tears at other moments. The officers, sensing our mood, were quiet and polite.

"Goodness, how things change," my mother said when we got back in the car and drove to our second house, the last place we lived in Wau. The zinc gate that had protected us so well from the militias one night was hanging off its hinges. We pushed it open with difficulty, then stepped through the door. Another family was living in the house. We didn't know them; the house was no longer ours. They'd built a grass-roofed hut in the yard. Our fruit trees were gone; the garden was dead. There were no cows. The offspring of my mother's cows were still in the village where she'd left them so many years before. One day she was going to reclaim them. She'd recognize them in a second, she said. And she would need them in order to pay a dowry if one of my brothers married a Dinka girl. Of course, she wanted us all to marry within the Dinka tribe.

The new family showed us around. It was fun to see the old house, though I didn't feel attached to it anymore and it didn't seem like it was ours. But for my mother, walking through the house was emotionally wrenching, and we didn't stay long.

"We've come to our broken home, destroyed by war," she said to me.

Afterward, she pointed at the houses of each of our neighbors, one by one.

"I heard this lady is dead," she said. "That man is dead . . . this one is dead." Then she turned and pointed to the last house. "And this one, the teacher, she survived and is now in Canada."

We walked to the pump where I used to collect water. The dead bodies that had been rotting in the grass the last time I visited were gone, but everything looked so shabby. Even though Wau had

Alek

always been a simple town, it had changed a lot and looked really run-down.

Just then, a tall woman wearing a violet-colored outfit appeared and called out to my mother.

"Is that you, Akuol?" Since there were no phones, no telegraph, no mail, and no Internet, this woman, whom we had known when we lived in Wau, had no way of knowing who was still alive. She'd assumed we were all dead. She burst into tears and my mother held her and stroked her hair.

Wau was now a town of refugees. The population had increased by fifty thousand since we left. Many people lived in camps. I saw a family living in a mud-walled house with a canvas roof. An old woman sat in the dirt, despondent. That could have been my mother, I thought. A young woman with a crutch and a withered leg hobbled past. That could have been me.

These people weren't begging for handouts. They wanted tools and the possibility of being able to do something, anything. They would find it, I knew. They were very determined people.

Farther along, we came to a tree where a young Dinka man was dispensing drops of polio vaccine to young children. He said he was responsible for an area the size of London. His expenses and salary were covered by Médecins Sans Frontières. Flies buzzed on some of the children's faces. They were dirty; some were naked. He had a seemingly endless, thankless job, but he had such a smile. As we spoke, it became clear that we were related, on my father's side. I felt so proud.

His name was Wilson Angeng. He told me that my relatives had dispersed to every corner of the southern Sudan. My mother wondered if we would ever find her sister.

. . .

We walked up the hill, past some boys playing in the dirt with a bicycle wheel. At the top of the hill, I sat down and remembered how I used to go there with my friends. We'd play and sing songs and, if we were really lucky, we'd spot a plane. I loved thinking about the exotic places they were sure to be flying to. I remembered how I dreamed of traveling the world back then.

The next morning, we set off in a truck for the village of Talakong, where my mother thought we might find her sister. The driver had to avoid certain roads because he feared they still hid land mines, which were left over from the civil war. The roads we could take were rutted and difficult: it took us eight hours of steady driving to cover less than two hundred miles.

Suddenly, we saw a cluster of small mud houses with conical grass roofs that looked like ice-cream cones in the distance.

"That's it!" my mother said.

We were surprise visitors. My mother's father had seven wives, so her family here is quite complicated. One of her stepbrothers spotted her and came over and gave her a hug. Soon we were surrounded by relatives I'd never met. My mother tried to introduce me to everyone, but even she couldn't get them all straight. It didn't matter: they were our family and they welcomed us.

They spoke so quickly; I tried to answer as best I could, but I was so embarrassed by my Dinka, which was rusty. I knew they were thinking, What *is* this girl trying to say? My mother fitted right in. One of the young men ran off to find my mother's stepmother. When her own mother had died, this woman cared for her. It is Dinka custom for the eldest member of a family to bless visitors who have been gone from the community for a long time. As we

Alek

stood in the yard, the chickens rustled underfoot and cattle lowed. The village seemed as alive as any city.

An old woman made her way slowly across the field. My mother became excited: there were tears in her eyes as she went up to the bent, bald woman. The woman seemed confused.

"It's Akuol," a man said. "Akuol, Akuol."

"Akuol?" the old woman said, her face brightening. They hugged. Then I hugged her. She cleansed us by pouring water on our hands and our feet and by wiping our faces.

The next morning, we drove to my mother's family's burial ground, where the male elders had already gathered, spears at their sides. A large steer was tethered to a stake.

"We have gathered to honor the return of our tribal daughters," they said.

They sang and danced and jumped into the air and trilled their tongues. I feared for the cow. And, sure enough, a man recited incantations as another man took a spear and cut the cow's vein. I was horrified, once again, by this sacrifice. It is a part of my culture that I can't get used to, but I still respect it.

"It makes me feel good to have the love of my people on display," my mother said. "Without that we are nothing."

Nearby were the tombs of my ancestors, set among a grove of trees. Each person had been entombed in a tall mud cone. Their names were inscribed on the side. The graves had monuments of mud made to look like almost human faces, or horns like cattle. I saw my grandfather's grave. It was an eerie sight.

"They are our fathers," my mother said. "The dead spirits. Whenever we call them they help us. Without them I don't think that anyone can be alive."

I asked my ancestors to guide my mother to her sister Anok.

I remembered Aunt Anok well. When I was four, the Dinka women wanted to pierce my ears. I refused: I didn't want them to hurt me. My mother said, "Come on, Alek. Let's get it over with." I ran away but Aunt Anok chased me. She caught me. She pierced my ears right there.

We drove for another couple of hours, to a village where we'd heard she might be. This village had been at the epicenter of the civil war. We were afraid that everyone would be dead. We stood for a few moments in the barren village. Then my mother saw a woman walking toward us. My mother ran to her. She threw her arms around her and burst into tears, saying, "Anok, Anok, Anok," over and over again.

My aunt was so skinny. She looked so much older. She was missing some teeth, and others stuck out. She honestly couldn't believe her eyes. "Akuol. Is that really you?" she said.

My aunt was so happy. She'd given up hoping to ever see her sister again.

The villagers took dust and ashes from the ancestral lands and rubbed them on my face and neck to bring us as a family together with the spirits of the ancestors. They chanted and clapped their hands. They covered my mother's face with dust, blew whistles, chanted, trilled their tongues.

That night, by the fire, my mother sat on the ground and looked at me.

"So many nights we sat like this, Alek. So many nights when we were going to the village. I'd lay the blankets down and you'd sleep there with your sisters, and your brothers over there." She pointed

to different places around the fire. "Your father there, and I was here."

She looked into the dark forest, a faraway look in her eyes.

"In the morning, if there was no food, I'd heat up the water and tell you it was tea."

The next day, we headed back toward Wau to catch a flight to Khartoum. On the long ride across the bush, my mother talked about our family and about her life.

"Your father was such a calm, strong man," she said. "He wanted you to know your rights. To have good values. Together he and I tried our best to make sure all nine of you got a chance in life."

In Khartoum, we rested for the night and then, in the morning, set off into the brutal heat to find my father's grave. When we arrived at the cemetery, my mother looked confused. Everything was different.

"What's happened here?" she asked the caretaker.

"A lot of dead people," he said. "There have been too many dead people in these last years."

The graveyard was now a vast, dry field of graves, without a bush, blade of grass, or flower in sight. Some of the dead were buried in cement boxes that rose high above the ground. Others were in wooden boxes in the dirt, with their names written in paint on sticks in the ground. My father had been buried in the ground, in a cement crypt. I'd never seen it, because children weren't allowed to visit the dead.

My mother looked distraught as we walked among the graves, afraid she wouldn't find my father. We wandered for an hour. She

became desperate. Then, suddenly, something looked familiar in the old section of the graveyard. There was my father's grave, his name etched into the cement.

I felt so low. My mother burst into tears.

I held her and then we both straightened up. She spoke:

"I have come with your child to see your grave. War sent us far away to seek safety for ourselves. Now the children are all well. Alek is here now. She has done very well. I want your spirit to stay with our children and bless them. We searched a long time for your grave. We thought we'd never find it, but now we're here. I beg you to look after our children—"

I began to sob.

"—so they can lead good lives."

Life has shown me that he has.

Alek

Dear Reader:

I love living in New York City. But I'm also fortunate to have a career that takes me to cities all over the world where I have my favorite shops, parks, museums, and other "hot spots." Below I've selected a few to share with all of you. Enjoy!

STORES and FAVORITE PLACES

NEW YORK CITY

Layla/Brooklyn

If you're visiting Manhattan, you may have to cross a bridge to find it but you won't be disappointed by this Brooklyn boutique. It has a handpicked selection of cool clothes and items from around the world. There's nothing you can't find here—from home furnishings to jewelry and clothing for adults and children. It even has its own in-house label.

ABC Carpet & Home/Manhattan

They don't call this an emporium for nothing. I'm blessed to own a beautiful home in Brooklyn and I love stopping by ABC to browse for new items for every room. Primarily a home furnishing and carpet store, this nearly 8-acre showroom and store carries everything you need to furnish a home—from imported antiques to exotic contemporary

furniture (think a modern sofa upholstered in colorful Indian fabrics). It also carries jewelry, children's clothing, china, and electronic equipment. I warn you, no matter how much time you plan on devoting to a trip here, you'll end up spending twice as long. Thankfully, there's a great café on the premises.

Diane von Furstenberg/Manhattan

In 1972 Diane burst onto the fashion scene with a simple credo: "Feel like a woman, wear a dress." I agree. In her boutiques you'll find much more than the iconic wrap dress; her shirts, skirts, and seasonal items are inimitable. One other thing: she doesn't just dress women; her very example encourages them as well.

Metropolitan Museum of Art/Manhattan

I attended art school and I still paint to this day. So it's no surprise that "The Met," as they call it in New York City, is and will always be on my list of faves.

Barneys/Manhattan

New York is one of the world's shopping capitals with amazing department stores, and Barneys is no exception.

Barnes & Noble/All over New York City

Knowledge is power! I love being surrounded by so many books.

Borders/All over New York City

Ditto for Borders.

Fort Greene Park/Brooklyn

This is my oasis in the middle of Brooklyn.

Equinox / All over New York City

One of the best places to work out in NYC!

Bronx Zoo

I don't know who enjoys it more—my nieces, my friends' kids, or me. A must for any animal lover.

LONDON

Selfridges

Between the Bond Street and Marble Arch tube exits, this full-service department store is great for basics as well as new eye-catching pieces.

Harvey Nichols

Shoes, clothes, items to pretty up a house: who could ask for more?

Matches

Read a British fashion magazine and the editors are likely to have picked out a unique piece from one of Matches' several stores located throughout London.

Victoria and Albert Museum

This art and design museum not only appeals to the artist and designer in me, but it's also a wonderful spot in which to pass a rainy afternoon.

WH Smith

A chain of bookstores that carries everything from classics to novels to travel books.

Anonymous

One of my favorite boutiques in the city.

PARIS

Colette Boutique

If you can't find what you are looking for at what is considered by many to be *the* boutique to visit in Paris, its neighboring stores, some of which carry vintage clothes, will surely do the trick.

Lagerfeld Gallery

A special treat—this boutique carries Lagerfeld's own line of clothes.

Galeries Lafayette

Located in Paris's 9th arrondissement, this world-famous, ten-story department store has got to be one of the most overwhelming (in a good way) shopping experiences I know.

54/58 Boutique

Eclectic, high-end boutique with a nice mix of established and talented up-and-coming designers.

MILAN

Corso Como

If you are so busy admiring the art at the nearby Duomo that you find yourself running short on time to shop, this street offers one-stop shopping.

No Seasons

Bilevel, high-end boutique on Corso Porta Ticinese.

Alek